A Vision of
DARTMOOR

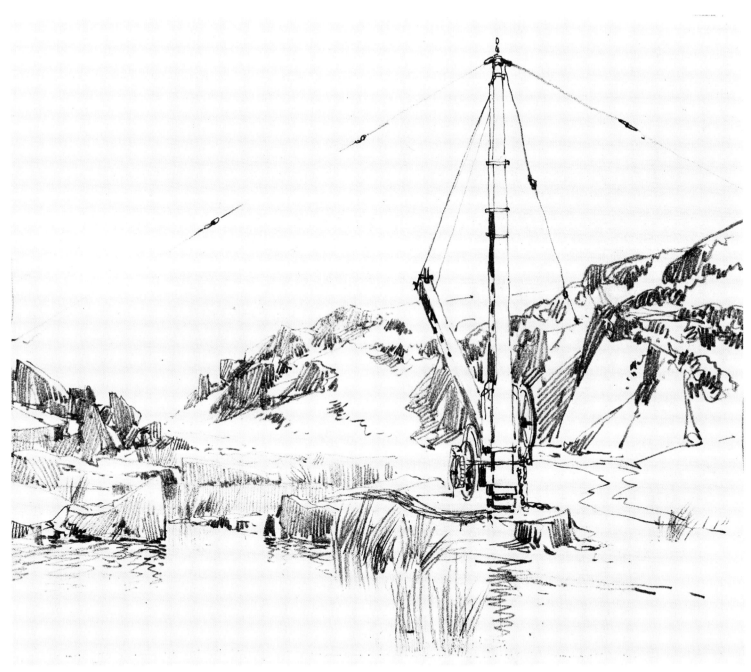

Hey Tor and Quarry,
22 May 1926

A Vision of
DARTMOOR

Paintings by F. J. Widgery 1861-1942

Introduction by C. Jane Baker
Curator of Fine Art
Royal Albert Memorial Museum, Exeter

LONDON · VICTOR GOLLANCZ LTD · 1988

This edition published in Great Britain 1988
by Victor Gollancz Ltd,
14 Henrietta Street, London WC2E 8QJ

British Library Cataloguing in Publication Data

Widgery, F. J.
 A vision of Dartmoor: paintings by
 F. J. Widgery 1861–1942.
 1. Widgery, F. J. 2. Dartmoor (England)
in art
 I. Title II. Olding, Simon
 759.2 ND1942.W5

ISBN 0-575-04294-X

Produced by Justin Knowles Publishing Group
9 Colleton Crescent, Exeter EX2 4BY, Devon

Designer Peter Wrigley
Editor Roy Gasson

Typeset by Keyspools Ltd, Warrington
Printed and bound in Italy by New Interlitho

CONTENTS

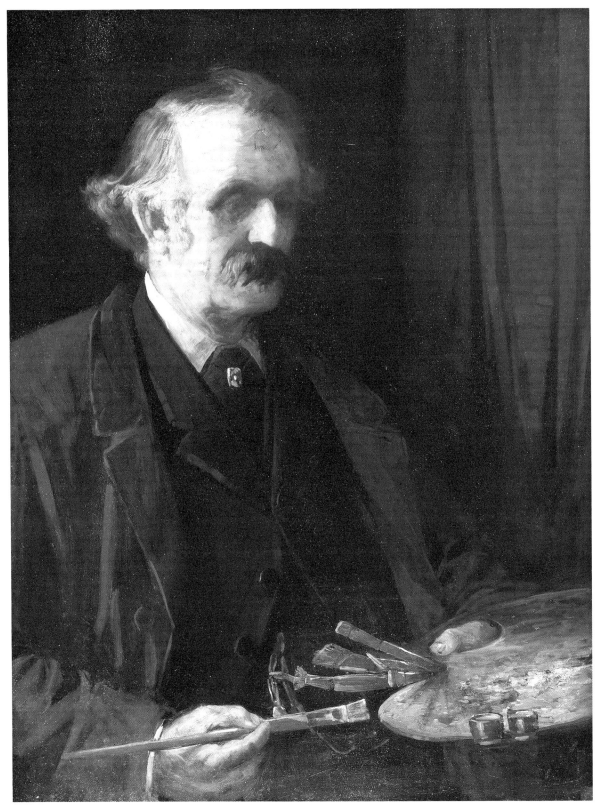

Portrait by F. J. Widgery of his father, William Widgery,
c.1887

DARTMOOR AND ITS ARTISTS

In the history of British landscape painting Dartmoor has never been as favoured a subject as some other parts of the country, notably north Wales, the Lake District, and the Highlands of Scotland. But it has nonetheless, seen from today's viewpoint, an indisputable place in the map of landscape art. That this is so is very largely due to the work of two Devonian artists – William Widgery (1826–93) and his son Frederick John Widgery (1861–1942). William, whose empathy with Dartmoor was as total as that of Constable with the Suffolk countryside, became the moor's most prolific illustrator. His son, benefiting perhaps from William's encouragement, example, and tuition and from a more formal art training, combined the roles of painter-recorder of the moor and Devon worthy playing his part in the local community. It is his work that this book celebrates.

Between them, father and son produced an enormous number of West Country landscapes, including a large proportion of Dartmoor scenes, and many of their local contemporaries, amateur as well as professional artists, followed in their footsteps. Consequently, a spate of Dartmoor landscapes was released on to the general art market and eagerly purchased by both Devonians and visitors to the region. Many of these paintings have found their way to all parts of the British Isles and overseas, particularly to Australia and New Zealand, as families moved in search of new employment or a different way of life. Dartmoor has not enjoyed such widespread popularity as a subject for art either before or since that time.

Before the Widgerys, a very strong inhibiting factor was the geographical situation and terrain of the moor and its lack of easy accessibility for would-be explorers and artists. This, coupled with the fact that so many other promising and attractive examples of coastal, landscape, and urban scenery were readily to hand throughout the entire county of Devon, made Dartmoor a non-starter, artistically speaking, to all but the intrepid few. Another reason for its earlier lack of popularity was its paucity of "picturesque" qualities – those features considered necessary to produce an "ideal" landscape.

The areas of Britain which were favoured by theorists and artists of the "picturesque" school were those that bore a distinct similarity to the majestic mountains and sylvan valleys and lakes of the Swiss and Italian Alps, which had amazed and awed those travellers who had made the Grand Tour. Thus by the late 18th century, north Wales and the Lake District had both become popular venues. This popularity led to such pleasing coincidences as two artists simultaneously working within a few miles of one another. Joseph Farington (1747–1821) and Francis Towne (1739/40–1816), for example, were both painting in the Lake District on 17 August 1786. Farington was executing his *View of Cockermouth and Skiddaw from Sandy Butts*; Towne was busy with views of *Raven Crag*, *Thirlmere* and *The Vale of St John*.

So Wales, the Lake District, and even Scotland monopolized the attention of artists and of ordinary, interested travellers. Dartmoor was virtually ignored, even by her native Devonian artists. Thomas Hudson (1701–79), Francis Hayman (1708–76), Sir Joshua Reynolds (1723–92), Richard Crosse (1745–1810), Richard Cosway (1740–1821), and Ozias Humphrey (1742–1810) were all Devonians, but they specialized in portraiture and set up their main practice in London once they became known. Another, Thomas Patch (1725–82), did not even return to Britain from Italy when he went there on the Grand Tour. He settled happily in a studio in the Via Santo Spirito in Florence, where he painted a steady stream of classical landscapes, topographical views of the piazzas, river, and bridges of Florence, and caricature or humorous portraits of the young British aristocrats and their companions who visited the city.

But Patch remained in contact with his family. When Joseph Farington was touring the West Country, in the autumn of 1810, he visited Patch's nephew, the Rev. Gayer Patch, who showed him a number of letters that Patch had written home, several of them being from Italy between 1747 and 1750. Although interested in the content of the letters, Farington was dismissive about their author: "Of this Mr Patch I had before heard something or other. He made little progress in the art, and died abt. 30 years ago."

Farington was indifferent, too, about Dartmoor as a source of subject matter. Although he made at least two

extensive visits to Devon and Cornwall, in 1809 and 1810, and in 1809 stayed with Sir William Elford (1747–1837), an amateur artist whose home was on the western fringe of the moor, he gives Dartmoor only a passing mention in his diary. Yet he was making frequent sketches on his tours and found the quaint buildings and streets of Exeter's West Quarter particularly charming – "the most picturesque combinations of this kind that I recollected to have seen".

It is possible that descriptions of the moorland scenery from other travellers had already decided him that it would not be to his taste. He certainly made sure of good local advice about worthwhile venues to visit when he arranged an introduction to the Rev. John Swete, who lived at Oxton House, a few miles from Exeter on the opposite side of the Exe estuary. Swete had inherited a charming house and estate and a comfortable private income from his godmother. Thus, freed of financial pressures, he was able to work and study primarily for his own pleasure. The result was a set of twenty manuscript volumes recording in text and paintings his comprehensive travels throughout the length and

Little Hound Tor,
September 1923

9

On the Lyd, Arms Tor,
2 April 1905

breadth of Devon. Together they provide one of the most detailed and complete topographical records of Devonshire scenery ever made or likely to be made. The visual record alone would be an incomparable source of reference, but the accompanying witty, scholarly, and interesting text gives the entire work a liveliness and flair that brings every aspect of 18th-century Devon alive to the reader. As such, the work is unique. Artistically, the illustrations are poor – Swete's style is flat, uninspired, and somewhat crude in both colour and draughtsmanship. Yet the essential topographical honesty and attention to detail shown in the pictures overrides their ineptness and gives them a quaint naïve charm. In fact Swete was not greatly enamoured of Dartmoor's scenery, finding it to be "of the most dreary nature. The horizontal line on every quarter was formed by the hills & Torrs of Dartmoor – a wide waste where the Eye found not a point to rest on – there was nothing picturesque, nor, though wild and rugged was there anything romantic." In another entry one senses almost

a note of quiet desperation when he states that "the wearied eye recoils from the waste but the active mind yet urges it to roam along to try if hill or dale can afford it one intervening charm to rest upon – but in *vain*!!" Nonetheless, Swete depicted Dartmoor scenes with the same scrupulous care that he accorded to the remainder of Devon. Unfortunately, three volumes from the twenty were lost during World War II; one of these was Volume III, which was devoted specifically to Dartmoor. However, Dartmoor scenes are included in several of the other volumes.

Swete had completed the whole set when Farington visited him on 23 September 1809, as Farington records in his diary entry for that day. He told Swete that the Bishop of Salisbury (who had provided him with his letter of introduction to Swete) "had spoken of His knowledge of the picturesque scenery of Devon, & that I shd. be greatly obliged by any information He cd. give". Swete replied that "He had devoted much time in making sketches with descriptions of much of what He

TOP: *Black Tor, 15 September 1907*
ABOVE: *The Valley of the West Ockment, 15 September 1907*

valuable source of encouragement and advertisement for both artists and artistic endeavours generally throughout the whole 19th century. It is mainly through their reviews, articles, and notices referring to art exhibitions, sales, lectures, and meetings, and the informative obituaries they published when local artists died, that we have any factual or biographical details at all available to us today.

Alongside the help they received from the local press, the artists also benefited from greatly increased local patronage. The patrons were generally well-to-do, educated professional men – lawyers, bankers and doctors – who purchased works from local painters to augment their existing collections, which were mainly of Italian or Dutch and Flemish paintings. Hence, artist and patron alike gravitated towards local scenery resembling that depicted in the works of the earlier Italian and Netherlandish schools. So artists such as

William Spreat (*fl.* 1824–87), William Traies (1789–1872), and William Williams (1808–95) favoured the more "charming" subjects – mills and cottages nestling amid trees and fields, or set beside sparkling pools and rivers – over the starker terrain of Dartmoor. However, this trend was mainly confined to their work in oils. For their work in water-colour or print-making they took a much broader view and so it is mainly through these two media that we see the earliest depictions of the moorland scenery.

The most popular venues were those that afforded some contrast of shape and colour – the tors, rivers, and bridges and the standing stones, cairns, and hut circles of the moor. William Williams painted water-colours of moorland rivers like the Cad and the Okement. Spreat produced in 1844 and 1845 lithographs of rivers and bridges (including "Granite Bridge, Lustleigh Cleave", "Fingle Bridge" and "The Teign at Gidley Park") and

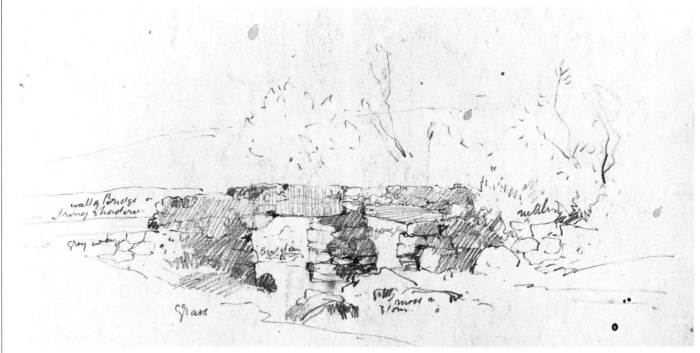

Old Bridge near Princetown,
20 July 1876

tors ("Bowerman's Nose from the East", "Bowerman's Nose from the North West", "Hey Tor", "Saddle Tor and Rippon Tor from Hey Tor", and "Logan Stone. Rippon Tor").

Other publications, marking further milestones in Dartmoor's artistic history, had meanwhile appeared. The first of these was *Scenery of the River Dart*, a set of three title etchings and thirty-six aquatints and etchings by and after Frederick Christian Lewis (1779–1856) and published by him in London in 1812. Six of the original drawings are credited to other artists (probably local amateurs) but Lewis engraved all the plates. The set covered subjects such as "Dartmeet Bridge", "Benshe Tor", and "Spitchwick Lodge from Holne Chace".

Lewis followed this with two other series based on local rivers – *The Scenery of the Rivers Tamar and Tavey* of 1823, which included plates of "Hill Bridge", "Tavy Cleave", and "Mill at Peter Tavy", and *The Scenery of the Exe* of 1827. A further set, which embraced the Devonshire rivers as a group, was published in 1842–3.

Another milestone, and a major work on Dartmoor, was N.T. Carrington's *Dartmoor, A Descriptive Poem*. Commissioned by William Burt, a local antiquary, the poem is a ninety-one page eulogy on every aspect of Dartmoor history and scenery. Its impassioned stanzas have served as an inspiration and source of quotation for numerous succeeding writers.

The illustrations were made by a Plymouth artist, Philip Hutchins Rogers (*c.*1794–1853). His twelve etched plates are neat, tightly drawn, and precisely observed representations which between them give a cross-section of some of the moor's outstanding features – the tors, bridges, rivers, standing stones, and monuments and the curious coppice of dwarf oak trees known as Wistman's Wood. Apart from this set of illustrations, Rogers does not appear to have painted or drawn any

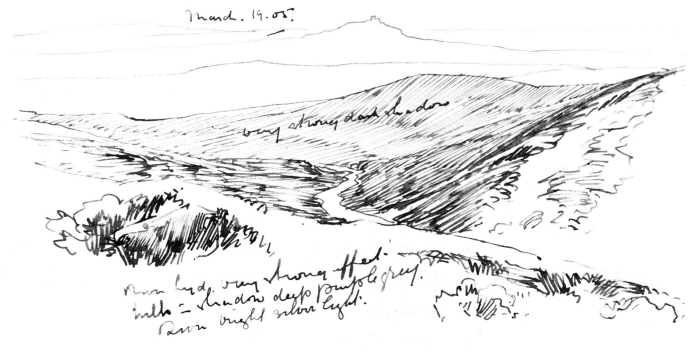

Arms Tor, Lydford,
19 March 1905

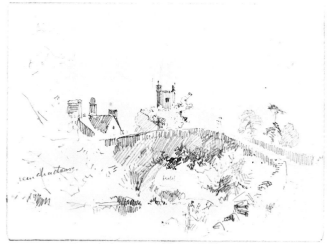

*Meavy Church Tower
and Bridge*

other Dartmoor views, preferring the gentle, more "classic" vistas of the fertile lowland areas. His work on this particular set of prints reveals how specific patronage or a special commission can encourage an artist to deviate from his normal preferred style and subject matter.

These are the first illustrations of the moor commissioned as a set to accompany a particular written text. The next publication to include a special set of appropriate illustrations was the Reverend Samuel Rowe's *A Perambulation of the Antient and Royal Forest of Dartmoor*, published in 1848, which was to become an indispensable and influential source of reference for all those with any interest in Dartmoor. The illustrations to this book comprised ten plates and a title vignette, all but two of which depict the unusual rock formations and distinctive archaeological remains to be found on Dartmoor. This focus on the "most prominent objects of antiquarian interest, in the Forest of Dartmoor" was no accident, as the text itself was basically centred on the same purpose. In his Preface, Samuel Rowe refers to an essay on this topic which had been read before the Plymouth Institution in 1828 "as a result of the united researches of a few members of that Society, who at different times had pursued their investigations in a district which, although within a few miles of their town, was little known to the neighbourhood and the County in general. The paper drawn up at the request of my esteemed coadjutors, was subsequently published in the Transactions of the Society." He then refers to the further investigations made by himself since that time "for the most part with the able assistance of my valued friend the President of the Institution, at such intervals as scanty leisure and few opportunities would permit; ..." Thus he had collected "abundant materials" for expanding the original essay into the volume published in 1848. Rowe's "valued friend" was Henry Woollcombe, the patron of Johns, who gave such a graphic account of the outing to Caddyford Bridge (page 14). The other members who made up the original group were Col. Charles Hamilton Smith F.R.S. and John Prideaux.

Although there is an emphasis on the historical and antiquarian interest of Dartmoor, Rowe is at pains to point out in his preface that the area has "within it's limits... enough to repay... also the scientific investigator" and his descriptions of the moorland scenery and its cultivation and use are as meticulous and exact as those of the antiquarian relics that provide the focus of his enthusiasm.

The illustrations admirably support his stirring and enthusiastic descriptions. They are all lithographs by Paul Gauci (*fl.* 1834–63) after original drawings by Charles Frederick Williams (*fl.* 1841–81). Williams was an Exeter drawing master who also painted in oil and water-colour and who had contributed the original drawings for several other local topographical print sets.

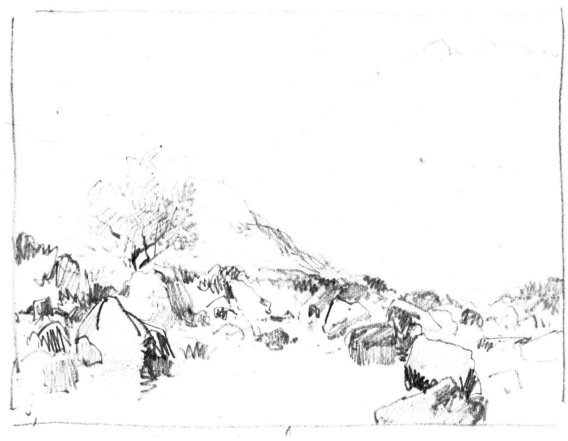

Tavy Cleave,
28 September 1902

Paul Gauci was a London-based lithographer, who, like Williams, had been involved in several similar projects and thus had ample professional expertise to bring to this particular commission.

The joint talent of Williams and Gauci is evident in the skill and panache of the plates, where the adroit handling of composition, light, and shade subtly emphasizes the dramatic qualities of each scene. In fact there is an almost theatrical presentation of the various views, which enhances both single stones or monuments and those found in groups or avenues. Thus they appear to have the same commanding grandeur as the seemingly limitless undulations of heath and hillside which swirl around and behind them like some well-drilled *corps de ballet*. The balance between the stone monuments and the natural scenery is so well held that the scale of the two elements is subtly altered from plate to plate. In "Bowerman's Nose", and "Logan Stone, near Rippon Tor", the hills are minimized and faded into the general background, where they blend imperceptibly with the sky. "Stone Avenue on the North Teign" and "Grimspound" are both depicted as if from the air, so the stone circles and avenues are seen only as a tiny change of pattern within the panorama of the landscape. The imposing prospects presented in the illustrations echo the grandiloquent descriptions in the text.

The wholehearted commitment to their subject that both Carrington and Samuel Rowe demonstrated in their works on Dartmoor had its visual parallel in the paintings of William Widgery.

Widgery, whose adult life almost spanned the Victorian era, was a man fortunate in his time – a time that might be summed up visually and symbolically in what most of us would look upon as a "typical" Victorian landscape painting. This would be a large, sombre oil-painting of a Scottish Highland scene, with mountains, a loch or foaming torrent, perhaps a distant castle, and a few shaggy Highland cattle or a single noble stag. The grandeur and strength of both landscape and beasts seem to echo the power enjoyed by Britain at the time, to be a visual expression, in natural terms, of her industrial and political prestige. Allied to the general atmosphere of solid prosperity and stability was a widespread sentimental and fervent interest in religious and moral subjects. No wonder that perhaps the two most popular engravings of the later Victorian era, purchased in large numbers to decorate parlours, halls, and landings, were of *The Monarch of the Glen* by Sir Edwin Landseer (1802–73) – a magnificent red deer stag against a backdrop of mist-veiled crags – and *The Light of the World* by Holman Hunt (1827–1910) – the figure of Christ carrying a lantern outside a cottage doorway.

Widgery matured into a proficient and talented landscape artist against this background, and his talents and ambitions fitted comfortably into the ambience of the era into which he was born.

Factual information about the details of Widgery's life is fairly sparse. There is no biography of him and he wrote no memoirs, kept no diaries, and seems not to have been a prolific letter-writer. His life, therefore, is something of a giant jigsaw with a large number of essential pieces missing. Fortunately, local newspapers are a valuable source of help.

The general information and advertisement columns of these papers, particularly during the latter part of the 19th century and the beginning of the 20th century, act as a kind of provincial Court Circular – they record and discuss a range of people and events and give constantly up-dated progress reports on certain of them.

William Widgery was one such favoured individual; as a self-taught artist, and one who made good by sheer enterprise and effort, he caught the imagination and sympathy of those around him, including certain members of the local press. The fact that he seems to have had a happy, genuine, and outgoing nature perhaps also helped his cause.

His beginnings seem to have been fairly prosaic, though even here the evidence is confused. His date of birth was until recently thought to be 1822, but his obituaries all firmly stated that he was 67 years old or in his 67th year when he died on 8 April 1893. This would accord with a birth date of 1826, and this seems to be borne out by a baptismal entry for one William Widgery, son of John and Urah Widgery of North Molton, in the register of the parish church of All Saints, North Molton, on 9 April 1826. The "abode" is given as North Molton and John's profession as that of a labourer.

This baptismal entry would seem to solve the problem were it not for a remark seemingly made by Widgery to one G.T. Donisthorpe, which the latter quotes in his obituary tribute in the *Exeter Gazette*: "I see the artist is reported to have died at the age of 67. When we were together last year he told me he was 70. But I suppose he made a mistake." He then goes on to report that Widgery had remarked, "I have had a good innings – I mustn't complain" and had then "commenced talking about the Moor, concerning which he was always enthusiastic".

Widgery indeed seemed to have been as devoted to Dartmoor as a source of subject matter as he was to the art of painting itself. He revelled in both, and this love and total commitment imbues his work.

Once Widgery had established himself as a practising artist he could virtually paint to suit himself without any of the limitations or demands as to specific size, subject, or colouring that are frequently made when paintings are commissioned. His great friend Richard Gowing, editor of the *Exeter Gazette*, mentions this in his own obituary tribute: "He had a peculiar dislike to painting on commission, always preferring that his friends should see his work before they purchased it. The consequence was that many of his admirers were in the habit of making pilgrimages to the breezy and bracing Dart-

moor bespeaking his pictures while still he was at work upon them, either by the sides of the rushing streams or in his studio at Lydford, where he was wont to put the finishing touches to them, after getting them into an advanced stage in the open air." Richard Gowing took several photographs of William painting on the moor. One shows the artist, warmly clad in a suit and ankle-length checked overcoat with a shoulder cape, a broad-brimmed felt hat on his head, holding a brush in one hand and a paint-box in the other. He is posed leaning his right arm against an enormous lichen-covered boulder which towers above his head and makes his easel and the painting resting on the easel pegs appear very small and frail in contrast to its solid bulk. The back leg of the easel is raised from the ground and wedged firmly into a crevice in the boulder, at right angles to the two front struts, and a small piece of rock or stone is steadying the foot of the front right-hand strut. Thus both the artist and easel appear well prepared to withstand the moorland winds! (All this is reminiscent of late-18th-century portrayals of the hazards and discomforts of outdoor painting, such as the satirical *An Artist Travelling in Wales* by Thomas Rowlandson (1756–1827). This splendid sketch shows an earnest artist perched precariously astride an overladen horse, picking his way gingerly down a precipitous hillside in a violent rainstorm. He has no hand free to guide the horse because he has his folded easel in one hand and an umbrella in the other. His kettle and coffee pot are strung from the easel and a large portfolio is strapped to his back.) A later study of William at work on Dartmoor was painted by his son Frederick John. It was recently found in a trunk belonging to Frederick that was bought at a local auction sale by the Royal Albert Memorial Museum, Exeter, in 1969. It is a small water-colour and gouache monochrome sketch and shows William seated at his easel, again well wrapped up against the elements.

Frederick also painted a large formal portrait of his father (see page 6), which was presented to the Museum by Colonel A. Wyatt-Edgell in 1887. It shows Widgery in a rather sad, reflective mood, explained perhaps by Richard Gowing in his obituary tribute:

Watern Tor and Cawsand,
19 July 1908

During the last few years he had suffered much from impaired health and consequent comparative depression of spirits, which nothing could relieve to any great extent except the bracing breath of his beloved Dartmoor. In his earlier days he was a man of exuberant animal spirits, bright, witty, abounding in anecdote, a perfect master of merry quips and repartee in broad Devonshire dialect, and his presence was hailed in a hundred rural retreats in all parts of Devonshire with an abounding delight. . . . As he grew older he grew quieter and more contemplative, but instead of age weaning him in any degree from his work, it befel [sic] him down almost to the hour of his death that he cared for almost nothing else in the world than the continuous painting of pictures, in full view of his favourite landscapes, or in his studio, almost as soon as daylight began, and almost as long as daylight lasted. It was a rare treat to his friends in these later days to see now and then a transient gleam of the old happy exuberance of animal spirits and laughter.

Gowing was well qualified to make this assessment of Widgery's character. It had been, he wrote in the same obituary, his "pleasure and pride to be acquainted with Mr Widgery for considerably more than a quarter of a century, and very many hours and days have I spent with him in the wilds of Dartmoor, strolling over the heather and rocks while he was seated at his easel making his beautiful paintings of the infinite aspects of the moor which he loves so well." One cannot help feeling that the pleasure may not all have been on the one side and that Widgery was fortunate in having so sympathetic and intelligent a companion to accompany him on some of his sketching trips.

Widgery's childhood and early youth were spent in the vicinity of Exmoor, and it is perhaps only chance that it was Dartmoor not Exmoor to which in later life he became so greatly attracted. He went to Exeter in his late teens or early twenties and gained employment with an Exeter builder. We know nothing of the reasons behind this. His father, John, was probably a farm worker, but William may have had no interest in farming and have shown some qualities of craftmanship and skill with his hands. It may simply have been that it was easier at that time to find employment in the building trade than in other trades. Probably any sort of

apprenticeship, which would have involved an indenture fee as well as very low or no wages during the term of apprenticeship, was out of the question. William had many brothers and sisters and his father would have been poorly paid, so there would have been no money available for such a luxury. Be that as it may, things were soon to work rapidly in William's favour. He was employed by Robert Williams, a builder whose address was The Exeter Inn, Bartholomew Street, Exeter, so it may well have been that Williams was also the landlord of the inn. Thus it could have been through this link that William became known to another Exeter landlord, Thomas Hex of the Seven Stars Inn, St Thomas (a district now part of the city which lies on the opposite bank of the Exe from the centre of Exeter).

Thomas Hex encouraged the young Widgery's interest in drawing, which seems already to have developed, and urged him to think of pursuing a full-time career as an artist. Already Widgery was occupying his leisure hours by making copies of paintings by other artists.

The fact that he began by copying other people's work in this way does not imply that he lacked artistic imagination. Copying was a long-established tradition in the art world – an ancillary to, and in his case a substitute for, learning within the studio of a professional artist, an apprenticeship of learning by example. Even when artists had become established masters in their own right they often continued to use ideas and compositions from the work of other artists. The advent of the engraved print made it possible to build up a substantial collection of works, and many painters acquired portfolios of Old Master prints for study and reference. Even Sir Joshua Reynolds openly advocated the practice to the students of the newly founded Royal Academy Schools when he delivered the President's Discourse at the Academy prize-giving in December 1774. Reynolds's defence of "copying" or "borrowing" was based on the premise that "INVENTION is one of the great marks of genius – but if we consult experience, we shall find, that it is by being conversant with the inventions of others, that we learn to invent; as by reading the thoughts of others we learn to think". At a further stage in his development an accomplished artist would then learn to borrow discreetly and so

improve upon or conceal his source that it would not be easily recognizable. (Unfortunately Reynolds was to be hoist with his own petard; a few months later one of his contemporaries, an Irish-born artist, Nathaniel Hone (1718-84), painted a brilliant satire of Reynolds's own borrowings from various Old Master prints in a painting entitled *The Pictorial Conjuror, displaying the Whole Art of Optical Deception.* The Conjuror, clad in rich, fur-trimmed robes, waves a wand at a swirling mass of the prints from which he will "conjure up" a new masterpiece.)

However, Widgery had no such problems: his copies were exactly that and the local newspapers had nothing but admiration for his industry and verisimilitude. The *Western Times* of 16 April 1853 comments:

> William Widgery, the self-taught artist, whose productions we have noticed on former occasions, has just completed two pictures of dogs after Landseer. They surpass any of his previous efforts, and are full of promise. We may again mention that the artist is a journeyman plasterer, and his favourite pursuit is carried on in the intervals between his labour. The steady industry with which he plies at his easel shows that he has an enthusiastic love of art, and his finished pictures prove that he has already gained much ability in fixing refined expression and perpetrating true poetic beauty. His handling is bold and firm, but free and fluent where needful, and has very little of the stiffness which is so often found in the attempts of young artists. Perfection or anything like it, is not, of course, to be expected in such an instance, but the artist has ample merit to entitle him to the patronage of those who have the means and inclination to foster or encourage talent in humble life. Some of his paintings may be seen at the shop of Mr Davey's, artists' repository, Fore-street.

A few months later, the *Western Times* draws the reader's attention to Widgery's latest work, "a copy of Ansdell's celebrated combat of the stags" and again commends the artist; "Taking into consideration the fact that it is a copy from an uncoloured engraving, it is a very creditable performance. The colouring is good and the handling is very bold. The expression is well caught and faithfully preserved. The artist deserves public patronage."

The critic's call for patronage did not fall on deaf ears;

three days later, another newspaper, the *Western Luminary*, noted that Widgery's *Combat of the Stags* had been purchased, as well as other paintings. In December he showed another work after Landseer, *Death of the Otter*, and that, too found a purchaser. This painting (or another version of it – for it seems likely that Widgery would do more versions if so requested) is now in the collection at Torre Abbey, Torquay.

The fact that Widgery did so many copies after paintings by Sir Edwin Landseer was probably only partly because he admired Landseer's work; another, more cogent, reason would be the easy availability of engravings or other reproductions after this popular artist, who was a particular favourite of Queen Victoria. Landseer specialized in animal paintings and Widgery's copies of his work soon led to specific local commissions in the same field. Here perhaps his childhood experience of the countryside and of farm animals stood him in good stead.

One of these commissions had rather awkward consequences. Widgery became innocently involved in an acrimonious case at Exeter County Court, where a local taxidermist, Mr Truscott, of 30, North Street, Exeter, was suing a certain Mr Atkinson (described as "very fond of sporting") of Bickington, near Ashburton, for non-payment for goods supplied. Widgery had accompanied Atkinson on his first visit to Truscott's shop, when Atkinson had bought a wood-pigeon and a snipe " which he requested should be handed over to Mr Widgery for him to copy when they were finished". Atkinson made further purchases and ordered other items to be delivered to Bickington when ready. When these goods arrived at Bickington, Atkinson refused to accept delivery, claiming that he had not ordered them, merely admired them in the shop. Various heated exchanges between the two gentlemen then took place, in the course of which Atkinson said that "'if that artist', meaning Widgery, 'turned against him he would ruin him'." The dispute was settled in the County Court on 15 August 1854, when the jury found in favour of Truscott. Happily Atkinson's threat to "ruin" Widgery came to nothing – on the contrary, Widgery's career as a full-time artist was soon to become firmly established.

Early commissions in 1855 included "a very pleasing

picture of Mr Carnell's coursing dog Hector... taken from life,.. with its paw on a hare which has just been run down" and two paintings of sheep. One was ordered by Mr Potter of Thorverton and featured his two prize-winning sheep; the other was called *The Meadow and the Stream*. The current whereabouts of these two works is not known but, interestingly, a third sheep painting surfaced in April 1987 in the hands of a London art dealer. Entitled *Symmetry*, it is of a sheep that was "Winner of the Bath and West of England Society's 1st Prize at Cardiff June 1858". It is signed and dated "W. Widgery 1858" on the reverse and shows an impressive sheep in the setting of a peaceful country scene – a field bordered on one side by trees, with another group of trees and some buildings on the left horizon. The sheep is built up with small, neat brush strokes but the surrounding landscape and blue, cloud-filled sky has been painted much more dashingly and sketchily, with quick flicks of the paint – a technique that was to become more apparent in Widgery's later work and a hallmark of his landscape style.

During the late 1850s his artistic endeavours seem to have been fairly evenly divided between other animal and sporting paintings, the occasional portrait, and more copies after well-known pictures of the day, such as *The Horse Fair* by Rosa Bonheur (1822–99). In the *Exeter Directory* for 1856 and that for 1857 he is listed as "William Widgery, Artist", of Paul Street; in the 1858 directory he is still "Artist", but has moved to 87, South Street. He may have retained his former job with Robert Williams for a time, combining it with his painting, but it seems likely that by 1858 or 1859, at the latest, he was a full-time artist.

A notice in the *Western Times* of 7 February 1857 states approvingly;

> We are glad to learn that Mr. Widgery is receiving many commissions from gentlemen in North Devon, who are more than satisfied with his ability and are delighted with his productions. He has been painting portraits of favourite steeds for Mr. Buck, M. P., Mr. Wren, and others, with great success. Animal painting is unquestionably [h]is forte and with study of the masters he will yet leave his mark on his age, as a self-taught genius of no mean order. We have seen one or two of his recent works which evince considerable improvement – truthfulness of drawing with a fine appreciation of color[sic] were their striking features. Since Mr. Widgery has been near Barnstaple he has made the acquaintance of Mr. Edward Capern, the postman poet, who has signalised their meeting by an effusion. . . .

Effusion is an apt description for Capern's lengthy ode entitled *Lines (suggested on seeing some fine pictures painted for L. W. Buck, Esq. M. P., and Adderley Wren Esq., by Widgery, the Mason-Artist)*. The first few lines give a fair sample of the poet in full and enthusiastic flow:

> Fav'rite of nature – Widgery
> What magic spirit prompted thee
> Thy lime-stained trowel to forego
> With life to bid the canvas glow?
> Was it a false ambition? – say, –
> That scorn'd thy toil-worn garments? – Nay
> It was the force of Nature's fire,
> A strong unconquerable desire
> The wonders of God's work to scan,
> And teach the sovereignty of man.
> Lovers of beauty, let us view
> What Nature taught her child to do.
> Behold! the "monarch of the glen",
> Wet with the misty morning's rain,
> As on the storm-swept crag he stands
> And snuffs the wind of cloud-capp'd lands.

Widgery repaid the compliment by painting a portrait of Capern. In it the poet's stance is like that seen in 18th-century portraits of notable generals or admirals, fresh from their triumphs in the fields of war. Although he is clad in a simple dark overcoat and tam-o'-shanter beret, his expression is not in the least humble or self-effacing but one of confidence and quiet pride. The plain effect of his clothes is relieved by a black-and-white check or plaid scarf, falling from his right shoulder, and by the postman's bag or satchel slung diagonally across his chest. His dual role as postman and poet is symbolized by a pen in his right hand and letters in his left; a moorland landscape forms the background.

A similar sense of pride, though a more self-satisfied one, pervades the portrait of Edward Adams of Crediton, which Widgery painted in 1856. It suffers, like so many 19th-century portraits, because of the plain, stark

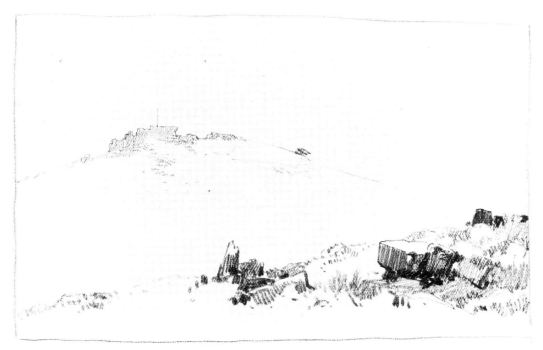

Yes Tor from West Mill Tor,
12 July 1908

black suit worn by the sitter – 18th-century clothes were more colourful. The only note of real colour in the Adams portrait is in the flesh tones and in the eyes and hair and William has handled these sympathetically, if a little crudely. His knowledge of anatomy was imperfect and he lacked the training and expertise to model the planes of the face to give it a three-dimensional quality; the result is the rather "flattened" appearance that one usually associates with portraits by 16th- and early-17th-century provincial artists. Yet Widgery's skill is obviously considerably greater than that of the average anonymous, local, Tudor portrait painter. He could have become a very competent portrait painter had he so wished. He could equally well have established a comfortable local practice as a sporting painter. Devon was, and remains, a predominantly agricultural area with an abundance of land-owning gentry and farmers. So there would have been no shortage of potential clients for paintings depicting prize-winning animals,

with or without their proud owners, or indeed more general scenes of traditional rural sporting pursuits, such as hunting, shooting, and fishing. This type of painting had already established itself in Britain during the 18th century as an offshoot of the landscape portrait piece. During the 19th century it increased in popularity, until (like so many subjects) it was hard hit by the invention of photography.

Widgery's early commissions reveal that he soon became sought after for such subjects. Laurence Palk M. P. commissioned him to paint a thoroughbred mare. In 1860 Lord Poltimore paid 100 guineas for *The Poltimore Hunt*, whose members included Sir Stafford Northcote and the Rev. "Jack" Russell. The painting shows Lord Poltimore leading the chase across the hills near Pinhoe, overlooking Poltimore Park, with Killerton and the open countryside towards Honiton in the distance. In 1861, a local printseller, Mr Clifford, who had exhibited the original painting in his shop, commissioned John

25

Harris to produce a coloured engraving of the work. Sales of the engraving were obviously brisk because we know of a number of copies still in existence. Unfortunately, none of the known owners have the accompanying key that identifies all the participants in the hunt by name.

Widgery's treatment of the figures and horses is still rather flat and wooden, even allowing for the tighter, disciplined lines of the engraving medium. Riders and mounts rather resemble the stiff cut-out figures and scenery of cardboard toy theatres, especially as the majority of them are depicted in the same pose, riding directly across the foreground of the picture and at a slight angle to the spectator. The single exception is a dismounted horseman who is urging his steed out of a pool of water in the central foreground. However, the patchwork pattern of fields, hedges, and hills which sweeps up to the far horizon behind the hunt reveals a much easier and more relaxed handling by the artist.

Sir Stafford Northcote must have approved of the painting because on 7 March 1860 the *Exeter Flying Post* noted that Widgery had painted a portrait of him on his hunter at his family home, Pynes. Other notices in the local newspapers between 1859 and 1861 mentioned various "pure" landscapes that Widgery had produced, including *Exwick Weir with Raddon Hill in the background* and a Devon landscape composition for Henry Docker Luckman of Manchester. On 2 February 1861, the *Western Times* reported that Widgery had several Devon landscapes in his studio and that the Bishop of Winchester was among his visitors and patrons. Widgery's natural proclivity and talent for painting landscape – which he had already tentatively demonstrated in the backgrounds of his earlier works – was obviously gaining ascendancy; from now on it was to become his prime source of subject matter.

Fortunately, his entry into the artistic profession was at a time when landscape painting had not only established itself but was overtaking portraiture in its popularity with the art-buying public. The invention and elaboration of a railway system within Britain had revolutionized travel as regards both comfort and speed and encouraged more and more people to visit and explore areas outside their own immediate locality. The Industrial Revolution had created the sprawling, ugly cities whose residents still wished to visit the countryside. The railways made it possible. Townspeople also wanted a visual reminder of the countryside in their own homes. Perhaps also the melodrama, moral sententiousness, and morbidity (or its opposite – cloying, ersatz sentimentality) that characterized the mainstream of Victorian art was rather too much for the average Briton to bear in quantity. He could admire and applaud it, but it was not comfortable to have on his walls. A balance was needed. And this was provided by the straightforward depiction of Britain's countryside and coastline. Some of the larger, set-piece oil-paintings still exhibited either vivid, almost lurid colouring or the dark, heavy tones of the opposite end of the spectrum, so that morbidity and depression continued to pervade even the most innocent landscape scenes. And bleak marshes, dark reed-encircled pools overshadowed by gloomy trees, and barren, rocky wastelands, all held strong appeal. In a sense they echoed the massive but claustrophobic grandeur and unrelieved starkness of the great factories and workshops and tightly packed streets of uniform terrace houses that were springing up in Britain's major cities.

However, in water-colour painting a much more balanced approach was maintained. The very lightness of the medium dictated a more spontaneous handling of the pigments and brush-strokes and a brighter palette. Thus even those artists whose style inclined to tiny, stippled brush-strokes and a minute attention to detail tended to avoid dark, rich colours which could easily go muddy and cause forms and shapes to lose their definition.

Water-colours, being portable and quick drying, were also the ideal medium for working *in situ* out of doors. Cecil Gould sagely remarks in *Space and Landscape* (1974) of the invention of oil paint in tubes, which enabled artists such as Constable, Corot, and the French Impressionists to paint out of doors, that it was "probably the crucial element in the development of landscape painting". Water-colours similarly allowed artists to work out of doors and this convenience contributed to the rapid development and popularity of the water-colour landscape.

Although Widgery's obituaries note his fondness for oils and tell us that it was one of the griefs of his later years that he had been forbidden to use them because the lead content was affecting his health, he obviously enjoyed painting in water-colour too. His feeling for colour, light, and atmosphere, which formed the major part of his talent, were those very qualities ideally suited to the medium. Like the great J.M.W. Turner before him, he delighted in bathing his subjects in light and colour. His work at its best has sparkle and vivacity and a feeling of the artist's total delight in the subject matter before him.

George Pycroft, in a biographical note on Widgery in his *Art in Devonshire*, published in 1883, also picks out colour as Widgery's strong point: "although his work at first was of course that of a beginner, the writer and the late Dr. W.R. Scott, of the Deaf and Dumb Asylum, an excellent judge of art, used often to look at them when exposed for sale, and agree that the painter had a rare eye for, and was never wrong in, his colour. Indeed, colour has ever been his strong point." Pycroft's further comments are equally apposite. They give a contemporary opinion, but one which anyone viewing the paintings today would strongly endorse.

Widgery had no instruction from any man, or any books. There was no art gallery in Exeter to instruct his eye. He went boldly out into the fields, and sat himself down with the colour that he gradually learned to select, and he painted what he saw, with Nature his only master. The consequence is that he has followed no man. It is impossible to say that "Widgery is of the school of So-and-so", although at the present time all the young painters in Exeter are copying him. He has a style peculiar to himself, a style in which he catches effects, portrays rural scenes and

Yes Tor and Rough Tor,
10 January 1898

wild landscapes boldly, and with very little finish. At the present date he has practised art for thirty years. He has painted over 3,000 pictures, and has sold them all; indeed they are generally sold before they are off his easel, and any left the dealers are ready to take immediately. He twice visited Italy and Switzerland, and for a time he painted glacier streams, and snowy mountains, and views of Venice; but he soon returned to the scenery of his native county. He has painted the coasts of Devon and Cornwall, and is peculiarly happy in his delineation of wild seas dashing on a rugged iron-bound coast; but Dartmoor is the chief scene of his labours, and in after years he will be chiefly remembered as pre-eminently the painter of Dartmoor.

He is a correct and spirited painter of animals, and introduces them with good effect. His pictures are well composed and he has the power of selecting picturesque bits, and of arranging his subject in a bold easy manner, that appears utterly unstudied. He possesses the *ars celare artem* to perfection. His touch is remarkably light and free; his colour is entirely without crudity or heaviness; he never uses any blue but cobalt, and every variety of green and grey he makes with this, the lightest of colours. He mixes a little of this pigment with all his tints, and thus carries a softening atmospheric effect over the whole of the work.

Pycroft might be challenged on one point – his remark that Widgery's "only master" was Nature. For though Exeter's museum was founded only in 1868/9, several art exhibitions had been organized in the city much earlier in the century and original works and prints by local and nationally known artists were exhibited frequently at various artists' repositories and print-shops. There were also the studios of the local artists, which no doubt Widgery could have arranged to visit – although whether he did so is another matter. What we do know is that he had access to prints or reproductions of well-known and popular paintings of the day in some form or other because of the local papers' faithful recording of the fact that he was producing copies of them.

However, Pycroft's more general comments are patently true and are echoed in the remarks made by the various authors of the newspaper obituary notices. As regards Widgery's use of green, for example, one notice mentions that "When a critic complained that a certain landscapist always spoilt his scenes with an offensive green, Widgery remarked 'Ah! he should use a selling-green, like I do'." The same notice goes on: "He knew by instinct how to hit the public taste, and he sold his pictures as fast as he could paint them. He had the power, too, of selecting suitable subjects for his brush. John Syer, whose pictures fetched as many pounds as Widgery's sketches fetched shillings, bore testimony to his friend's capacity for seeing beauties of Nature best adapted for pictorial representation, ... When the two artists roamed about Dartmoor together in search of subjects, the elder trusted to the gifted eye of the younger for selection."

The author of this particular obituary (who signs himself G.T.D. – without much doubt G.T. Donisthorpe) gives us two more columns lyrically describing the beauties of Dartmoor and extolling Widgery's talent for capturing the "Flashes and phases of Moorland" which "were his chosen themes". To Widgery, says G.T.D., "Dartmoor was never desolate, never solitary.... The sheen of the mountain-tarn smiled at him; the spirit of the granite tors held commune with him, and the babbling torrents sang songs which he understood." And he concludes: "If Carrington was the poet of Dartmoor, Widgery was its artist. To love your work for its own sake, and to win reputation, wealth and admiration by it, is a blessedness which comes only to Fortune's favorites[sic]."

The effusiveness of G.T.D.'s compliments may seem cloying and over-sentimental when we read them today, but we cannot doubt their sincerity, particularly as a similar, if less picturesque, tone of admiration permeates most of the writings on Widgery, both before and after his death.

His work certainly seems to have found many patrons. One of them was Kent Kingdon of Exeter, one of Widgery's "best friends". Widgery seems to have felt greatly indebted to Kingdon for some advice that Kingdon gave him. "Dear Sir", he wrote to Kingdon, "I dont know how to thank you for your kind advice to me I have been getting letters every day since you told me what to do. *Ten thousand thanks* yours very truly W. Widgery." The letter was sent from "Studio Queen Street Exeter", was dated 23 October, and was addres-

sed to "Kent Kindon[sic] Esq". The lack of a year in the date makes it difficult to guess what sort of advice this could have been. If it were early on in Widgery's career, it may have been artistic advice. Later on, it would have been more probably a business matter. There are difficulties, though, with both theories. The "Studio" address implies that Widgery was by this time an established painter and not much in need of artistic advice. On the other hand it is hard to imagine a business matter that would involve William receiving letters in quantity. So the matter must remain a mystery.

However, there is no mystery regarding the paintings purchased by Kent Kingdon. Many of them are listed in a house inventory for Kingdon's home, Taddyforde, which was made in 1883. Then, at his death, they were bequeathed to Exeter's Albert Memorial Museum, where they still are today. They appear in the museum registers of 1892 as the "Kent and Jane Kingdon Bequest" (Jane being his favourite sister who lived with him at Taddyforde). This generous bequest makes up at least three-quarters of the entire group of works by William Widgery in the museum's permanent collection. Several of the oils are listed by title in the 1883 inventory so that we know what they were and in which

rooms they were hung. The water-colours are not listed individually but appear in three main groups as "Watercolours by Widgery". One set was hung in the "Gallery", a second in Kent Kingdon's bedroom, and a third in the "Oak Sitting Room". The last group comprised eleven paintings, so the total number of water-colours owned by Kingdon could have been as many as thirty.

Most of the water-colours are of a uniform size of about 300 mm high × 500 mm wide (about 12 in × 20 in), but the dimensions of the oils vary considerably. There are two obvious pairs of oils – a large, oval painting of Bowerman's Nose (one of the more notable tors on Dartmoor) matched by a lush study of plants and leaves entitled *Burdocks, Brambles and Furze* and two medium-sized rectangular paintings, *Sharpitor Rocks* and *View in Gidley Park, Devon. Bowerman's Nose* is recorded as hanging in the dining room in 1883, but there is no mention of its companion piece being in that room and it is not listed by title elsewhere in the house. Perhaps it was painted especially to make up the pair after 1883, or it may simply be one of the anonymous landscapes noted in the inventory as hanging on the walls of the staircase.

Most of the water-colours depict the tors, marshes,

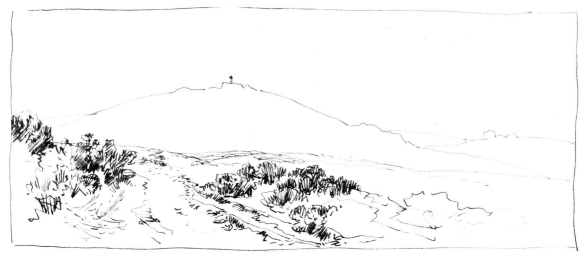

Bray Tor,
2 April 1908

and streams of Dartmoor; they range in colour and mood from a wintry scene with Dartmoor ponies, through the gentle, heathery shades of autumn, to the more golden tones of spring and early summer.

The oils are much more varied in subject and style, the latter generally complementing the former. Thus, the pictures of two of the imposing stone crosses on the moor are painted in rich, sonorous hues, whereas the paintings entitled *On the Lyd* are much lighter and brighter, echoing the luxuriant verdure of trees and plants and the sparkle of water tumbling among rocks and stones.

The Lyd was one of Widgery's favourite painting areas. So it is not surprising that, as sales of his paintings grew and his financial position became increasingly secure, he should build a house and studio in the village of Lydford. From here he had quicker and easier access to all his favourite haunts – Lydford village is on the west side of the moor, while Exeter lies to the east of it. The house still survives and is now a hotel. Its exterior at least seems to have changed very little over the years. It is a pleasant, two-storey building and its simple, unassuming architecture gives it an air of quiet relaxation and charm. According to the hotel brochure, Widgery built the house about 1880 and occupied it for over ten years. Presumably, the sale was due to the deterioration in his health, a deterioration exacerbated by the death of his academically gifted elder son, William, in 1891 at the age of thirty-five. This sad event seems to have been the only real tragedy in William's life and it probably shortened his own. He died about eighteen months later.

He lived to see the fulfilment of two permanent memorials to his name and life. One he directly produced himself. This was a memorial cross which he constructed on Bray Tor, near Lydford, to commemorate Queen Victoria's Jubilee in 1887. The cross is built up of granite sections, rather than being carved from a stone block, and thus appears almost an extension of the tor on which it stands. In 1987, the centenary year of the cross, the villagers of Lydford celebrated the occasion with a special exhibition that included a display of paintings by Widgery, and with a pilgrimage walk up Bray Tor to the cross.

The other memorial was the bequest of Kent and Jane Kingdon to the Royal Albert Memorial Museum. We are able to gain some idea of the display of these works from a photograph in an issue of the *Magazine of Art* which appeared between November 1896 and April 1897. This shows one of the main rooms on the upper floor of the museum after its official opening as the New Exeter Art Gallery and many of Widgery's works are easily recognizable in the carefully constructed patchwork quilt of paintings which covers the entire surface of the walls. The frames of the works are virtually edge to edge so that the total effect is almost that of a giant marquetry inlay.

William's death was recorded in numerous obituaries and in several valedictory poems. Among the more straightforward chroniclings of his career and achievements, there appeared a delightful story which illustrated his friendly and unassuming character. The inn sign at the Traveller's Rest at Whitestone, near Exeter, then owned by a Mr T.M. Snow, had been "shot away by certain mischievous jokers". Snow got in touch with an "artistic friend" and asked him if he would paint a new one for him. He received no reply to his request and, wondering if he had offended his friend, mentioned his fear to Widgery, when he happened to meet him one day. "Bless my soul, no!", Widgery exclaimed. "David Cox and lots of better men have painted signs; why should not other people? I will paint one for the 'Traveller's Rest' if you like". Snow protested politely but "Widgery said he should be delighted". In due course he appeared with the new sign – a picture of the inn with its old signboard and a couple of horses with a carter near by. Snow felt that he could not allow "such a work of art" to go outside the inn and be exposed to "all the vicissitudes of weather". Widgery insisted that he keep the painting as a gift and then painted another signboard as a commission. The new sign was duly installed, complete with shutters to protect it from bad weather. Sadly, neither painting nor signboard appears to have survived and the inn itself is completely modernized. But it seems appropriate that having been helped in his early career by one (if not two) inn landlords, Widgery should have been able to repay the compliment so handsomely in later life.

F. J. WIDGERY

Frederick John, Widgery's younger son, was nearly thirty-two years old at the time of his father's death. He had been born in May 1861, at just about the time his father was becoming established as a professional artist.

His father left him – and other local artists of his generation – an invaluable legacy. William Widgery's work had created a strong market for local landscapes. Now, as F. J.* was embarking on a professional artistic career, the improvement of travel facilities was encouraging more visitors, and therefore more potential customers, to Devon and to Dartmoor. And all this coincided with a general demand for water-colour landscapes and seascapes from a wide cross-section of the general public.

Unlike his father, F. J. had the advantage of a comfortable financial background and a long and thorough artistic training. The disadvantage, to us, is that his progress through this more orderly and straight-forward education is not charted so graphically by the local papers. The later years of the 19th century saw tremendous progress in promoting the spread of art education. Consequently, many more people were able to take up art as a profession and the local artist became less of an exception, less remarkable, and less newsworthy.

However, we can form a good idea of the pattern of F. J.'s training, artistic aims, and life-style.

His education began at Exeter's Cathedral School; in those days the school was probably strictly reserved for the choristers so it seems likely that he had some musical talent. Unfortunately, there are no extant records of his registration or attendance at the school, but he must have stayed there until he was twelve or thirteen years old because he seems to have then moved directly on to a specialized art education. He studied first at the School of Art in Exeter, which was by then incorporated into the Albert Memorial complex, along with the museum, the Schools of Science, and the library. The School of Art was not then the large-scale institution it has become today; it would have numbered only a handful of pupils and teachers and there would have been an emphasis on drawing. F. J. would have spent many hours studying and drawing from casts of Greek and Roman sculpture, which acted either as a substitute for, or an ancillary to, study from the live model.

F. J. must have shown above-average aptitude, for he transferred first to the South Kensington art schools in London (now the Royal College of Art) and then went to study abroad, at the Academy in Antwerp. The tradition that British artists should study abroad remained strong, even with the growth of a more formal training system at home. Artists continued to study in Italy if the opportunity availed itself, but Paris had also become popular – it was closer to home and thus cheaper and easier to visit. We cannot guess why F. J. went to Antwerp, rather than Paris. Perhaps it was felt to be a more solid and "safe" background for him than the more flamboyant, Bohemian atmosphere of Paris; or possibly the Antwerp Academy just happened to be the fashionable place to attend when he was due to go abroad. Several other British artists also attended the Academy around this time, so F. J. was not alone.

In Antwerp he studied under Charles Verlat (1824–90), a Belgian-born artist who painted historical subjects, portraits, and animal studies and was known also as an engraver. Verlat had been a pupil at the Antwerp Academy before going, in 1849, to Paris where he was impressed by the new, realistic approach to painting demonstrated in the work of Gustave Courbet (1819–77). Verlat himself was particularly interested in painting animals stalking, chasing, and attacking their prey. However, from financial necessity, he had to paint many humorous works which provided his bread-and-butter money. In 1866 the Duke of Saxe-Weimar summoned him to be Director of his School of Fine Art and during this period he painted several portraits and studied the paintings of the early German School. After leaving Saxe-Weimar he spent two years in Palestine, where he painted biblical scenes. He was then appointed a professor of the Antwerp Academy, becoming its Director in 1885.

It is to be supposed that F. J. received the benefit of his master's rich and varied experience. In addition, he would have had the opportunity of seeing many

*We shall refer hereafter to Frederick John as "F. J.", rather than the more normal "Widgery", to avoid confusion with his father. As he always signed his work simply with his initials, there is another justification for this practice.

examples of the work of great Flemish painters, in the museums in Antwerp and Brussels. However, the great emphasis in his training, as in other art schools and studios at the time, would have been in life drawing.

F. J. returned to England for the next, and final, stage of his studies, under Hubert Von Herkomer (1849–1914). Herkomer founded his art school at Bushey, Hertfordshire, in 1883 and received several hundred applications from young artists anxious to study there. Obliged to "narrow the field of choice", Herkomer asked each of the candidates to submit a drawing from the nude. He would be looking, he said "for originality, truth technically well expressed and some evidence of promise". Perhaps F. J.'s training in life drawing at Antwerp stood him in good stead; he was at any rate one of the thirty-four successful candidates who formed the school's first student intake.

The students came from far afield and even included one or two from the U.S.A. A letter home from one of the latter – Edith Ashford from Elyria, Ohio – expresses what must have been the prevalent spirit of enthusiasm and determination among these first pupils: "The rules are to be very rigid, the work tremendous; but I scent the battle afar off and rush in like a war horse. I never felt so stirred to do my best as now when this *impossible* work stares me in the face *to be done*. One term is allowed us. If before that time we do not show signs of talent we are to be sent home ignominously[sic]. Please have my bed made up; for I may soon desire to creep quietly home and crawl into it"

Unfortunately, we have no similarly revealing letters from F. J., nor even sketches or drawings from his student days. But we know the "very rigid" rules to which he, like the other students, was subject. The school opened every day at 8.00 a.m. and models were provided between 10.00 a.m. and 3.00 p.m. and 7.00 p.m. and 9.00 p.m. The students were expected to work at least seven hours a day, except on Saturday afternoons and Sundays, and even then were forbidden to go to "balls, concerts or plays". This hard regime, which meant that the students were ruled by the demands of their studies from early morning to late evening, was ameliorated by their enthusiasm for their work and by their home-made entertainments of music, dancing, and

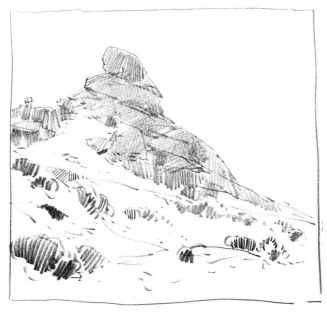

Hey Tor,
13 September 1923

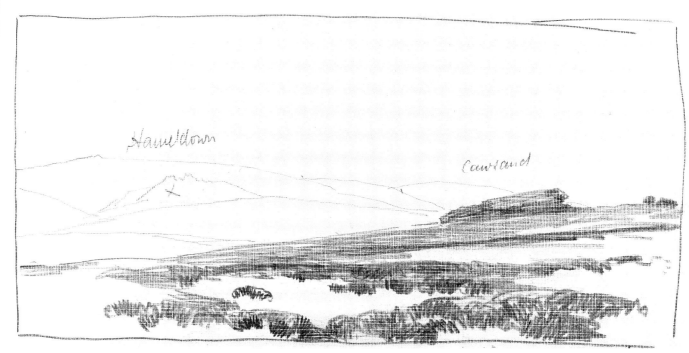

Hey Tor, Hameldown,
and Cawsand

convivial get-togethers. And Herkomer was a practising and highly respected artist, so the students were also able to absorb vicariously the excitement and rich flavour of the bustling London art scene through his commissions, exhibitions, and sales.

It seems likely that F. J. developed a friendly relationship with Herkomer because years later, in 1905, Herkomer presented one of his paintings – *The Trysting Place* – to the museum in Exeter, almost certainly because of his affection for F. J.

Having had such a long and thorough training, it would have seemed logical for F. J. to have pursued a career based in, or centred upon, London. Judging from the portrait of his father (*see* page 6), painted soon after he left Herkomer's school, he could easily have established himself as a portrait painter and earned a comfortable income from this practice alone. Possibly it was his father's declining health, homesickness for his "native heath", a desire to paint in a quieter and more

relaxed environment, or a combination of all these factors which dictated his return to Exeter. Apart from a short absence from the city in the late 1880s and early 1890s he was to remain there for the rest of his long life. However, he did have a London dealer – the firm of Samuel Coombes – to whom he sent his work at regular intervals. We know this from a letter from the dealer's office, dated 27 August 1928, which highlights the production-line aspect of the work of the successful aritst: "I am rather anxious to receive the 14 × 10s, & 11 × 7s on order. Will you please include a drawing of 'Hey Tor' in each size? I have no 'Hey Tors' & they are good sellers."

F. J. seems to be addressed here more like a clothing manufacturer than an artist. But, as though to remind us that he was a creative artist, he used the blank reverse of the letter for a rapid sketch (opposite) of a sunset sky at Exmouth which, judging from his colour notes, must have been superb. He records "blue", "white clouds",

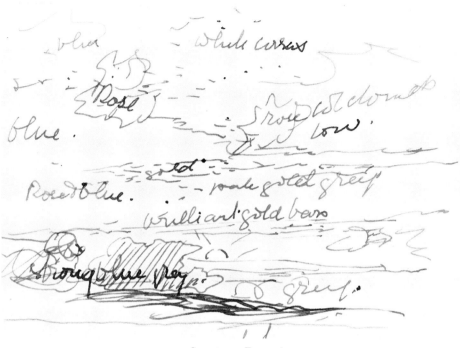

Sunset over Exmouth,
28 August 1928

and "rose col[oured] clouds, low" at the top; "Rose & blue", " gold", "pale gold grey" above "brilliant gold bars" (emanating from the setting sun itself); and "strong blue grey" and "grey". The sketch is dated 28/8/28, so he must have seized upon the first scrap of available paper that happened to be in his pocket.

The seaside resort of Exmouth lies within easy reach of Exeter, being about thirty minutes away by train, and it was a favourite sketching area for F. J., as was the equally convenient Woodbury Common. He could easily reach both places for a short break from working in his studio or from his many civic activities.

He was involved in so many local enterprises that it is a wonder that he found time to paint at all. He was a Governor and later Chairman of the Board of Governors of the Royal Albert Memorial College and also served as Chairman of the College Committee and Fine Arts Committee. He was elected a City Councillor in 1898, appointed the city's Mayor by "unanimous vote"

for the term 1903–4, made an Honorary Freeman of Exeter on 27 March 1905, created Alderman in 1909, and made a Justice of the Peace in 1912. Appropriately, he served as Chairman of the Town Planning Committee from 1919 until his resignation in 1938, feeling that "at 77 he ought to step aside for a younger man who can bring a fresh mind to new problems". He also maintained a long and close contact with museum affairs, both officially (via the Board of Governors) and unofficially – his studio, which he took over from his father, was at 20a Queen Street, directly opposite the museum building, so he was ideally placed to make casual visits to the museum. He also found time to be a Freemason; a member, and the first President, of the Exeter Rotary Club; and a member of the Exeter branch of the 1st Devon and Somerset Royal Engineer Volunteers, in which he served from 1897 to 1907, rising to the rank of captain.

In spite of his obvious commitments to, and enjoy-

ment of, his many other activities, F. J.'s artistic side always occupied first place in his life and thoughts. A pleasing illustration of this is the way in which he occasionally made use of fragments of paper or letters connected with his other activities to jot down ideas for paintings or simply to sketch attractive subjects that he felt he must record. Thus we find one side of a plain, stamped postcard used to sketch a charming view of "Withycombe Mill" (opposite, left) and the other for the colour notes and title. Similarly a little pen-and-ink sketch of trees overlooking a stretch of water is drawn on a fragment of a printed committee memorandum to be presented to Council. A sheet of headed notepaper of the Devon and Somerset Royal Engineers has notes about a regimental dinner and church parade on one side and a delightful pencil sketch of "Stoke Canon Church" on the other (opposite, right).

The pace of life generally was probably less frenetic in F. J.'s time than it tends to be today. Nevertheless, he was obviously happiest when actively involved in some commitment or other and, far from interfering with his art, his many other interests probably prevented him from growing stale as an artist. The steady demand for his work and the production-line process to which he had to submit might have reduced his work to the level of shallow pastiche – and in fact it very occasionally did. But generally he managed to obtain a freshness and sparkle in his landscapes, though one sees a more disciplined and controlled approach throughout than is ever evident in his father's work. This is not just a matter of his more thorough and formal training; his instinct was towards qualities of line and shape and this comes out strongly in his sketches and drawings. Whereas his father would favour brush and colour, F. J. loved pen and pencil, both of which he handled in masterly fashion. Thus, his exhibits at the Royal Academy exhibitions for four years were in the pen-and-ink section, though in 1917 he also exhibited a water-colour of Mamhead Woods. A notice in the local Exeter paper, the *Express and Echo*, on 9 May 1917 comments on this aspect of his work: "Mr Widgery's pen-and-ink work has never had the local recognition it deserves. The limited marketable value of black-and-white has probably led to him restricting his output in this direction,

but whenever he does turn his hand to the pen-and-ink medium we get work of perfect technique It is safe to say, in fact, that no living artist can equal Widgery in pen representation of rock, boulders, and moving river scapes No-one, in fact, can pen-draw Dartmoor[sic] rugged wastes and streams with the same unerring light and shade and the same suggestion of space as Mr Widgery." The sketches reproduced in this volume confirm the accuracy of these comments, though the critic's praise is perhaps a little excessive.

This mastery of tone and line was typical of many of Herkomer's students. F. J. was taught by Herkomer and by another etcher and engraver, Charles Verlat, and was most probably trained by one or both as an etcher, although no etchings by him seem to have come on to the art market or to be known in private hands. However, in his trunk (see page 21), alongside his easel, palette, and sketching stool, there were also his etching and engraving tools and a pile of etched plates. Some of them have "strike" marks through them, which means that the artist does not wish any further prints to be made from them; but others, though slightly marked and corroded, could possibly be still printworthy.

F. J.'s mammoth pile of sketches (between 500 and 600 in all) are a delight. They range in subject matter from Dartmoor scenes to Woodbury Common, Exmoor, North Devon, and many places along the Devonshire and Cornish coasts. There are a number of sky studies and thumbnail studies of trees, figures, cottages amid trees, and picturesque bridges – all the myriad of things that caught F. J.'s eye and struck him as compositionally appealing.

Many of the sketches have been glazed and framed with passe-partout so that they can be hung on a wall. F. J. possibly had them hanging in his own studio as *aides-mémoire* when he was working on his more ambitious paintings. In 1921 he announced his intention of bequeathing the whole collection to the Governors of the Royal Albert Memorial Museum. He thought "they might be of use to students and of interest to the public generally" and "was anxious to give to his native city some proof of his appreciation of the high honour accorded in having elected him Mayor and placed his name on the roll of honorary freemen".

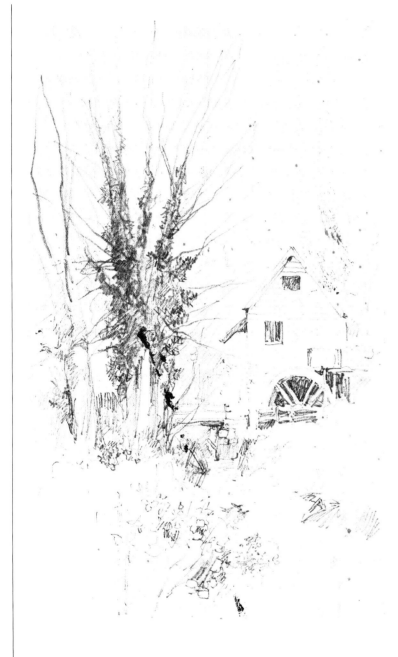

Withycombe Mill
near Exmouth
(Right) Stoke Canon Church
and F. J.'s notes on reverse

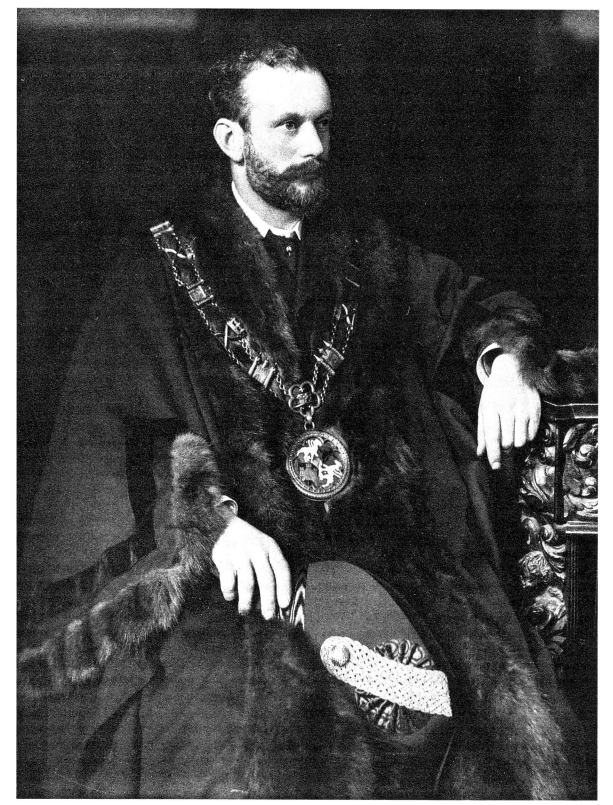

F. J. Widgery as Mayor of Exeter,
1903–4

The journalist reporting the meeting at which this offer was discussed in the *Devon and Exeter Gazette* of 22 November 1921 recorded that "The Mayor said he was sure the Governors would accept this kind offer with thanks. He moved to this effect. Mr. Stocker seconded, and expressed a hope that it would be a long time before the collection came into the possession of the Governors. The meeting agreed to the motion unanimously. Mr. Widgery in reply, remarked that if the collection proved of use to students he would have attained the object he had in view. (Hear, hear.)."

Among the piles of loose sketches there is a bundle of small pocket sketchbooks, one of which is of especial interest. For it is the sketchbook that F. J. took with him on a holiday trip to Greece. This holiday was undertaken with a group of other gentlemen, including two fellow artists, Walter Crane (1845–1915) of London and Henry Babb (1843–92) of Plymouth, in the spring of 1888. The day-to-day events and adventures of the holiday were recorded in a delightful book, *Greece and the Grecians*, compiled by Albert Groser of Plymouth, who was in effect the leader of the party. Babb, F. J., and Crane contributed the illustrations to the volume, which was published in Plymouth in 1889. The illustrations were fewer in number than originally intended because the artists failed to meet the printing deadline. Groser explains this in an amusing and understanding foreword ending with "Gentle reader, forgive them; they couldn't help it!".

F. J.'s two illustrations are "A Bit of Gibraltar" (drawn from the *Garonne*, the ship on which they sailed to Greece) and "A Bit of Venice". The former is of buildings near the harbour with sea and rowing boats in the foreground; the latter a charming little canal scene. In his sketchbook there are one or two delicious vignette drawings of passengers on board the *Garonne*. Apart from one or two other hasty sketches there is very little else in the book – evidence that F. J. was too busy seeing the sights and enjoying his holiday to find the time to draw.

All F. J.'s sketches were done purely for the artist's own pleasure – they were visual jottings to which he could turn when working on a specific commission, but they were also an expression of his own constant interest in the landscape around him. Thus, they have a

Tavy Cleave,
3 March 1901

spontaneity and liveliness which is generally held in check in his commissioned work. One can see this in comparing his sketches of Dartmoor with the group of twenty-two water-colours which he was commissioned to produce for the revised edition of Samuel Rowe's *Perambulation of Dartmoor*, published in 1896.

Knowing that the work was to be published as a set and would therefore have to have not only a common linkage of subject matter, but also of style and tonal values, he has not allowed any one plate to be too strikingly different in colour or approach to any of its companions. So the general ambience throughout the series is that of a sparkling, fresh spring or early summer day. Thus, we get the vivid, bright greens of the tree foliage and the new grass among the bleached yellow

Near Meldon,
24 March 1907

tussocks of the more barren heathland areas of the moor. The sunlight dances on the tumbling waters of the rivers and streams, and glances off the edges of the standing stones, the bridges, and the boulders of the river banks, while the skies, though uniformly blue or blue-grey, all differ from one another in the treatment of the pattern and movement of the cloud masses. This constant refraction of light and air gives the landscapes the feeling of unhurried timelessness and space so attractive to visitors to Dartmoor. Thus, F. J. has deliberately catered to the vision of the moor held dear by those who wish to visualize or recapture its natural beauty and resisted the temptation to overlay or alter the scenes with a more artistic or dramatic interpretation.

Although the water-colours were reproduced in black and white, rather than colour, his immaculate range of tones still results in an impression of life and movement within the plates and the sense of atmosphere is still definable. However, one wonders if the initial intention of the publishers had been to publish the plates in colour and that the decision to reproduce them solely in black and white was a last-minute one dictated by lack of finance. This is only conjecture, but if the plates had been envisaged as being in black and white at the time of the original commission, one would have expected F. J. to have drawn rather than painted the illustrations at the outset. Given his undoubted graphic talent, this would have given a much more powerful result when the plates were reproduced. One can see this easily if one compares the greater richness of tone and line in the

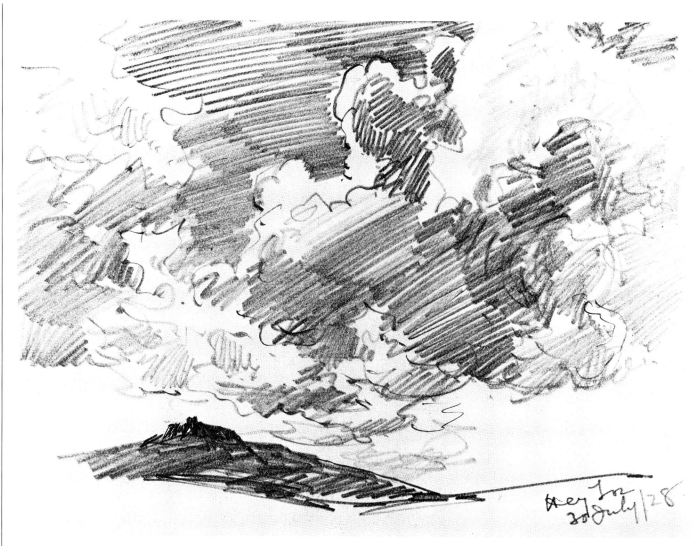

Hey Tor,
30 July 1928

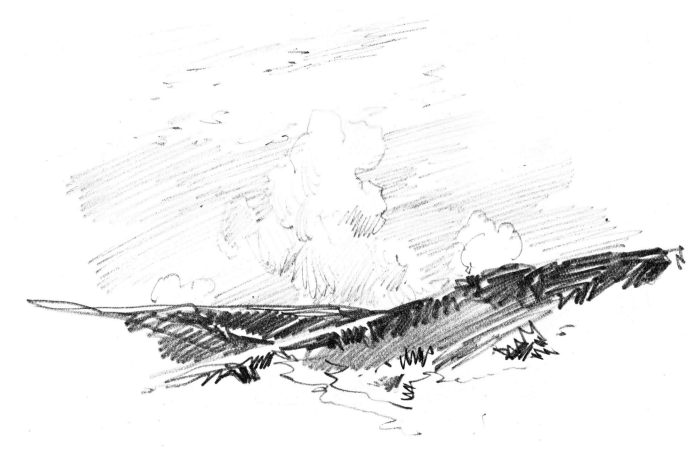

Dartmeet,
30 July 1928

Williams and Gauci illustrations to the original 1848 edition of the *Perambulation* with the softer, more even quality in F. J.'s plates. The translation of his subtle colours into black and white has resulted in a loss of clarity in some areas, so that it is often difficult to distinguish the stones, boulders, and bridges from the surrounding grass and foliage. One also loses the impact of F. J.'s varied and skilful handling of the moving pattern of clouds and sky, which is totally different in every scene but is scarcely apparent in the overall greyness of the black-and-white reproductions.

Knowing this drawback, Williams and Gauci paid scant attention to the skies in their work and concentrated on bringing as much contrast of velvety black against pure white as was possible into their depiction of the various scenes; they also cut down or eliminated other large areas of background wherever possible. Thus "Spinster's Rock", which is featured on the title page of the 1848 edition, is seen as a towering and powerful monolith – a massive arch or gateway through which is glimpsed a vista of distant, but impressive, interlocking hillsides. F. J.'s version of the same scene (page 67) is completely the opposite. Here one sees the three uprights and horizontal cross-piece of the rock as

large and gently rounded stones rather than jagged and serrated blocks of granite and the setting is that of a peaceful meadow, bordered by trees, with sheep placidly grazing in the background.

Again, in the illustration of a "Tolmen on the Teign", one sees Williams and Gauci dramatizing the scene by drawing the tolmen at an acute angle, with heavily shaded sides and surrounding boulders, and a background of very steep hill slopes. F. J.'s background (page 65) is a gentle, horizontal undulation and the tolmen and boulders blend easily and almost indivisibly into the swiftly flowing waters of the river.

There is much more similarity of approach in two scenes where the dramatic content of the subject is itself overwhelming. In "Bowerman's Nose" the imposing silhouette of the stones is starkly outlined against the sky, towering above the surrounding landscape like some votive primitive idol, in both the Williams and Gauci and the F. J. versions. They differ, though, in the treatment of the area around the Nose. F. J. (page 71) has filled the lower half of his painting with the grass and rocks leading up to the main granite outcrop, which is seen poised slightly left of centre. Williams and Gauci have omitted the lower slopes of the tor completely, so that the main outcrop stands alone, and have depicted it against a backdrop of overlapping hills. The topmost part of the tor rears up in the gap between these hills and into the sky above. This same theatricality is also apparent in the Williams and Gauci version of the "Sacred Circle", where the stones are seen in close-up, spotlit by a pure white light from the sky above; the shadowed sides of the stones and ground, and the remainder of the sky, are virtually black. Thus the whole scene has an unreal and almost magical quality. F. J.'s treatment of the subject (page 81) is equally eerie but much more realistic. The stones are stark, black shapes outlined against a lowering, stormy sky and they are placed in the very centre of the painting so that the spectator's eye is led towards them via a vast expanse of barren foreground. The bleak emptiness of this foreground is alleviated by the judicious use of light and shade so that the area is broken into smaller patches of light, medium, and dark colours; the lightest area is carefully structured into a zigzagging line which directs the spectator's gaze directly to the very edge of the circle.

F. J. employs a similar zigzag motif in his illustration of "Cranmere Pool" (page 61), where the pool itself appears as a jagged highlight within a dark and empty landscape. The very lack of other elements or incidents within the scene thus evokes the darker, more frightening aspect of the moor so successfully demonstrated in prose terms by Conan Doyle in *The Hound of the Baskervilles*.

It is probably with this idea of emphasizing the sheer vastness of the landscape and the relative insignificance of outcrops, monuments, and buildings in comparison to the moor itself that F. J. places each subject in the widest possible setting. Thus in "Fingle Bridge" (page 69) the bridge itself is small – barely discernible at first glance. The viewer is much more aware of the massive sweep of hillside on the left of the picture and the wildness of the boulder-strewn riverside. "Hill Bridge" (page 89) is given similar treatment and in "Wallabrook Clapper Bridge" (page 59) the long stone which forms the bridge is virtually indivisible from the other rocks and stones around it .

Reminders of human insignificance are the tiny figures to be seen in several of the plates – the little fisherman in "Wallabrook Clapper Bridge"; the two people crossing the bridge in "Hill Bridge"; and the man in "Rock Pillar at Merivale" (page 55), who is dwarfed by the towering stone pillar on his right and the acres of moor and sky stretching around and above him.

Within the twenty-two plates there is a judicious balance of subject so that all the better-known monuments, tors, and bridges of the moor have been given equal coverage. The most notable omissions – if such they can be called – are the various stone crosses which occur sporadically across Dartmoor, the relics of the several mining enterprises, and the small hamlets, villages, and farms which impinge on to the outermost fringes of the moor. Therefore the emphasis throughout has been on the more natural elements of the landscape.

The one major exception to this theme is "Okehampton Castle" (page 87), in which F. J. returns to the subject favoured by the artists of some of the earliest paintings of the area. Like Francis Towne (see page 12),

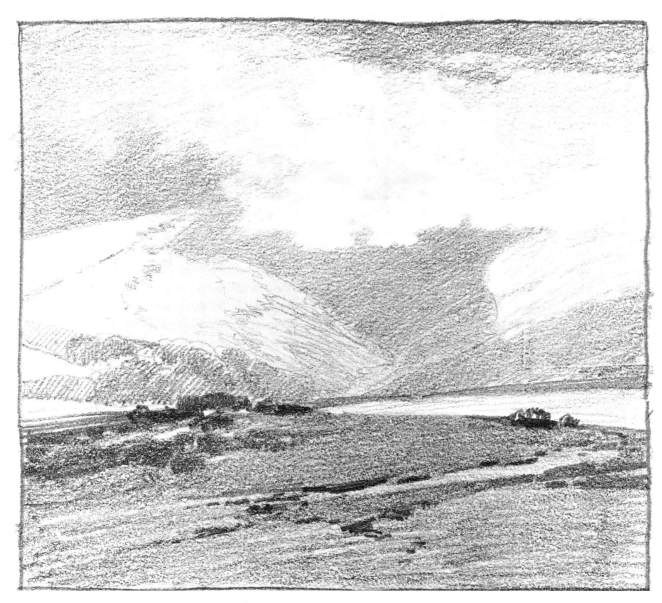

Rain clouds over Sourton Tor, Lydford,
7 August 1921

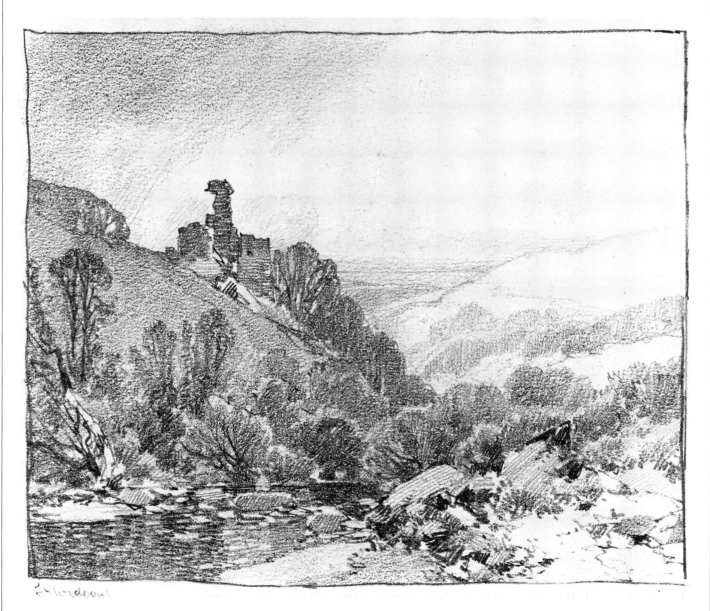

Okehampton Castle
Near Meldon

Near Meldon,
24 March 1907

he has taken a view of the castle from a distance, but there the resemblance ends. Towne's view of the castle was that of a virtually whole and habitable building bathed in mellow sunlight; F.J.'s is a stark and dramatic ruin viewed across the rushing waters of the nearby river. This watery barrier forms a natural moat to the castle and heightens the spectator's feeling of isolation and awe.

In his drawing of the same scene (page 45), F.J. creates a warmer and more intimate feeling by simply foreshortening the foreground and viewing the castle from a much closer distance. The river is reduced to the span of a small, friendly pool and the hills, rocks, and trees nestle companionably around the ruin as if guarding it against the natural forces of the weather. His subtle use of the pencil in both depth of tone and gradation of the lines gives the whole work a rich velvety appearance and this further inculcates a feeling of warmth.

A similar textural quality is evinced in "Rain clouds drifting over Sourton Tor" (page 44). F. J. has carefully built up his pattern of ground, hill, and cloudy sky with minute and precise pencil strokes and has emphasized the strength of the three major shapes by subtly interweaving the varying tones of light playing over sky and landscape.

In other scenes, such as "Near Meldon Dartmoor" (above) and "The Lyd from near Great Nodden" (opposite), he exchanges pencil for pen and ink. The fine lines of the pen and intense black of the Indian ink combine admirably to depict the wispy outlines of bare twigs and dying scrub and the strong,

The Lyd from near Great Nodden,
2 April 1905

flowing outlines of the hilly landscape. In the areas requiring more heaviness and strength, such as the mass of a boulder or a patch of shadow, he uses overlapping lines and cross-hatching to create a feeling of depth and power. In an area such as Dartmoor, where simple, strong outlines and a feeling of space are paramount features of the landscape, pen and ink is an ideal sketching medium and F. J. employed it frequently to make his rapid notes of changing light effects or of an interesting grouping of stones in the moorland scenery.

F. J.'s work on the set for Rowe's *Perambulation* probably led to the further illustrative commissions he received, all of them involving books related to Devon. These were the *Fair Devon Album* (1902); Lady Rosalind Northcote's *Devon. Its Moorlands, Streams and Coasts (1914)*, published by Chatto & Windus, London, &

James G. Commin, Exeter; and two books by John Presland, *Lynton and Lynmouth – a Pageant of Cliff and Moorland* (1918) and *Torquay. The Charm and History of its Neighbourhood* (1920), both published by Chatto & Windus, London.

Lady Rosalind Northcote's book on the county was very much a product of local enterprise for she, like F. J., was Devonshire born and bred – she was a daughter of the Earl of Iddesleigh, whose estates lay just outside Exeter. There were sixty colour plates in all. The subjects chosen for the ten plates devoted to Dartmoor are mostly quite different from those illustrating the *Perambulation*; they include views of "The Windy Post, or Beckamoor Cross", "Widecombe-in-the-Moor", "Lustleigh Cleave", and "Wistman's Wood".

Readers of one of the local newspapers of 13 April

1907 (its title has unfortunately been omitted from the clipping) were given a literary preview of these illustrations in preparation when a reporter visited F. J. in his studio. He comments admiringly on the work he saw, stating firmly that it includes "some of the artist's best workmanship. His treatment of the subjects recalls the methods of years ago, when beauty of detail was regarded by artists as something worth striving for, and in distinct opposition to much of the work of the present day, when this love of detail receives for the most part only secondary consideration. When the series is completed, some twelve months hence, Mr Widgery hopes to arrange with the owner of the drawings to exhibit them in Exeter, and if this intention is carried out, we can promise lovers of art a rich treat." The reporter went on to cite three works in particular which he found especially attractive – a view of Teignmouth and Shaldon, a seascape of Berry Head, and a view of Bideford Bridge and Town.

The plates in the two Presland books are all reproduced in colour. Although somewhat bleached and flattened by the reproduction process, they have a sympathetic and gentle feel. True to the audience for which they were designed, they have the quiet, bland charm one associates with the enticing country scenes depicted on early London Transport posters or the prints which used to decorate railway carriages.

F. J. did not execute any specific commissions for public buildings in Exeter. His father had painted two drop curtains for theatres in Exeter and at least two series of panels – one set, in the Victoria Hall, was destroyed when the building burnt down in 1917, the other, six paintings done in 1882 for the Rougemont Hotel, is still in place. Perhaps F. J. avoided local civic commissions because he was so heavily involved in local civic affairs and was careful to avoid charges of "unfairness" or "influence". It seems unfortunate, however, that he was not prevailed upon at least to paint his own mayoral self-portrait. Were it not for a copy of a photograph of him as mayor (page 38), discovered in his trunk, we would have no record of his appearance. One also wishes that he might have produced portraits or group portraits of some of his colleagues and fellows in the various organizations with which he was associated and so brought the tradition of the 17th-century Dutch and the 18th-century English conversation pieces and club portraits alive again.

F. J. was a friendly man, who obviously made visitors to his studio as welcome as his father had before him. A delightful snippet from the *Western Morning News* of 25 April 1949 recalls that "In his untidy studio in Queen Street, Exeter, Widgery would talk to visitors with a cigarette dangling from his lips while at the same time applying his colours with a seeming casualness".

He was also a clubbable man, who enjoyed to the full the tremendous variety of activities that he managed to interweave so successfully. The life of a full-time, committed artist, with no other major interests, such as that led by his father, would possibly have been too empty and lonely for his nature. And had he been more dedicated to art *per se* , he might not have managed his enormous output of delicate and precise recordings of West Country scenery.

F. J. died on 27 January 1942 and, like his father before him, received many glowing testimonials as to his character and ability. His paintings stand today as his memorial. So, too, does the fact that, because he was mayor in the year that motor-vehicle licensing was introduced to Exeter, the city's car number plates still carry the identifying letters "FJ".

THE PLATES

The texts accompanying the Plates are the relevant
sections from Samuel Rowe's *A Perambulation of the
Antient and Royal Forest of Dartmoor* (third edition, 1896),
the book for which these paintings by F. J. Widgery
were originally commissioned (see pages 39–46).

SCENE ON THE TAW, STEPPERTON

THE PRINCIPAL RIVERS which have their source in the north table land of Dartmoor are: The Dart, formed of the East Dart with numerous nameless tributaries flowing under Hartland Hill to Post Bridge, and of the West Dart receiving the Cowsick, Blackabrook, Cherrybrook, and other small streams. The two branches unite at Dartmeet Bridge; receive the Webburn near Holne Chase, and flowing by Buckfastleigh and Totnes, the Dart finally reaches the sea at Dartmouth, after a course of about forty miles.

The Teign, which is the next river northwards, also consists of two main branches. The north Teign rises near Sittaford Tor, north of the Grey Wethers' Circle; takes an easterly course towards Gidley Common, where it receives the Wallabrook; and being joined near Chagford by the South Teign, which also rises near the Grey Wethers, the united stream passes under Chagford, Fingle, Clifford, and Dunsford bridges, amidst some of the most picturesque and striking scenery, and bounding the moorland district to the eastward, proceeds by a southerly course towards Chudleigh and Teigngrace, where it receives the Bovey; and, taking a tributary from Newton, disembogues itself into the sea at Teignmouth.

The Taw rises near Cranmere Pool; and taking a northerly direction flows below Cosdon Hill and Belstone, and leaves the Moor at Sticklepath. In its northward progress, it gives the name to South and North Tawton, and being joined by the Yeo, near Eggesford, by the Little Dart, near Chulmleigh, and the Mole from Southmolton, flows into the Bristol Channel in Barnstaple Bay.

The West Ockment or Okement taking its source near Cranmere Pool, flows below Yes Tor to Okehampton, and there is joined by the East Ockment, from the glen below Belstone and Okehampton Park, it takes a northward course through the centre of the county, and falls into the Torridge near Meeth.

The Lyd rises in the hollow below Branscomb Loaf, flows south by Doe Tor, forces its passage through the rocky chasm at Skit's Hole, thence through the celebrated ravine of Lydford and beneath its romantic bridge, towards Maristow, where it receives the Lewwater, and being increased by the Thrushel Brook, renders its tributary waters to the Tamar, near Lifton.

The Tavy rises about a mile westward from Cranmere Pool below Great Kneeset Tor, flows north of Fur Tor and Watern Oak, above Tavy Cleave it is joined by the Rattlebrook which comes from the north, down a deep valley below Amicombe Hill, leaves the moor by a fine mountain gorge between Gertor or Great Tor, and Stannon Hill, flows amidst a succession of picturesque scenery to Tavistock, and receiving the Walkham at Screeche's Ford, passes under Denham Bridge through the richly-wooded dales of Buckland Abbey and Maristow, to join the Tamar at Beer Ferrers, where the noble estuary presents all the appearance of an inland lake of singular beauty.

The Walkham, incorrectly called in the old one inch Ordnance Map, Wallacombe, rises in a swamp below Lints Tor, and taking a southerly course leaves Great Mistor on the left, flows under Merivale Bridge and Huckworthy Bridge by Walkhampton, to which probably it gives name, and thence through Horrabridge to its junction with the Tavy.

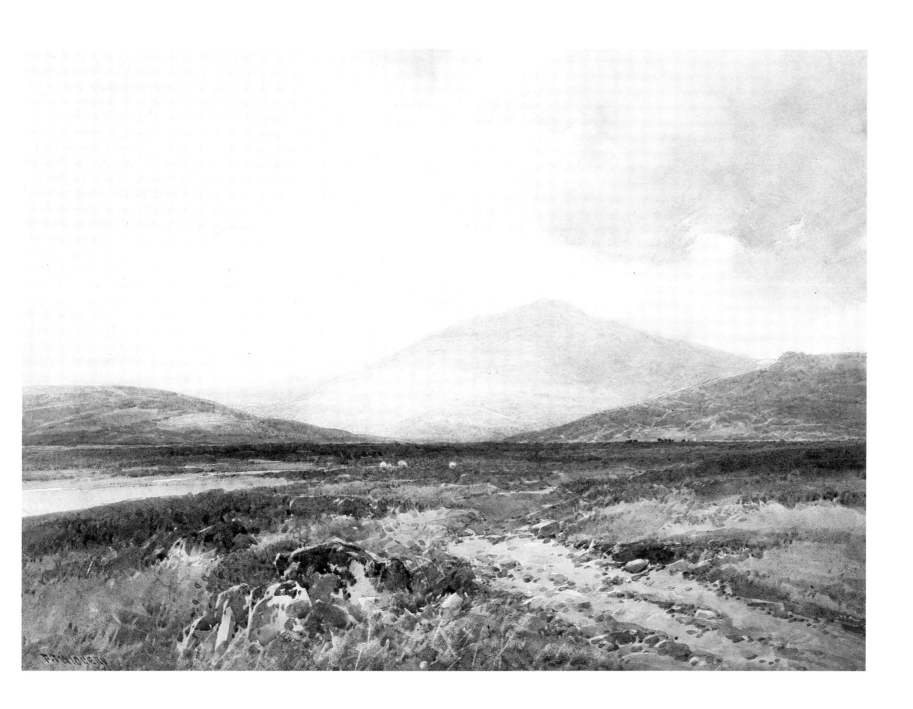

LOGAN STONE, RIPPON TOR

THE LOGAN STONE seems to have formed an important and characteristic feature in the mystic apparatus of Druidism, but there are only one or two specimens now known to exist in Devonshire, and even these have almost, if not entirely, lost the quality which originally gave them fame and distinction. The celebrated Drewsteignton logan stone might be repeatedly passed by, without exciting more curiosity or attention than any other huge granite mass

And it is impossible to traverse the moor in any direction without observing many a similar rock, which once might have been a logan stone, or might have been easily made *to logg*, that is, vibrate—so fantastical and singular are the positions in which such superincumbent masses are continually found, balanced on another rock below, so nicely as to admit of the immense bulk being moved, by the application of no more force than the strength of a man's hand. Such curiously adjusted masses, seem not to have been unknown to the antients. Pliny, observes Polwhele, hath evidently the logan stone in view, when he tells us that at Harpassa, a town of Asia, was a rock of a wonderful nature, "Lay one finger on it, and it will stir; but thrust at it with your whole body and it will not move." But the most curious mention of the logan by the antients, is that of Apollonius Rhodius; from which it would appear that such rocking stones were sometimes artificial, and raised as funeral monuments, in connection too, with tumuli or barrows.

> In sea-girt Tenos, he the brothers slew,
> And o'er their graves in heapy hillocks threw
> The crumbling mould; then with two columns crowned
> Erected high, the Death devoted ground;
> And one still moves, (how marvellous the tale)
> With every motion of the northern gale.
> *Fawkes' Argonaut, b.* iv.

In Wales, such stones are called *maen sigl*, the shaking stone, a term equivalent to the logan or logging stone of Devon and Cornwall. Our vernacular probably still retains the word; and "*a great logging thing*" familiarly and popularly describes any large mass in vibratory motion.

The purposes to which the logan stone was supposed to be applied by the Druids have given rise to no little antiquarian controversy. According to Toland, "the Druids made the people believe that they alone could move these stones, and by a miracle only; by which pretended power they condemned or acquitted the accused, and often brought criminals to confess what could in no other way be extorted from them." Borlase having observed rock basins on the logan stones in Cornwall, conjectures, that by means of these basins, the Druids made the logan subservient to their judicial purposes, and applied it as an ordeal to convict or acquit a culprit, by filling or emptying the basin, and by this displacement of the centre of gravity, rendered the mass immovable, or the contrary, at pleasure. This ingenious conjecture of the antiquary has been thus felicitously rendered subservient to poetical purposes by Mason:

> Behold yon huge
> And unhewn sphere of living adamant,
> Which poised by magic, rests its central weight
> On yonder pointed rock. Firm as it seems,
> Such is its strange and virtuous property,
> It moves obsequious to the gentlest touch
> Of him whose heart is pure; but to a traitor,
> Tho' ev'n a giant's powers nerved his arm,
> It stands as fixed as Snowdon.

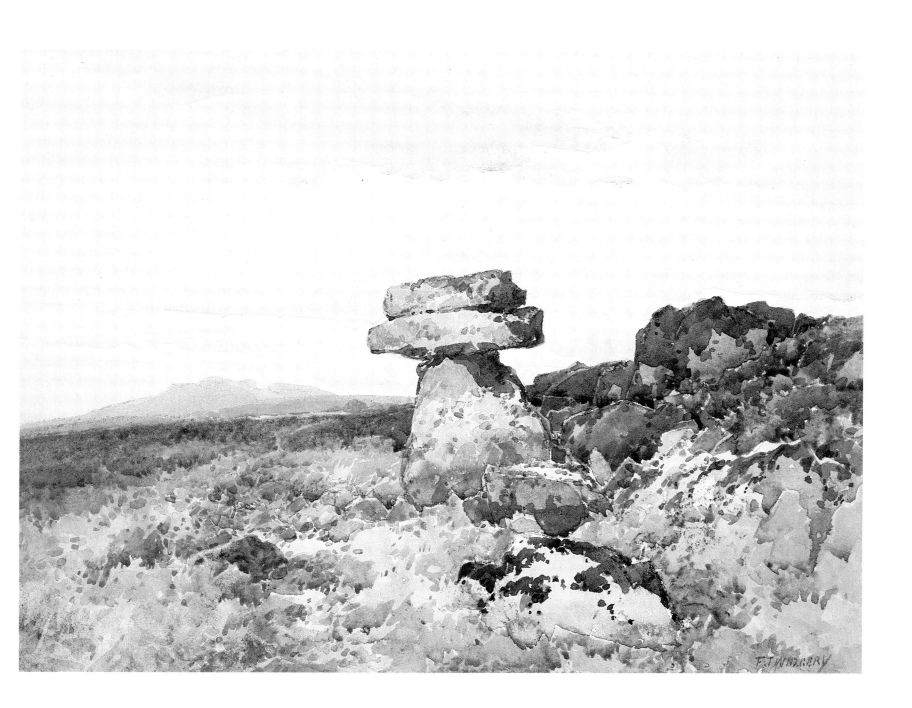

ROCK PILLAR AT MERIVALE

A SIMPLER COMMEMORATIVE MONUMENT is the rock pillar, or rude stone obelisk—similar, probably to that pillar [called Galeed] which Jacob erected . . ., and still more like that which he had previously set up at Bethel, to commemorate the precious manifestation of his Divine presence, which the God of his fathers had vouchsafed, and the promise to his countless posterity of that whole land on which he lay a forlorn and houseless wanderer.

In the former case, where the pillar stood only as the witness to former transactions between man and man, we have no mention of any ceremonial or dedication. But the pillar, which was raised to transmit to future generations the remembrance of the heavenly vision of the Most High, appears to have been dedicated by the patriarch as marking a spot consecrated by the manifestation of the Almighty Presence, and regarded by him as none other than the House of God and the Gate of Heaven. The sacred historian writes, that Jacob took the stone that he had put for his pillow, and set it up for a pillar, and put oil upon it. "This passage," says Burder, "evinces of how great antiquity is the custom of considering stones in a sacred light, as well as the anointing them with consecrated oil." And in speaking of blocks of stone, still worshipped in Hindostan and other eastern countries, the same author observes, "that it is very remarkable that one of the principal ceremonies incumbent upon the priests of these stone deities, according to Tavernier, is to anoint them daily with odoriferous oils. From this conduct of Jacob, and this Hebrew appellative (*Bethel*) the learned Bochart, with great ingenuity and reason, insists that the name and veneration of the sacred stones called *Bactyli*, so celebrated in all pagan antiquity, were derived." Thus, the setting up of a stone by this holy person, in grateful memory of the celestial vision, probably became the occasion of idolatry in succeeding ages to these shapeless masses of unhewn stone, of which so many astonishing remains are scattered up and down the Asiatic and European world. Many such are to be found on Dartmoor, and were probably designed for similar purposes. A striking specimen appears amidst the relics near Merivale Bridge, on the Walkham, in the western quarter. Tapering in form, it presents, in a shaft of unwrought granite, twelve feet high and eight in girth, at the base, a rude type of the architectural obelisk, and may be regarded as a characteristic illustration of the designation by which monuments of this kind are described by antiquaries—*maen hir*—the *long upright stone*. The Bair Down Man, near Two Bridges, and the fine menhirs at Drizzlecombe are also typical examples. When thus found, in connection with other relics, a variety of purposes to which these columns might have been applied, suggest themselves to the mind; but that the primary objects were those of burial memorials, or the commemoration of remarkable or important events there seems little reason to doubt. But it may also be observed, that although our Dartmoor menhirs cannot compare in magnitude with those to be found in Brittany, it is difficult to suppose that the objects which the people who erected them had in view were different; and that if the *Pierre du Champ Dolant* at Dol, was the scene of certain rites, it is probable the upright stones of Merivale and Drizzlecombe were resorted to for the same purpose.

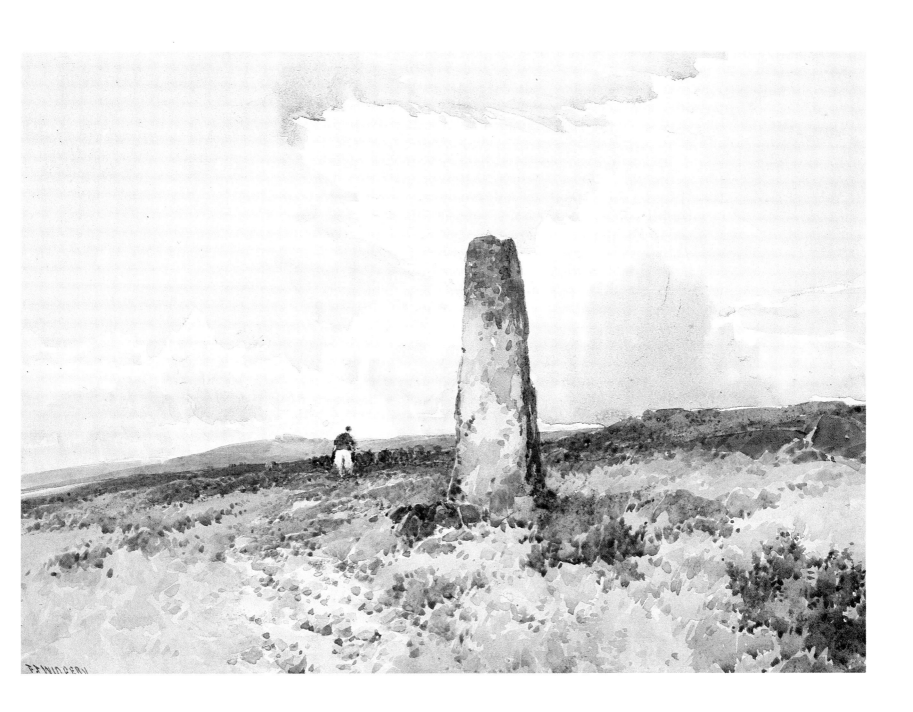

LEATHER TOR BRIDGE

THE METAMORPHOSED ROCKS on the verge of the Dartmoor granite afford abundant material for investigation. The varying course and nature of the changes depend apparently less upon the course and activity of the metamorphising agency, than upon the constitution of the rocks altered—the Carboniferous slates and shales taking a different aspect upon them as a rule to the Devonian.

It is, however, in the latter rocks, probably because they were the most deeply seated, that the alteration is most marked. Thus near Shaugh, the Devonian clay-slate at a third of a mile from the granite assumes a slightly unctuous or silky character; then becomes sericitic, with a very fine fibrous silky texture; next andalusite appears in the form of spots, which increase and spread until the rock becomes an andalusite slate; and the development of mica in the andalusite spots and nodules, in its turn, leads the way to the production of a well-characterized mica schist, either touching or in immediate proximity to the granite. But there are deviations from this method. In some localities chiastolite is produced instead of the andalusitic form. This is well seen at Ivybridge, and is indeed apparently a tendency in the Carboniferous rocks. Sometimes the mica schist passes into a very deceptive well-foliated gneiss, as at Meavy. Occasionally, as at Shaugh, the slate next the granite has been fused into a hornfels—a distinct felstone, but never absolutely to the obliteration of all trace of origin, or to incorporation with the granite.

Elsewhere the effect of the granite—possibly where pressure had a larger share in the production of the change—is mainly one of induration. Grits are changed into quartzites—at times, when the contact agency is also strong, with the development of tourmaline; slates into compact rocks, with semi-conchoidal fracture. The combination of shearing action with ordinary pressure upon a gritty slate, near Okehampton, has led to the production of a series of evenly-dotted glossy spots, which suggest augite, but are merely the result of the uneven texture of the original rock, under this peculiar form of slipping pressure. Carboniferous slate in the vicinity of Lydford, may be seen porcellanised in bands: and on the other side of the Moor, near Ugborough, there are beds of what has been termed "green jasper". The original rock has been silicified, the green colour being due to the development of actinolite, forming a kind of prase. This has no doubt resulted from the action of the granite on hornblende; for a similar development of actinolite is observable in connexion with the hornblendic rocks near Mary Tavy. It seems as if these Ugborough rocks may have been originally massive dolerites, rendered schistose before the final change. One of the most interesting points connected with the production of contact minerals, is the formation of garnet. This is specially to be seen at Belstone Consols and at Meldon, where green and brown garnet, massive and crystallised, abound. Here the change is clearly dependent on original constitution.

The most singular occurrence of garnet in connection with Dartmoor is, however, near Leather Tor. Here we have a laminated rock, one set of the lamina consisting of massive brown garnet; while the other set have resulted from the change, by pressure largely, of a Carboniferous shale. The garnet may have come of the metamorphism of a dolerite or eclogite, though how it should have been injected so regularly as to give several alternations in the space of an inch, it is difficult to see. This is one of the many petrological problems of Dartmoor that await final solution.

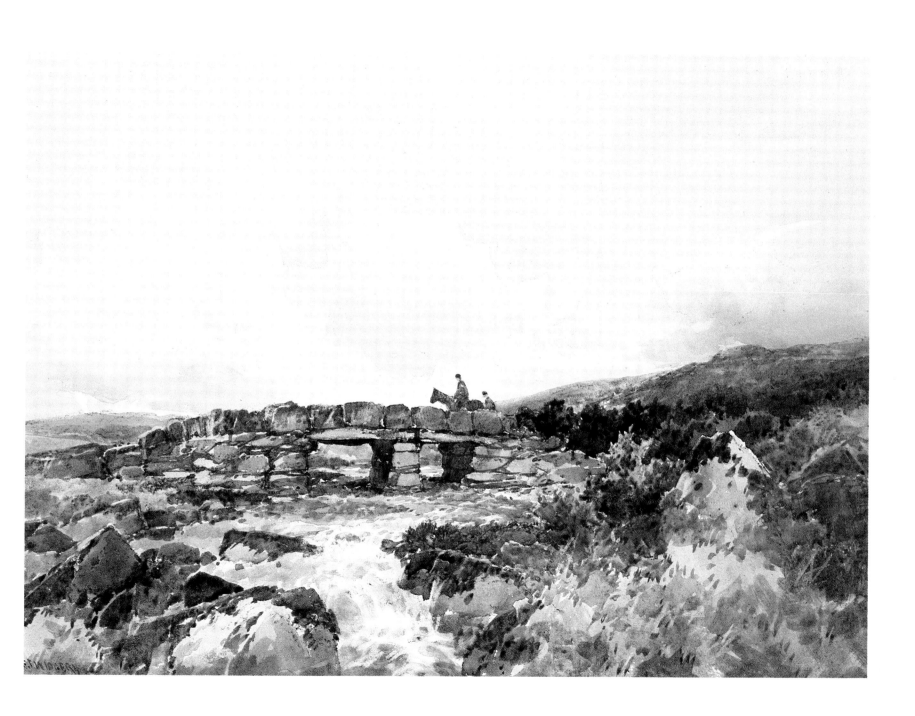

WALLABROOK CLAPPER BRIDGE

OUR COURSE NOW LEADS TO THE WALLABROOK, which flows at the foot of Scorhill Down. The means of crossing is afforded by one of the primitive bridges, of which we have so many examples on the Moor, consisting of a single slab of ponderous granite, fifteen feet long, nearly three wide, and twenty inches thick. Proceeding westwards, we shall cross the swampy flat, between the Wallabrook and North Teign, and mount Watern Hill to examine the singular tor which forms so conspicuous an object on the northern extremity of the ridge.

Watern Tor is one of the many remarkable natural conformations of the granite rock which will repay a more particular examination. It consists of a series of piles, rising from the ridge of the hill, the stratification of which presents the appearance of laminar masses in a horizontal position. The two piles at the N.N.E. extremity, in one part near the top, approach so closely, as to appear to unite when seen from some points of view, leaving a large oval aperture in the tor, through which, the moormen say, a man can ride on horseback. But on a closer examination, it will be observed that there is an interval of at least one foot wide in the narrowest part; and in the widest, the piles stand about eight feet apart, leaving ample room for man and horse to pass through. This aperture appears to have given rise to the name of Thirlstone, by which this part of the tor is known. The lesser of the two piles, if viewed apart from the rest of the tor, is not unlike the far-famed Cheeswring, on the Cornish moors, but the courses (to borrow a term from masonry) are thinner. Its elevation is about twenty feet above the grassy surface of the hill. Had all rock basins been merely natural formations, we think many would have been found on Watern Tor, but not one example is to be found.

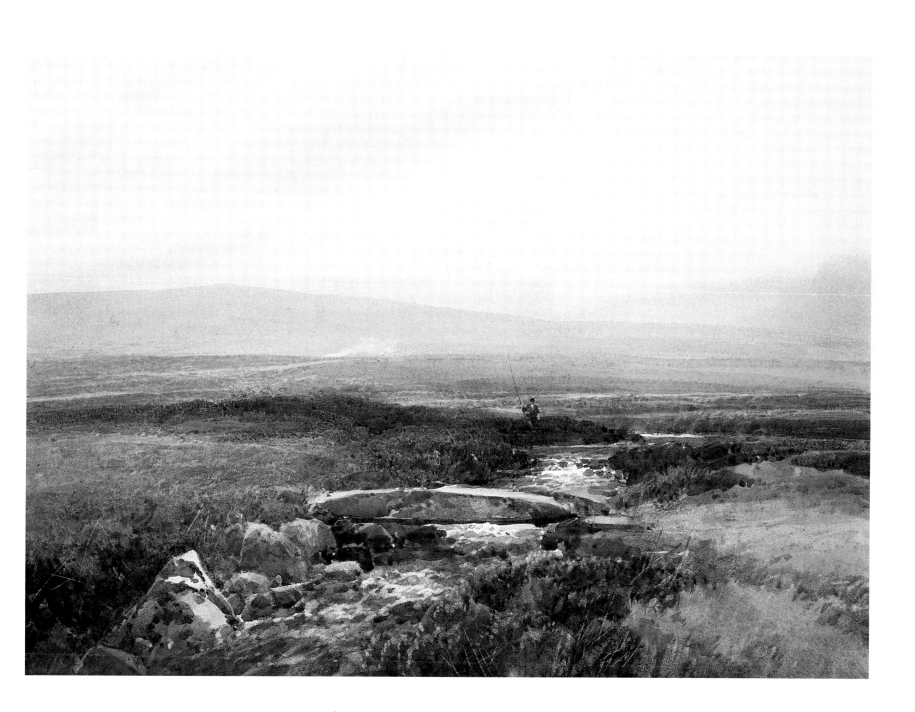

CRANMERE POOL

FOLLOWING THE RIDGE [OF WATERN TOR] at the southern extremity, we shall observe a large barrow or cairn of the ordinary description. Other similar cairns will be noticed on the opposite hill near Wild Tor, and on the higher hills above Taw Head, towards which we shall now bend our course, bearing due west from the cairn on Watern Hill. Watern Tor being a well known object, may serve the tourist as a landmark in his search for Cranmere Pool, which hides itself almost as successfully from the Dartmoor explorer, as the Nile concealed his fountains from the antients.

From the cairn at the eastern end of Watern Hill above mentioned, we descend to the Wallabrook (here, only a small rivulet near its source,) and proceeding westward to White Horse Hill, which is a track of high heathy land, undistinguished by tors, ridges or bold features, but probably taking its name from large patches of the granite floor of the mountain having been laid bare and whitened by exposure, presenting probably, at a distance, the rude outline of a horse. In this immediate neighbourhood, quantities of turf are cut for fuel, and somewhat beyond the farthest point of the turf-cutters operations, the approach to Cranmere may be made on horseback without difficulty. The tourist will find himself on the borders of the vast expanse of boggy tableland, which characterizes the remotest and most inaccessible parts of the moorland wilderness. If he has penetrated thus far by the aid of a Dartmoor pony, he will find it prudent to take advantage of the rude hut which the turf-cutters have raised in this wild spot, for temporary shelter against "the war of elements," to leave his horse, and pursue his wearisome way on foot towards Cranmere Pool. The way in itself is toilsome, as you are continually plunging into the plashy soil; or, to avoid getting knee-deep in the bogs, are constrained to leap from tuft to tuft of the firmer patches of rushy ground. Nor is there anything in the surrounding scenery to cheer the wanderer who requires a succession of new and attractive objects to animate him in his progress. Here the image of "a waste and howling wilderness" is fully realized. Glance where it may, the same slightly undulating, but unvarying surface of heath, common, and morass, presents itself to the eye. Scarcely even a granite block on the plain, or a tor on the higher ground, "breaks the deep-felt monotony" of the scene....

... Cranmere Pool itself, is not, as it is sometimes supposed, the source of the numerous streams which pour down from the reservoir which nature has established in this lofty but humid region. Taw Head is half a mile distant eastward; the sources of the Tavy are under Great Kneeset, a mile to the south-west; Dart Head about the same distance south; and the springs of the Teign still farther in a south-easterly direction. Ockment alone flows from Cranmere Pool, which was the largest piece of water in Dartmoor or its precincts, where we can boast of nothing like the mountain tarns of Wales and Cumberland. It is exceedingly difficult to find without a guide, and when the indefatigable tourist has reached the object of his toilsome walk he may perhaps scarcely think that the deep dark-looking hollow before him, imperfectly filled with water, with the heap of stones, has repaid him for the trouble he has taken to penetrate the watery fastnesses of the moor. The pool was formerly of an oblong form, and at its brink was about 220 yards in circumference and with an average depth of five feet. The bank some fifty years ago was apparently dug through on the northern side and the result is that for a considerable time past it has been and is now nearly dry, a mere hollow in the bog, but the outline of its former extent is clearly to be seen.

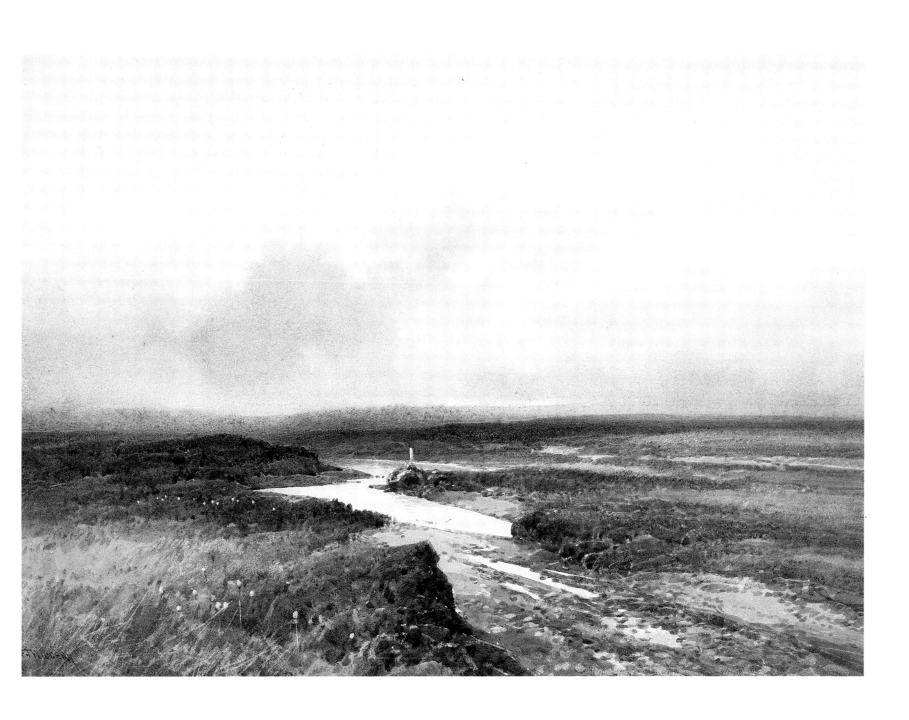

STONE AVENUE ON THE TEIGN

Proceeding northward, about a mile and a half from Frogymead, we shall explore a cluster of remarkable relics, beginning with the Gidleigh Rock Pillar, called in the Ordnance Map, Long Stone. The letters D.G. inscribed on one face, and D.C. on another, denoting the division between the parishes of Gidleigh, Chagford, and Dartmoor Forest, show that this primitive obelisk has been used as a boundary stone in modern times; but that it is a fine specimen of the genuine menhir of antiquity, there can be no reasonable doubt. It stands on the slope of a hill, about a mile S.W. of Castor Rock The stone measures twelve feet in height, and is at the base, three feet by two feet.

The avenues, although presenting the same general features with those at Merivale, are in far less perfect preservation. If any of these parallelithons deserve the name of *Cursus*, which has been sometimes applied to them, from the supposition that they were designed as race courses by our British forefathers, the Longstone Avenue certainly could not have been one. The ground is ill-adapted for the purposes of a hippodrome; while on the other hand, the construction and arrangements indicate to the believer its character as a *Via Sacra* or *processional* road of Druidical worship, according to the Arkite ceremonial. Beginning on the acclivity above Longstone Maen, the avenue passes over the hill towards the Teign in the direction of the great Sacred Circle on Scorhill Down. ... The Teign flows at the distance of about one mile from the Pillar, and this row, one hundred and fifty four yards long, terminates in full view of another, near at hand, which runs down the declivity towards the river. At its southern extremity, is a dilapidated cairn, the only example observed in the immediate neighbourhood. The avenue instead of being perfectly straight, as at Merivale and Stanlake, in the West Quarter, is in some parts slightly curvilinear. This is the only indication of an ophite feature which we have been able to detect in any of the Danmonian avenues, and it is so slightly serpentine, as scarcely to warrant the belief, indulged in by some, that the vestiges of a Dracontium or Serpent Temple may here be traced. The avenue appears suddenly to stop one hundred and ten yards from the kistvaen. From its second commencement it runs nearly direct, and almost parallel to another at a short distance down the declivity eastward. These two avenues can be traced about one hundred and forty yards, the eastern having its commencement at two large stones lying on the ground on the north side of three concentric circles. There are ten stones in the outer circles, six in the middle circle, and eight in the third. The diameters are, outer circle twenty-six feet, middle circle twenty feet, and third circle three feet. This avenue runs down the hill, becoming more and more imperfect until it disappears for a considerable interval. There is however apparently a distinct termination later on, in two erect stones, which stand apart, although evidently in the same line. Great havoc was made with these monuments, when the walls of Thornworthy New-take were erected. At the same time what is supposed to have been a Dolmen, known as the "Three Boys", was destroyed, two of the great stones having been removed. The impost was lost long before.

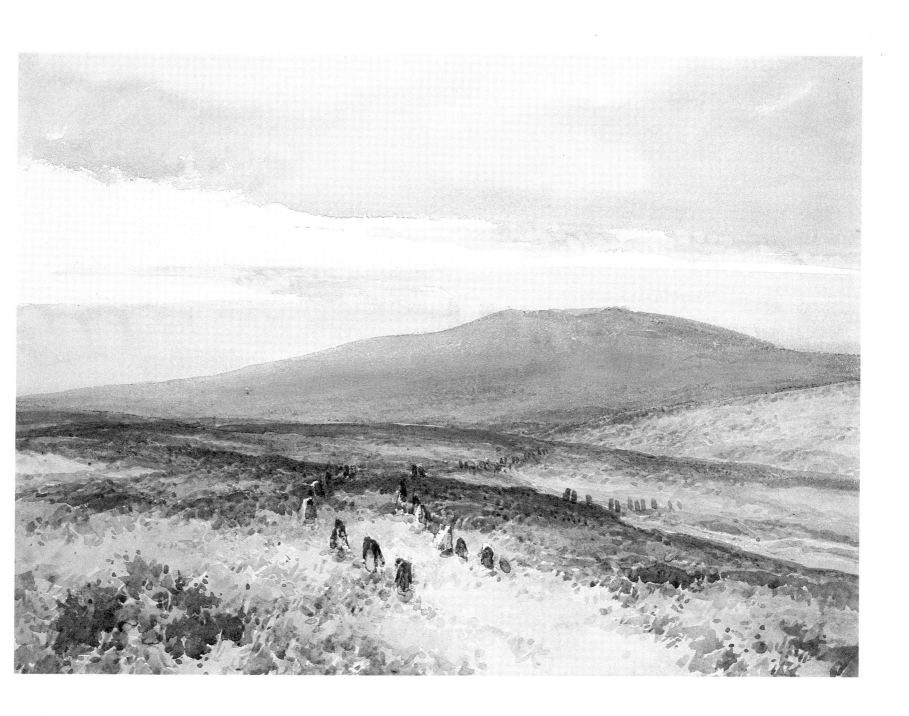

A TOLMEN ON THE TEIGN

SCARCELY HALF A MILE ABOVE HOLY STREET, a tor rises near the river's brink on the south side, called by the country people the Puckie, Puckle, or Puggie Stone, and celebrated for the large rock-basin, or pan (as it is popularly called) on its summit. The antiquary, trusting to local report, will be disappointed when, after having succeeded in scaling the rock, he finds that the characteristics of the genuine rock-basin. . . are not sufficiently clear to enable him to pronounce that this is not one of the examples attributable exclusively to the operation of natural agencies.

Although of large size, it is not of the usual circular form, nor do its sides display any decisive indications of artificial adaptation. But if disappointed in the main object of his research, the explorer will be repaid for his escalade, by the commanding view he will have gained of the wild-wood glen, down which the Teign rushes, foaming along its rock-bound channel, in all the youthful vigour of a mountain-born torrent. And if, on his descent from the crest of the Puckie Rock, he will brave the difficulties of the rugged glen before him, and thread his adventurous path up the course of the North Teign, he will skirt the fine woodland scenery of Gidleigh Park, until he emerges upon the moor, amidst the countless granite masses which strew the steep sides of the declivity, or have been precipitated into the channel of the river, checking the force of the headlong current for a moment, and forming a succession of miniature cascades. Among these, let us pause to remark a singular mass, lying near the right or northern bank of the river, as we ascend the stream, which, had there been no other object of attraction, would repay the antiquary for his walk up this sequestered and romantic glen.

This granite mass, approaching to an irregular rectangular form on its north side, is embedded in the channel of the Teign, and rests on two subjacent rocks, at an angle of about twenty-five degrees. The outline of the stone, above the surface, measures about thirty feet, and near the southern edge is a large and deep perforation, of a form so regular, that at first view, it will scarcely fail to convey the idea of artificial preparation, but a closer inspection will probably lead to the conclusion that natural circumstances, within the range of possibility, may have concurred to produce this singular conformation, although, on the other hand, it is far from improbable, that advantage might have been taken of some favourable accident of nature, and as in the case of the logan stone, art had perfected the operations of nature, and this remarkable cavity had thus been adapted to the rites of Druidism, for lustration or some other religious ceremonial, which is the tradition connected with this stone by the legendary chroniclers of the moor. But its present condition (as it has no bottom) precludes the possibility of its having been used as a rock basin, except in some extraordinary flood, when the waters of the river might rise above the under surface of the block, and partially fill the cavity so as to admit of its being appropriated to the purposes of a font or lustral vessel. . . . Without therefore pronouncing that this was never "a rock" which the Druid "scoop'd to hold the lustral waters", the antiquary will not fail to have suggested to his mind another kind of aboriginal relic, from an inspection of this curious memorial of by-gone ages. From its present aspect, he will probably conclude that it should rather be pronounced a tolmen; and if it really belong to this class of relics, the interest with which we shall regard it, will be much increased, as it is the only known specimen in Devonshire. It has hitherto escaped the notice of topographers

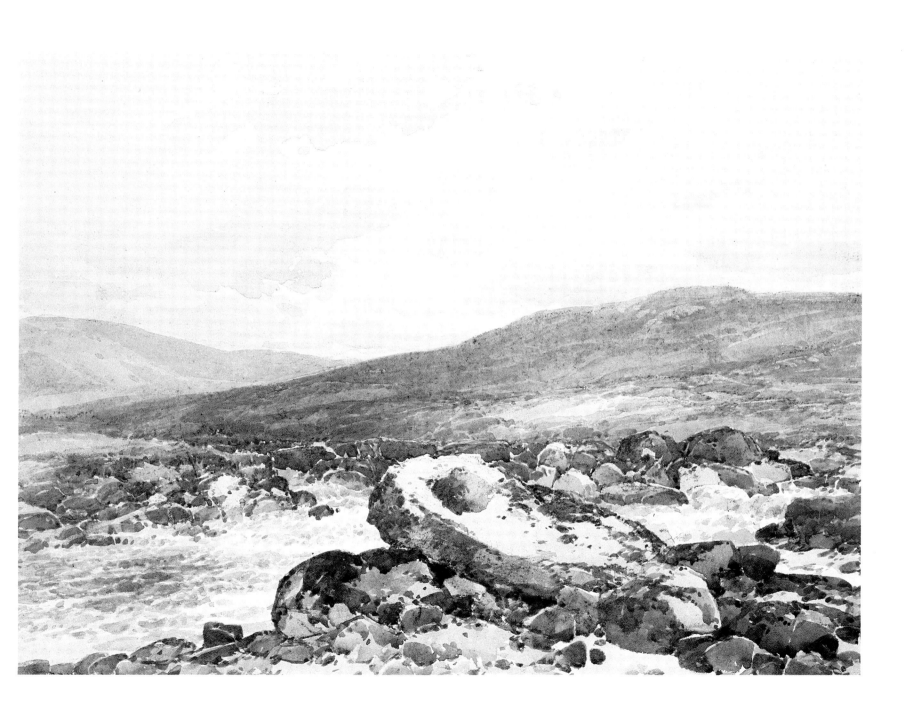

DREWSTEIGNTON CROMLECH

WHILE IN THE MIDST of scenes and sounds like these, the valetudinarian may successfully "woo Hygeia on the mountain's brow",—the artist may richly replenish his sketch-book—the botanist store his herbarium with specimens of moorland flora—and the geologist fortify his theories of volcanic protrusion, or aqueous deposits, from phenomena presented in the abrupt hills and deeply-scoop'd valleys around; the antiquary, with whose pursuits this work is more immediately concerned, will find himself most advantageously stationed at Chagford for visiting such monumental relics as the columnar circle on Scorhill Down—the tolmen—the stone avenues with the Longtone Maen—the Roundy Pound, Castor Rock—hut circles, on Teigncombe Down—the rock-basins, on Middletor, and the Puckie Stone, as well as those near Sandypark—the Drewsteignton cromlech—the logan stone, in the Teign, near Whiddon Park—Cranbrook Castle on the heights immediately above, and Prestonbury, near Fingle Bridge. . . .

Among these, the Drewsteignton cromlech holds a pre-eminent place. It has been noticed that the character and position of the abacus may probably be traced in the name of the adjoining farm. But without relying too much on the controverted evidence of etymology, the name of the parish is much more important, since it has been confidently appealed to as intimately connected with and directly relating to, the aboriginal relics with which the environs abound. Polwhele's enthusiasm has led him to regard these relics, viewed in connexion with the name, and with local circumstances, as pointing to the very metropolis of Druidism in the West—the seat of the regal, or arch-druidical court. That such courts existed in countries where the Druidical religion prevailed, there can be no doubt in the minds of those who are acquainted with Cæsar's clear and circumstantial account of the nature and extent of the authority, exercised by that powerful priesthood in Gaul. Nor can we hesitate in coming to the conclusion that similar authority was wielded in Britain, whence, as it has been already observed, the Gauls derived their knowledge of Druidical system. But whilst the existence of such courts in Britain will hardly be disputed, the precise spots where they may have been held must ever remain a subject of pure conjecture. Monumental relics are the only guides in the absence of historic testimony. Presumption, therefore, is in favour of a spot where an unusual congeries of Druidical relics still exists—and such a spot is certainly found in the immediate neighbourhood of the Drewsteignton cromlech—where the conditions requisite to make out a case *(prima facie)* are probably less equivocal than in Anglesea, where Rowland and others have traced vestiges of the seat of an Archdruid. Our Devonshire cromlech is incomparably more striking and curious than that at Plas Newydd, on the Menai Strait; nor is that accompanied by such an assemblage of relics, as enriches the neighbourhood of Drewsteignton. With all due allowance for local predilection, and for the sanguine conclusions of the antiquary, whose wish is confessedly often "father to his thought", the following observations of Polwhele, with reference to this point, may not be deemed altogether unworthy of consideration. "If we confine ourselves within the limits of Devon and Cornwall, and fix an archidruidical seat in the west, I should imagine that Drewsteignton would be the most eligible spot. . . .

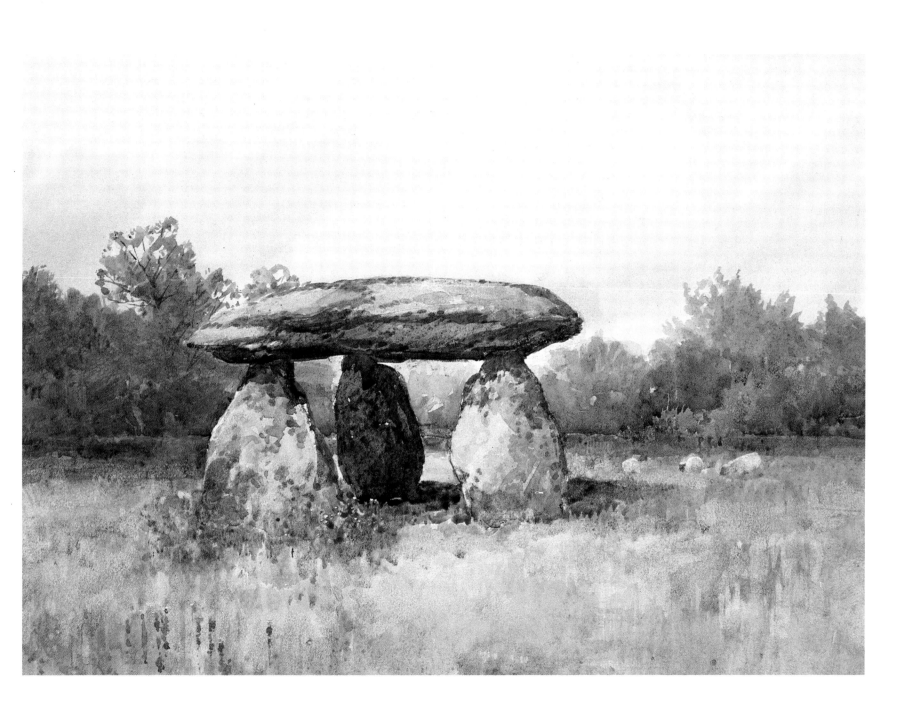

FINGLE BRIDGE

PROCEEDING DOWN THE RIVER we shall be greeted with some of the most striking vale scenery in the west of England. The course is a continuous succession of graceful curves; the banks on the south, or Moreton side, clothed with wood and heather, as high as the eye can reach, and on the Drewsteignton slope presenting abrupt and bare declivities occasionally interspersed with craggy projections, beetling above our rugged, but romantic pathway.

In one particular spot, high in the abrupt declivity, two bold cliffs will be observed, jutting out from the hill, like the ramparts of a redoubt, guarding the narrow pass below. Lower down, the northern bank becomes wooded and the path, proceeding through a tangled copse, at length emerges upon the Drewsteignton and Moreton road at Fingle Bridge. Here let us pause on its narrow roadway—just wide enough for a single cart—to gaze from its grey moorstone parapet, on a scene, the general features of which may be recorded by the pen, but of whose particular features of loveliness, the pencil alone can convey an adequate idea. Three deeply-scooped valleys, converging to one point—two or three little strips of greenest meadow-sward, occupying all the narrow level at the foot of the encircling hills—the fortified headland of Prestonbury, rising bold and precipitous, its rigid angular outline strikingly contrasted with the graceful undulations of the woody slopes which confront its southern glacis—the mill at their base embowered in foliage, and the river, clear and vigorous, giving animation to the scene without marring its sylvan seclusion—all combine to form a scene of surpassing loveliness, which it is a disgrace for any Devonians not to have visited, before they set out in search of the picturesque, to Wales or Cumberland, or the highlands, and, still more, before they make their continental peregrinations,

> Or by the lazy Scheld, or wandering Po;
> Or onward, where the rude Carinthian boor
> Against the houseless stranger shuts his door.

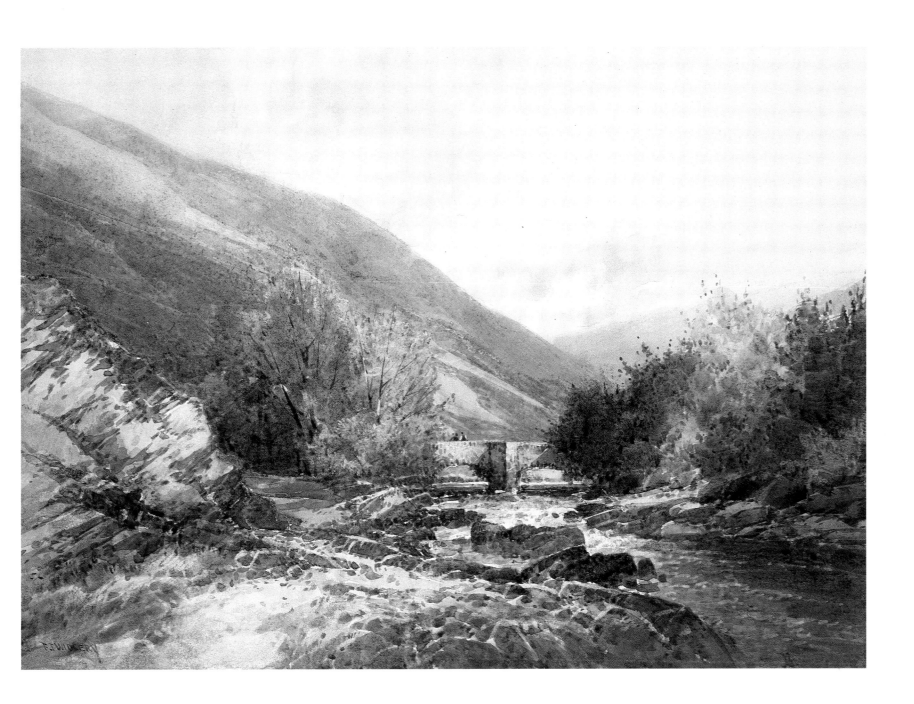

BOWERMAN'S NOSE

OUR NEXT EXCURSION will cause us to retrace our steps to North Bovey, on our way to Bowerman's Nose, but when about a quarter of a mile from Manaton, leaving that village on the left, and crossing a tributary of the Bovey, we shall mount the hill by a moor-tract passing over Heighen or Hayne Down, in front of that remarkable pile. Bowerman's Nose, as it is popularly called, rises from the brow of the headland which projects from Heytor and the hilly track, between the dale of Widecombe and those of Manaton and North Bovey.

It is seen to greatest advantage when approached from the north by the road we are now traversing; and is found, on examination, to consist of five layers of granite blocks piled by the hand of nature—some of them severed into two distinct masses; the topmost stone (where we presume the nasal resemblance is traced), being a single block. Polwhele seems to have been mistaken in calculating the height at fifty feet; it is rather less than forty above the clatter from which it rises conspicuous from its position, and remarkable for its form, it is easy to conceive that this fantastic production of nature, might have been pointed out to an ignorant and deluded people as the object of worship; nor is it unworthy of remark that, viewed from below, it strongly resembles the rude colossal idols, found by our navigators when they visited Easter Island, in the Southern Pacific; and when seen from the south, on the higher ground, it presents the appearance of a Hindoo idol, in a sitting posture.

It is only on the spot that we can duly appreciate Carrington's graphic and faithful description,

> On the very edge
> Of the vast moorland, startling every eye
> A shape enormous rises! High it towers
> Above the hill's bold brow, and seen from far,
> Assumes the human form; a granite god—
> To whom, in days long flown, the suppliant knee
> In trembling homage bow'd. The hamlets near,
> Have legends rude connected with the spot
> (Wild swept by every wind), on which he stands
> The giant of the moor.

Among the unnumbered shapes, which, as our poet so truly sings,

> By Nature strangely form'd—fantastic, vast,
> The silent desert throng

Bowerman's tor will always occupy a position of highest rank, for its singular natural conformation, and for the legendary recollections with which it is associated.

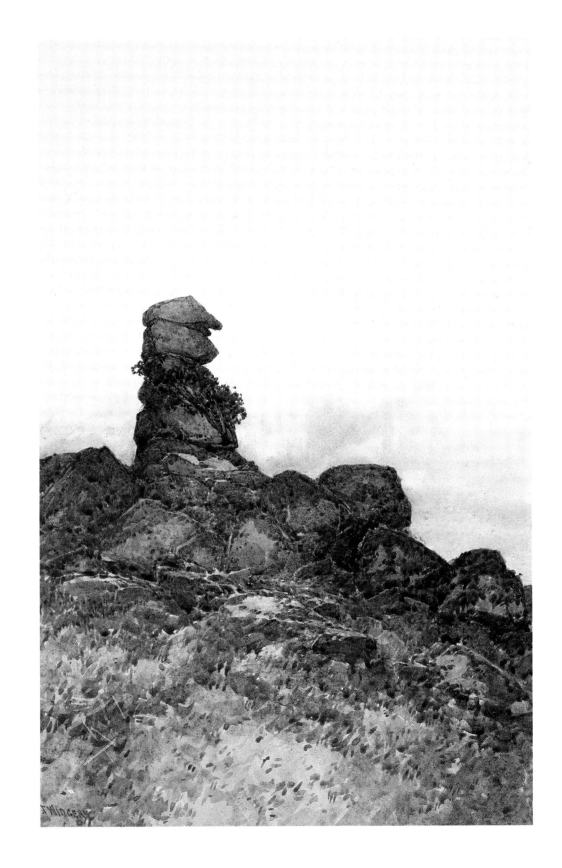

HOUND TOR WITH CIRCLE

LEAVING THE HEIGHT, and proceeding southward, we shall soon enter the Ashburton road, and passing through a moor gate, shall not fail to remark a lofty tor on the left, the north front of which presents the appearance of a mimic castellated building with two bold projecting bastions. On closer examination we shall find it to be Hound Tor. . . .

The top of the hill is flanked by two colossal walls, piled up of huge granite masses, sixty, eighty, and in some places probably a hundred feet high, with an open space between forming an esplanade where Titan sentinels might have paced along, or rebel giants might have held a council of war. Returning from Hound Tor about a furlong south we shall pass the kistvaen. . . and follow the Ashburton road, until at the foot of Rippon Tor, where the road diverges to the left, bringing us very soon to Heytor—which from its commanding position on the south-eastern frontier of the moor—at the head of a wide expanse of declivities sloping directly down to the level country (through which the great mail-roads from Exeter to Plymouth passed, by Totnes and Ashburton, in full view of the tor for many miles) is probably more generally known and admired than any of its granite kindred of the waste. Heytor rises from the brow of the hill with sombre grandeur in two distinct piles, and when viewed from the neighbourhood of Kingsteignton, and other adjacent lowlands, under the influence of a sullen and cloudy sky, presents a singularly accurate resemblance to a ruined castle, the massive keep of which is represented by the eastern pile. On the top is a rock-basin, two feet and a half in diameter, but much less perfect than Mistor Pan and many others.

We shall now find ourselves amidst "the sights and sounds" so eloquently described by William Howitt. And if our visit can be so timed, we may even realize the characteristic accidents which will not fail to enhance the intrinsic loveliness of the scene. Here are "the wild thickets and half-shrouded faces of rock;—the tors standing in the blue air in sublime silence, the heather and bilberry on either hand showing that cultivation has never disturbed the soil they grew in;" and here, too, perchance, "one sole woodlark from the far-ascending forest on the right, filling the wild solitude with his wild autumnal note." We shall look with eager interest for that "one large solitary house in the valley beneath the woods," which he has commemorated; and, contemplating the manifold variety before us, of rock and mountain, flood and fell, wood and meadow, busy towns and silent wastes, the level flat of Bovey Heathfield and the beetling steeps of Dartmoor, the placid estuary of the Teign, and the wide expanse of ocean seen over the rock-bound coast stretching far away to the misty verge of the southern horizon—shall enter into the feelings which he has thus enthusiastically recorded, "So fair, so silent, save for the woodlark's note and the moaning river, so unearthly did the whole scene seem, that my imagination delighted to look upon it"

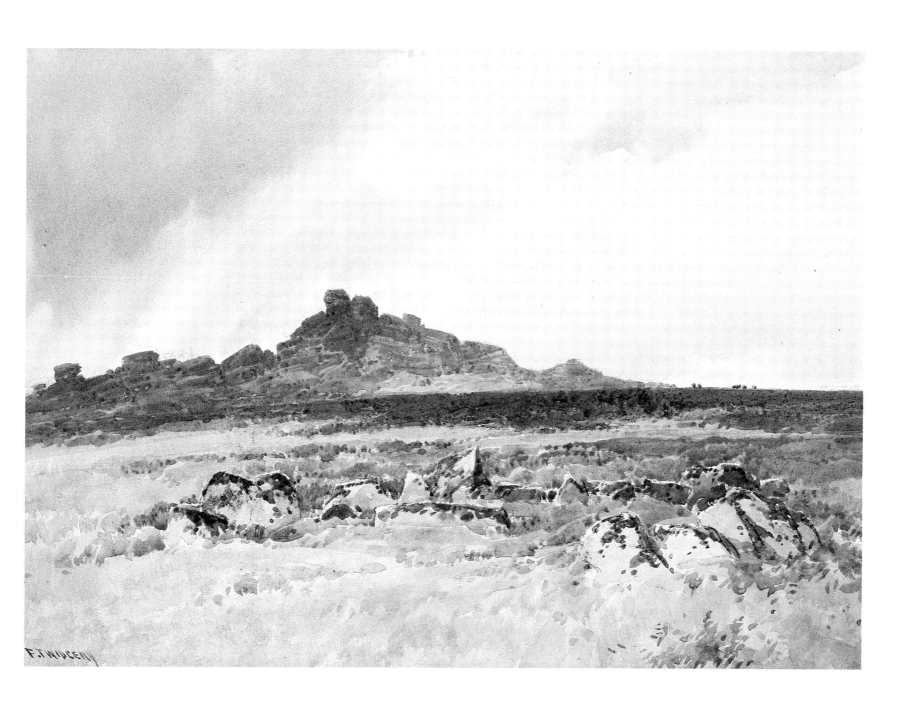

F.J.WIDGERY

GRIMSPOUND

BY A STEEP DESCENT, we shall reach the vale of Challacombe, where the origin of the local designation will be observed at a glance, and its significance manifested in this secluded nook, hollowed out of the acclivities of surrounding hills. This coombe, which opens pleasantly to the south, is watered by another spring of the West Webburn, and presents a pleasing proof of successful cultivation, under favourable circumstances, in the heart of the moor.

But Grimspound is now before us, as we mount the southern slope below Hooknor tor.... A large stone on the eastern side of the circle, marks the spot where the spring rises, and from whence, beneath the foundations of the wall, as already described, it flows, under the name of Grimslake, to join the Webburn. After a dry spring, and a whole month of continuous hot weather immediately preceding, we have found at Midsummer a clear and copious stream issuing from the source, so that it would appear, under ordinary circumstances, those using the enclosure would have been always sufficiently supplied with pure and wholesome water. The classical investigator will probably be disappointed at not finding in Grimspound the characteristics of an antient British town, ... defended by woods, swamps, and thickets, ... where a large body of persons ... might be congregated in security. But without raising the question whether, when Grimspound was originally built, these naked declivities might not have been clothed with wood, as some suppose, it has been contended that it presents all the features of a stronghold, and that the present natural circumstances might suffice to account for the different kind of castrametation exhibited in the stronghold of that valiant British prince. The eastern Britons, on the banks of the Thames, had not the same advantage, in point of materials, as their Danmonian compatriots possessed, in the granite blocks and boulders of Dartmoor, from which an effectual circumvallation could be speedily formed; to which these aboriginal engineers appear to have deemed it unnecessary to add the further protection of a fosse, since Grimspound is totally unprovided with any kind of ditch, or additional outwork, beyond its single rampart. This, it is contended, is a feature of much significance, and should be duly regarded in our endeavours to ascertain the period of the erection of this rude but venerable fortress. The rampart is doubtless much lower than it was originally built, but unlike many of the valla of our hill-forts and earth-works, it has not been tampered with, nor the original design altered by successive occupants. Sir R. C. Hoare furnishes us with an important axiom in archæology, which may be legitimately applied in determining with proximate accuracy at least, the era of the erection of Grimspound. "In examining those earth-works, we must endeavour to discriminate the work of the people who constructed them; and wherever we find very strong and elevated ramparts, and deep ditches with advanced outworks, such as Bratton, Battlesbury, Scratchbury, Yarnbury, Chidbury Barbury, Oldbury, etc., we may ... attribute these camps to the Belgic or Saxon era"

But to whatever conclusion the investigator may be led, as to the people by whom this marvel of the Moor was constructed, or the objects contemplated in its erection, he will not return from his examination of Grimspound, without being convinced that he has inspected one of the oldest monuments of our island; whilst the mystery in which its origin is shrouded, and the appearance of hoar antiquity, with which its gigantic rampart is invested, will add interest to his speculations, and deepen his recollections of this extraordinary, if not unique, relic of aboriginal times.

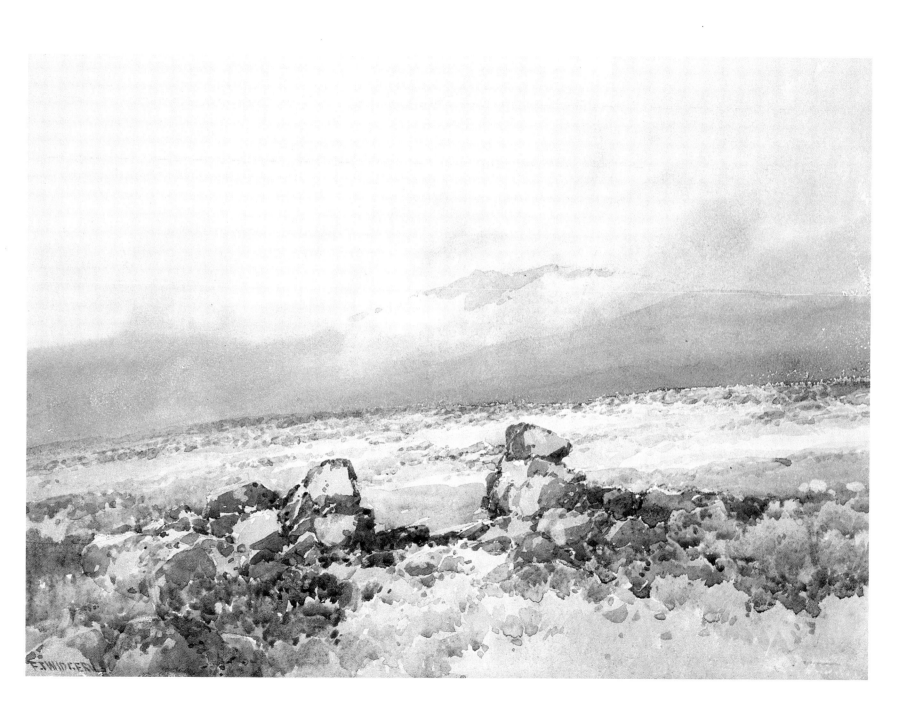

DEWERSTONE

AT SHAUGH BRIDGE ... the stern ruggedness of the upland ravine appears blended with the softer lineaments of downs and woodlands. From Dewerstone to Saltram Point, where its estuary widens into a tidal lake, the banks of the Plym are, for the most part, clothed with woods, chiefly of England's national tree, the noble oak. The bold headland, from the eastern flank of which Dewerstone protrudes, is mantled with copse down to the "margent" of the united streams.

Few spots in the west display a greater share of natural charms "than this vale in whose bosom the dark waters meet"; and here too the "accidents" of moorland scenery in the most sublime and awful forms may be contemplated, under singularly favourable circumstances, by those who fear not to woo Nature in her wintry garb, and in her mountain seclusion. A low temperature and a thick fall of snow, are not unfrequently in our variable climate succeeded by a rapid thaw, accompanied by heavy and continuous rain. Such a sudden thaw took place during the severe winter of 1823, on the night of the 27th of January. The pouring rains and the melting snow rushed together from a hundred hills into a narrow glen of the Plym, and speedily swelled the stream to a mighty river, which overspread the entire floor of the vale, and swept along high up the slopes of the acclivities with resistless force, until the adamantine barrier of Dewerstone checked for a moment the impetuous torrent. But like a furious animal loosened from its bonds, and maddened by resistance, the raging stream dashed its turbid waves against the beetling cliff and threw the foaming spray, as in triumph, over its loftiest crag, while the roar of conflict was heard far along the echoing dales. The unbridled flood came careering down the widened vale, and rushing amain through the lofty arch of old Shaugh Bridge, filled it to the key-stone, and directing the main force of its overflowing current along the eastern bank, dislodged the huge masses which formed the antient causeway to the mill This bridge has been replaced by the present substantial structure of hewn granite.

Following the road along the line of this causeway, we shall diverge from the river and mount the hill, eastward, on our way to Shaugh church-town, a straggling village of genuine moorland character. ... The village church, with its lofty, well proportioned moorstone steeple, forms a conspicuous and pleasing object as we ascend the breezy common. And should we be tempted to turn aside to examine more closely this simple but venerable moorland sanctuary, we shall doubtless hear from the sexton an account of the well-remembered thunder-storm, which occured in the same winter as the flood above recorded, and which would have been no less terrific in its results than that of Widecombe, had it not providentially happened on a weekday, instead of on Sunday, in service time, as in the former case. The lightning struck off one of the pinnacles of the tower level with the battlements; and hurled the fragments on the roof over the southern aisle, the western part of which was laid in ruins. About two hundred and thirty panes of glass were shivered, and among the few that escaped uninjured, was a small one, at the east end, of stained glass, the emblazonment of which intimated the antient dependance of Shaugh church upon the priory of Plympton. Stones of large size were flung into the neighbouring croft, at a considerable distance. The rural chronicler will perhaps "point a moral", by telling us that a parish meeting for certain business, had been fixed to be held in that very part of ... the aisle where the pinnacle fell and where, had the parishioners met as intended, the loss of life must have been far more terrific than at Widecombe

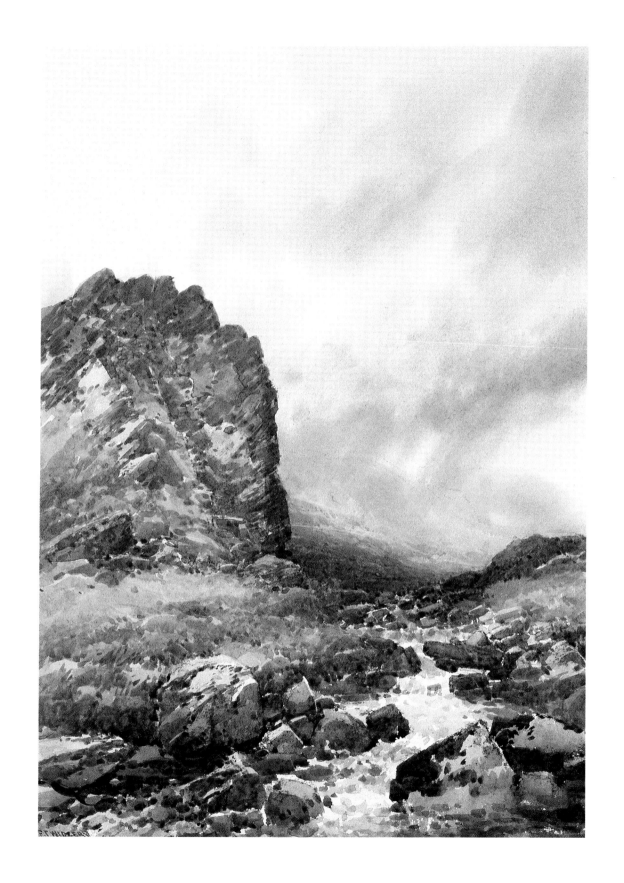

POST BRIDGE

IN A REGION SUCH AS DARTMOOR, intersected by rivers and brooks in all directions, and these streams so peculiarly liable to be swollen by summer torrents, and by the thawing of the accumulated snows in winter, the progress of the trackways would be continually interrupted by these natural and formidable obstacles. In some instances they may be found pointing to a ford, as would appear to be the case with the grand central road below Chittaford Down; but as the East Dart would frequently become impassable at that ford, the necessities of the case would task the ingenuity of the earliest inhabitants in contriving the erection of a bridge.

Happily the materials, which lay at hand, when such a necessity arose to a primitive people, were of a more durable kind than the felled tree, which in more wooded districts forms a ready and not inconvenient bridge. Vast slabs of granite afforded the means of constructing solid piers by being merely laid one upon another, yet stable enough without cement or other adventitious appliances, to breast the impetuous rush of the moorland torrents. The necessity of arching was obviated by massive imposts of a tabular form laid horizontally from pier to pier. Some of these are formed of a single stone, and would then probably come under the vernacular denomination *clam*, a term also frequently applied to a bridge formed of a plank or single tree, although we have noticed a distinction sometimes made, the wooden bridge being called a clapper, and a stone bridge a clam.

Adjoining Post Bridge (a modern county bridge over the East Dart, traversed by the Tavistock and Moreton road) stands one of these venerable and characteristic relics of probably very early times, presenting a truly interesting specimen of primitive architecture. The piers are two, and these with the abutments form three sufficient openings for the waterway. Its construction though rude, is of the most durable kind. No structure of ordinary stability could have withstood the fury of the vehement Dart in his most turbulent moods for so many centuries. The piers consist of six layers of granite slabs above the foundation. The superincumbent stones are singularly adapted for the purpose to which they are applied. The centre opening is narrower than the side openings; the imposts here were two, one of these was thrown down many years since in an attempt to form a duck-pond, and it remained in the bed of the river for a long time. It has now however been restored to its original position, and the bridge is again perfect. The stones are about fifteen feet long, and six wide, and thus a roadway was made over which, even the scythed chariot of the Danmonian warrior might pass the river in safety. There are other specimens of what has been called the Cyclopean bridge, in various parts of the moor, those at Two Bridges, Okery Bridge and Dartmeet may be mentioned, but this is by far the largest and most interesting. Mr Bray in enumerating other local antiquities, bears the testimony of an observant traveller to the uncommon character of these curious structures. "It is not unlikely that they are unique in their construction; at least I can say that though I have visited in England, South Wales, and Brittany, many places celebrated for Celtic remains, I have never yet seen anything like our antient Dartmoor bridges." Nor are there any such examples to our knowledge in North Wales or in Westmoreland or Cumberland, but at Tar Steps between Hawkridge and Winsford in our county, there is a bridge over the Barle, of similar construction, with nineteen openings, the total length being one hundred and fifty feet.

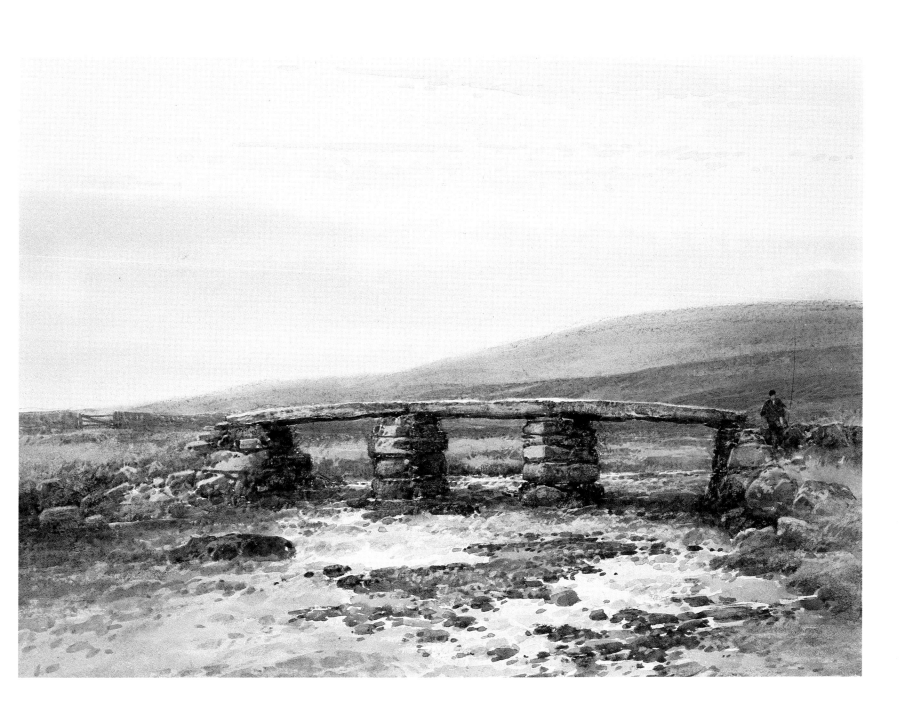

SACRED CIRCLE ON LANGSTONE MOOR

LEAVING THE SUMMIT OF MISTOR, on our way due south, we shall pass Greenaball, and its three mutilated tumuli on the right hand as we descend the steep slope to the Walkham river, and reaching the bank take our way across its rocky channel. Scaling the opposite side we shall find ourselves on Langstone Moor (on the Ordnance Map, Launceston), so called from the menhir which stands upon it, and which has been recently re-erected by the Duke of Bedford under the direction of Mr Baring-Gould.

Here, as well as on the western slope of Mistor as before-mentioned, are a large number of hut circles. Some of these—there are upwards of thirty—are surrounded by a pound-wall of the usual character. So far as they have been examined, these huts are similar to those at Grimspound and Broadun. The hearths and the beds, and charcoal and flint have been found, but no pot-boilers, and not a vestige of pottery. Mr Robert Burnard is of opinion that if a hut is that of, or has been used by, a miner, pottery ought to be discovered. Ascending the hill still further we shall find a sacred circle of much interest. It was discovered in 1894 by the Rev. G. B. Berry, who drew the attention of the Exploration Committee to it. There was not a stone erect, but none had been mutilated or taken away. Willing permission having been granted by the owner of the land, the Duke of Bedford, and ready help having been furnished by his steward, Mr Rundle, under the superintendence of the Rev. S. Baring-Gould, the stones, sixteen in number, have been once more placed upright, and in their proper places, there being no difficulty in ascertaining their original positions, and thus a very fine and perfect monument has been preserved. Two of the stones composing it are of a different character from the rest, which are ordinary moor-stone. These appear to be a fine sandstone. It would seem that there was another circle outside this one, but three stones only on the western side remain. We know no other instance on Dartmoor of a circle within a circle. The diameter of the Langstone Circle is about fifty-six feet. Approaching it from the north, with the pile of Great Mistor forming a grand back ground, the appearance of this antient monument—more especially as the day is closing—is weird and solemn in the extreme.

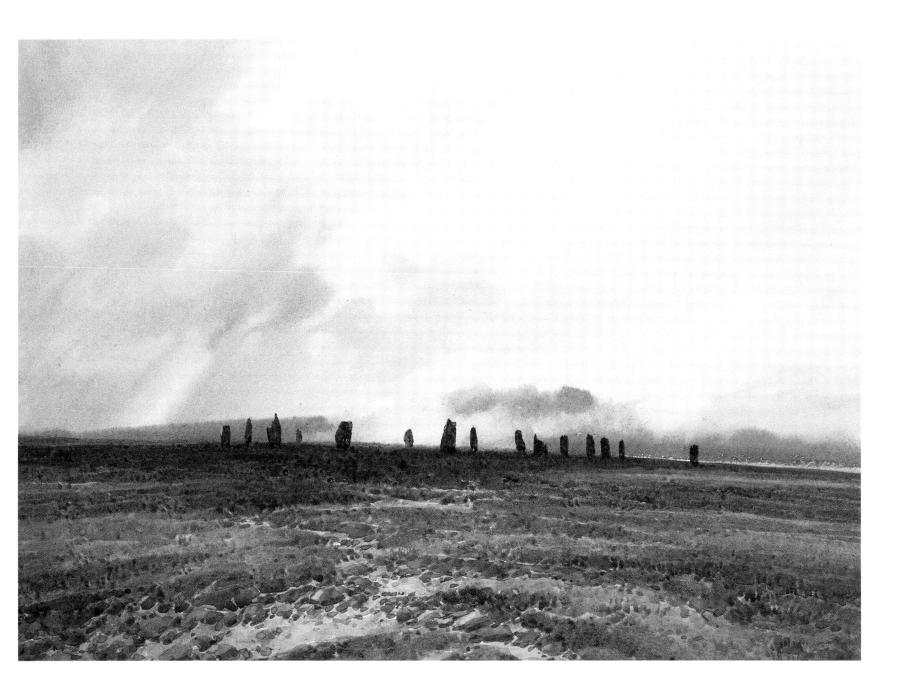

VIXEN TOR

Continuing our southward course, we shall cross the road from Tavistock to Two Bridges, leaving Merivale Bridge in the valley on the left. From hence we shall observe Vixen Tor, not forming the crest of an eminence, as is more frequently the case, but rising majestically from the common, near the steep banks of the Walkham, about a mile below Merivale Bridge.

On a nearer approach, we shall remark the resemblance which it bears to the Egyptian Sphynx, when beheld from a particular point of view. Fronting the river, the huge masses of which the tor is composed, are piled up, tier after tier, in a rude, but noble façade, divided into three compartments by perpendicular fissures, through which an ascent to the summit can be effected, whereon appearances of rock-basins will be observed. The river-front faces directly south, and this lofty rock is traditionally reported to have been resorted to in past times for astronomical purposes. Vixen Tor, whether considered in itself, or with reference to the striking scenery of which it forms the central object, is one of the most interesting in the moorland district. The vale of the Walkham presents a long-drawn mountain defile, stretching away to the south. On the acclivity beyond Merivale Bridge eastward, is the aboriginal town, above described, where the admirer of Scott's truthful pictures of natural scenery may trace the main features of the Black Dwarf's forlorn retreat on Mucklestane Moor. There is "the huge column of unhewn granite, raising its massy head on a knoll near the centre of the heath, and the ground strewed, or rather encumbered, with many huge fragments of stone of the same consistence with the column, which, as they lay scattered over the waste, were popularly called the Grey Geese of Mucklestane Moor." And down the stream southward, near Ward Bridge and Huckworthy Bridge, the river, rock, and wood scenery is of the most fascinating description. Should the tourist recross the Walkham, and follow the windings of the Prince Town railway, as it sweeps round the opposite hill by King Tor and Crip Tor and Foggingtor, he will be abundantly repaid by a succession of views of wide extent and varied interest. Near the point where the railway crosses the Plymouth and Prince Town road, he will be struck with the peculiarly fine grouping of the tors, as he looks towards the N.E., with the lofty tower of Walkhampton rising conspicuously from the acclivity in the foreground. The railway station at Prince Town is about five thousand four hundred feet above sea level. From the junction at Yelverton the distance to Prince Town, as the crow flies, is about six miles, but to reach it and overcome the steep ascent, the railway winds for nearly eleven miles, the gradient being one in sixty-five. Returning by Walkhampton, we shall leave the steep lane leading to the church, and crossing a fine old moorstone stile, shall find a pathway along the fields, which commands the vale of the Walkham at some of the most picturesque points. Far inferior as the accompanying mountain elevations confessedly are, yet, in all other respects, the scenery of this lovely glen may dispute the palm with the most celebrated spots of North Wales or the Lakelands.

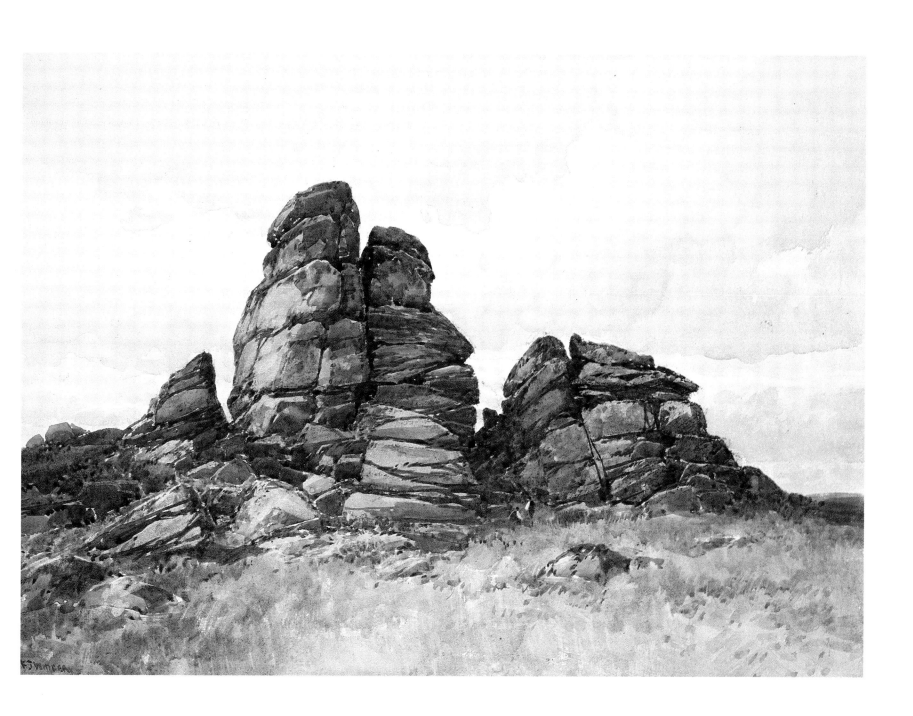

TAVY CLEAVE

WE NOW FOLLOW THE STREAM OF THE TAVY downwards to Watern Oak and Western Redlake, a natural boundary, specified in the Perambulation, to which the line comes from Lints Tor. Between these two latter points according to the Perambulators, the Western and Northern Quarters meet. Near the same point a considerable stream from Amicombe Hill called Rattlebrook, falls into the Tavy, and forms the Forest boundary northward for some distance, to its head.

Still following the course of the Tavy downwards, we shall soon reach Tavy Cleave, a magnificent range of castellated tors with which nature appears to have fortified this fine peninsular hill, while the rapid stream sweeps round the headland, and forms an effective moat to the Titanic citadel above. These tors range in succession along the precipitous sides of a rock-strewn declivity. There are five principal piles, of which the third is the loftiest and most majestic, and the whole cliff presents a remarkable resemblance to the dilapidated walls of a time-worn edifice. Even on a nearer approach, the illusion is kept up by the whortle, heath, and other plants flourishing in the interstices, so that the aspect of this mimic castle is novel and peculiar. Imagination, too, with little effort, may figure a natural outwork, or barbican, in the lower pile, on the southern glacis, guarding the approach, and thus fortifying this inland promontory almost to the river's brink. The whole declivity being overspread with scattered masses of granite, stands in bold contrast with the grassy common on the opposite bank.

The bed of the Tavy presents in general, the usual rocky characteristics of the Dartmoor rivers, but immediately below the Cleave, the stream flows for some distance over a solid granite floor. The view down the moorland glen, with far off glimpses of the cultivated country beyond, will abundantly repay the tourist for scaling these natural ramparts on his way to the neighbouring heights, along which we shall proceed westward to Gertor, or Great Tor, which crowns a bold eminence beetling over the Tavy, and is remarkable for its stratified character, as contrasted with Tavy Cleave. If rock-basins are always to be ascribed to natural agencies, few tors would be more favourable to the production of such cavities, but none are to be found on any part of the rock. Between Tavy Cleave and Gertor we shall notice a hut-circle, with the jambs erect, and the doorway facing the river. A track-line appears in connection with this ruined dwelling. From hence, passing Great Tor, with the river for our guide, we shall wend our way to Marytavy, another rural church, amidst scenery pleasingly varied by homely objects, and the bolder features of the moorland border, and returning to the turnpike road, shall close our excursion at Tavistock.

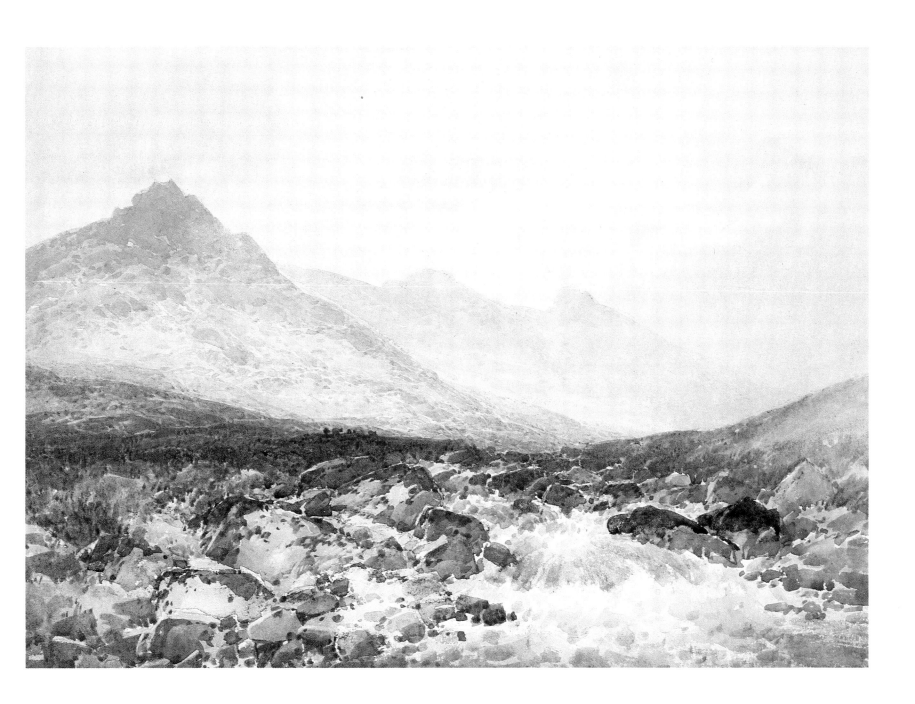

OKEHAMPTON CASTLE

THE SCENERY ON THE WEST OCKMENT, in the deep glen at the foot of Black Tor, is grand and impressive, but will not long detain us from tracing the course of the river onwards till it sweeps below the venerable ruins of Okehampton Castle, which occupy the summit and declivity of a rocky mound, about half-a-mile from the western entrance of the town, and full in view of the main road into Cornwall.

Above this eminence, thickly clothed with foliage, the massy walls of the keep are seen to rise, with the most picturesque and happy effect. One lofty fragment appears ready to topple down headlong, at the first assault of the blustering tempests from the neighbouring wilds of Dartmoor; but from the durable qualities of the cement, it has withstood the fury of the elements and may, we trust, long remain to add interest and beauty to this charming scene. The antiquary, with his thoughts reverting to the lordly barons who once here held sway, the Baldwins of the Norman era, and the Courtenays of Plantagenet times, will enter from the east, and trace the remains of the castle gate and the moat, the base court and the chapel, and reach the square keep on the western side by a pathway overhung with trees. Embosomed in foliage—its mouldering walls mantled with ivy, and surrounded by hills of varied form and hue, Okehampton Castle, in sunshine or in shower, "at morn or dewy eve", will be always an object of pleasing interest; but ... to see it in perfection the tourist should "visit it by the pale moonlight".

To facilitate this object, we shall take up our quarters for the night at Okehampton, and before proceeding next morning on our final excursion, shall visit the most prominent objects of interest in this antient borough, which we shall observe is situated on the very verge of our moorland district, nestling beneath the bold brow of the once celebrated park, on a pleasant little plain, watered by the twin streams of the Ockment, which peninsulate a large portion of its site, and unite their waters just below the town. The two bridges in the main street, the chantry chapel, dedicated to St James, near the east bridge, with its embattled steeple, and some old gabled dwellings, will not fail to attract our attention; nor shall we grudge our walk to the church of All Saints, which occupies a commanding situation on the hill that rises above the town on the western side. This, the parish church of Okehampton, a spacious structure with a lofty pinnacled tower, forms a conspicuous and pleasing object amidst the surrounding scenery. The old church was accidentally destroyed by fire a few years since, but it has since been re-built.

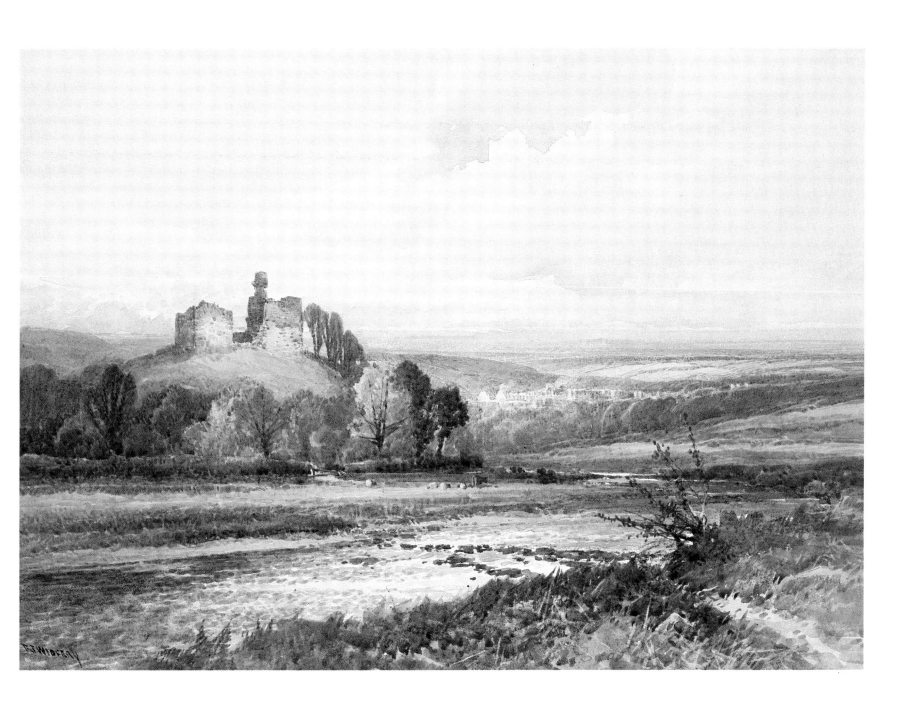

HILL BRIDGE

IN A RECENT COMMUNICATION to the Geological Society entitled "Notes on Dartmoor", General McMahon ... maintains the post carboniferous eruptive hypothesis. He says: "There certainly seems no escape from the conclusion that the metamorphism of the fringing-zone is due to the thermal contact-action of an uncooled, unconsolidated granite. The fringing-rocks exhibit in the mineral changes set up in them, such as the production of chiastolite in beds rich in carbonaceous material, evidence of the contact-action of heated granite.

"Now the material point is, that directly we get beyond this fringing metamorphic zone—that is to say, when we get a mile or a mile and a half, from the boundary of the Granite and the Culm Measures—we pass into unaltered rocks. Is it possible that a stupendous north-and-south squeeze exerted on the whole region, and capable of fusing a rigid rock, covering an area of two hundred and twenty-five square miles, would have left these beds untouched?

"The best locality for studying the two types of granite, that I have seen, is in the valley of the Tavy, in the neighbourhood of Hill Bridge, between Hill Town and White Tor. The passage from the fine, even-grained type to the porphyritic normal type is rapid. In the bed of the river, owing to a long period of dry weather, I was fortunate enough to reach a mass of granite *in situ*, worn smooth on the surface by the water that showed the actual blending of the two types. About fifty yards from where the slates first crop out, a mixture of the porphyritic and fine-grained varieties may be seen. Masses of porphyritic rock containing rectangular crystals of felspar, from two and a half to three inches in length, are included in the fine-grained variety. They have not the appearance of blocks of a coarse-grained granite, included in another eruptive rock, but look like aggregations of porphyritic crystals, in a fine grained non-porphyritic base. The whole suggests the idea of an imperfectly stirred plum-pudding, in which the plums have got together in a lump. We have here, I take it, evidence of the imperfect mixing of two portions of the granitic magma in different conditions of fluidity. Students of quartz-porphyries and similar rocks, are well aware that when a relief of pressure takes place, and a partially crystallized deep-seated rock is moved toward the surface, a partial remelting of the already-formed crystals takes place. The relief of pressure in this case, is believed to give increased potency to the solvent action of the heated liquid in which the crystals are suspended. It seems to me, that a similar result would be produced, if the pressure remained constant, and the heat were locally increased. And the explanation I would suggest, is that, as the partially crystallized granite was moved upwards, the traction and friction against the sides of the vent, broke up the larger crystals and increased the heat, and consequent fluidity, of the marginal portions of the mass, so that we have a margin of fine grained granite around the normal porphyritic rock, and an imperfect blending of the two along the line of junction. The loss of heat during cooling, would have been more rapid along the margin, than in the central portions, and although it evidently was sufficiently slow to enable both portions to set up a holocrystalline structure, it was not slow enough to enable the marginal portion to develop porphyritic crystals."

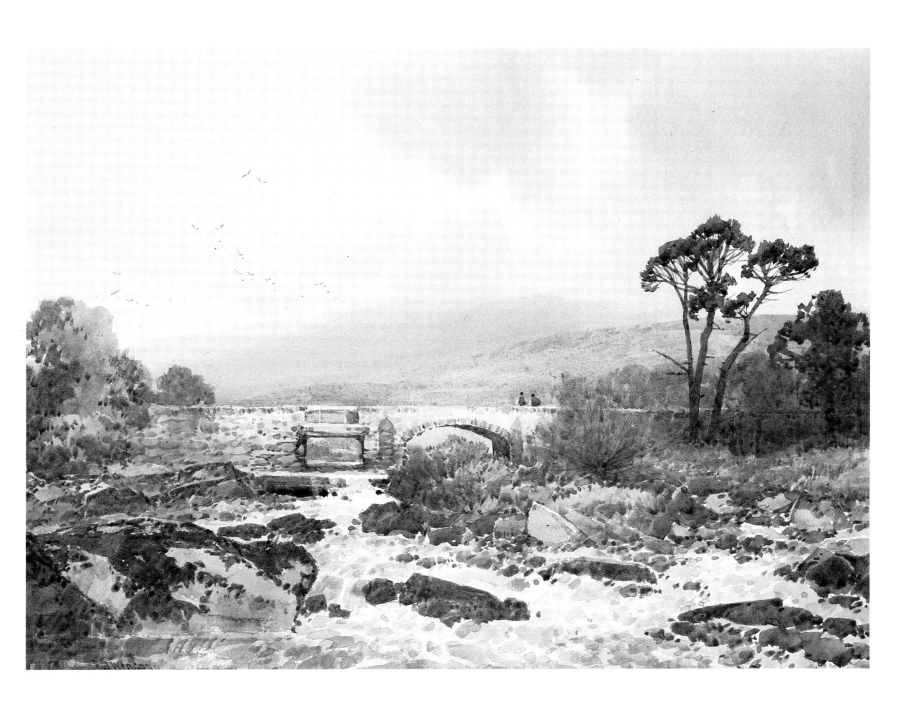

VALLEY OF THE ROCKS ON THE WEST OCKMENT

THE MINERALOGY OF DARTMOOR, like its petrology, would supply material for a treatise in itself. The most important metallic mineral connected with the Moor, is the oxide of tin, or cassiterite, detrital deposits of which have been worked in the moorland valleys from before the dawn of history. The existing tin lodes on Dartmoor are small, though often rich; and an enormous quantity of rock must have been removed and reduced by denudation ere such extensive deposits of tin stone could have been retained, as a consequence of their superior weight, in the river beds.

In fact no better index could be supplied of the extent of this denudation, than the formation of deposits of stream tin which kept the tinners of Devon at work for centuries, and are not wholly exhausted even now, though all the more recent operations have been by mining proper and not by streaming. Next in importance to the tin lodes of the district, are the copper, but these were very little worked upon until within a century or so ago; and at the present moment all the copper mines are abandoned and tin mining has only a precarious existence, though the Dartmoor tin ore is the richest and most valuable in the world. The chief mining centres in and around the Moor, have been Sheepstor, Mary Tavy, Okehampton, Belstone, Sticklepath, North Bovey, Ilsington, Ashburton, Buckfastleigh; and most of the mines have yielded various ores of iron, though not of commercial value, lead, and occasionally silver. Gold was frequently found by the old tin streamers, in small grains, in the beds of the moorland streams; and it is probable that it occurs, or has occurred, more or less in the beds of all the larger rivers, the debris of the tin streamers in which, by the way, has been occasionally taken for moraines.

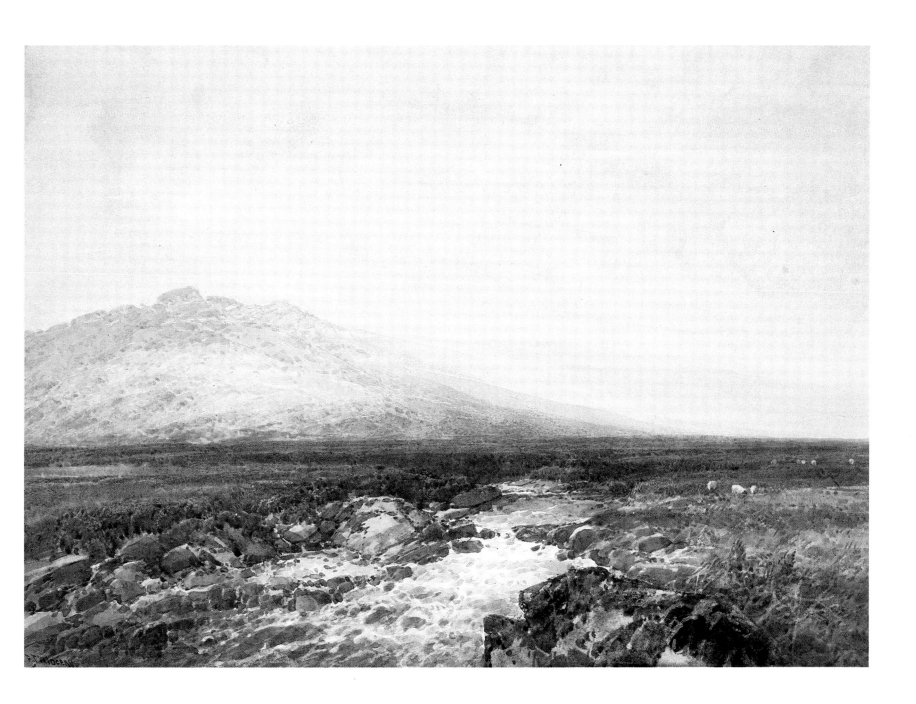

YES TOR

TAKING CASTOR ROCK FOR OUR LANDMARK we shall now bend our steps northwards, and on the western acclivity of the hill from which that conspicuous tor rises, we shall notice an interesting specimen of the hut circle or ruined habitation, surrounded by an external inclosure. By the moormen it is well known as the Roundy Pound, and is situated near a moorland road which forms the boundary between the parishes of Chagford and Gidleigh.

This consists of an external enclosure in the form of a spherical triangle, with an inner circle nearly adjoining the north west side of the outer enclosure. The walls were probably built of upright rough masonry, those of the inner circle have had care paid them in their erection, and the door jambs still remain. The inner circle is thirty-five feet in diameter and the wall about five feet thick. The area between this circle and the outer enclosure, now a confused heap of stones, was divided into six compartments by narrow walls extending from the inner circle to the outer enclosure. Here is a small hut circle ten feet in diameter at the north angle of the outer enclosure, and a small triangular enclosure adjoins the remains of the outer wall of the western side. The late Mr Ormerod has described the foundations of other remains situate about a hundred yards to the south of the Roundy Pound, consisting of small enclosures and two huts which he has named the Square Pound. There are no other huts within a hundred yards of these pounds. At Bovey Combe Head there is an enclosure greatly resembling the Roundy Pound, which Mr. Ormerod describes.

Castor Rock rises high above Chagford, and, standing on one of the outposts of Dartmoor, forms a conspicuous object from a large tract of North Devon, and consequently commands a varied and extensive prospect. From Cosdon in the N.W., to Mardon in the E., the eye ranges round a grand amphitheatre of moor and mountain. Besides Cosdon Beacon, Yes Tor, Watern Tor, White Horse Hill, Warren Tor, Heytor, and East Down above Manadon, are all conspicuous eminences. Haldon, the Blackdown hills, and Exmoor, bound the view in the distant horizon. Chagford "tower and town" are seen on the slope below Middledown in front, with the rocky dells and sylvan wilds of Gidleigh on one side, and the glades and groves of Whiddon Park on the other.

On Castor, besides five other smaller ones, is one of the finest, so called rock basins, on the moor, it is seven feet six inches in diameter at the top, four feet two inches, half-way down, and two feet at the bottom, and is two feet seven inches in depth. This basin was discovered by Mr Ormerod, in 1856, it having been completely concealed by heather and it is now surrounded by iron rails to prevent accidents to cattle. On Middletor, a singular rock on the same common, is another very perfect specimen of the Rock Basin, almost circular in form, and about six inches deep. One side of this tor overhangs at least ten feet, and forms a massive granite canopy, under which the cattle frequently are seen to take shelter.

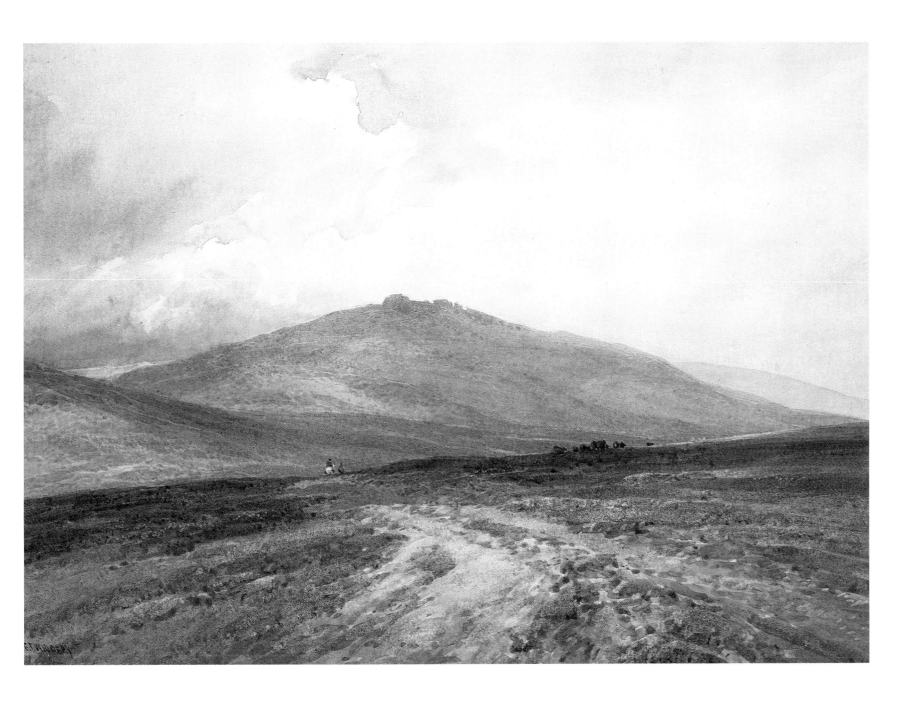

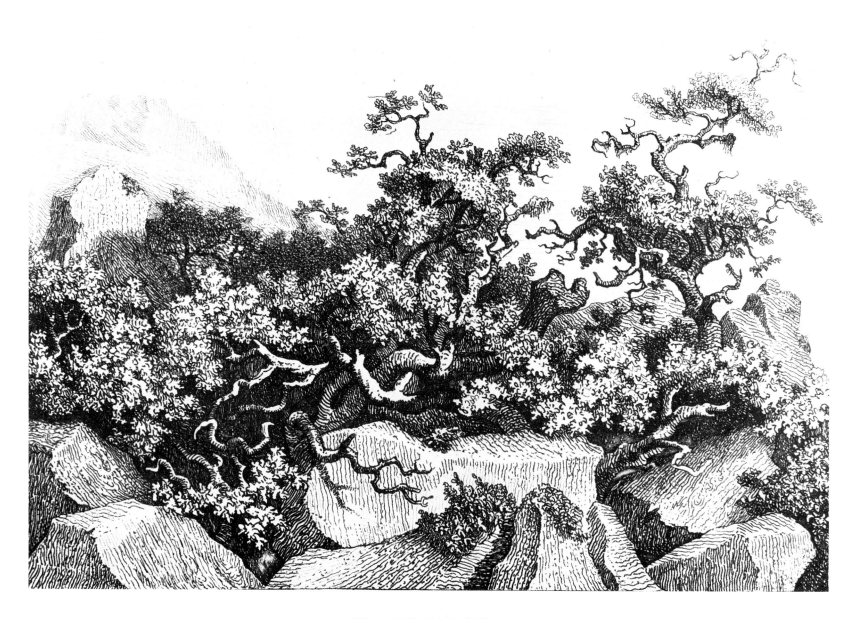

Wistman's Wood, by P. H. Rogers

DARTMOOR AND ITS WRITERS

Late 19th-century Dartmoor writing has received a bad press from contemporary critics. W. G. Hoskins (b. 1908) remarks in his authoritative history, *Devon* (1954), that the county's landscape has inspired only unmemorable poetry and that "even Dartmoor" has failed to produce writing of quality. Other critics point to the superficiality of the writing of this period concerned with the moor.

The authors themselves, no doubt, would have rejected such a view. Quiet literary backscratching was a feature of their commentaries – both for well-established authors and those with reputations to make. This is not surprising given the relatively small number of authors writing about the moor at the turn of the century, the vogue for such writing, and the friendships shared between many of the writers. These friendships were often forged as they worked together on archaeological excavations on the moor, publishing their findings in journals of local history, in local newspapers, or as books.

The aim of the selection of texts that follows is to highlight the work of this "coterie" of writers. The description of Dartmoor is naturally the focus of the work. Through the writing run common themes: people and nature; the weather; the vision of archaeologists; the inadequacy of some historians (particularly those persuaded by theories of Druidism); and the mystery and folklore of the moor. Common in the writing is a brooding sense that each author regards the moor as a great literary challenge. Writers seeking to "encapsulate" the meaning of Dartmoor often start from a position of inadequacy and end with a lame quotation.

It is a feature of the best prose on Dartmoor (and there is good writing in these extracts) that it is done without pretence or artifice. The close community of authors, often living close to, or on, the moor, may have watched each other's writing too carefully at times. But their common bond of subject, and their devotion to spreading a knowledgeable awareness and love of Dartmoor to a wide public, make the best writing characterful and atmospheric.

A number of distinctive approaches to Dartmoor prose were shared by authors around the turn of the century. Many writers were conscious of a tradition of antiquarian publication. The Devon texts often refer to the work of the influential historian Sir Richard Colt Hoare (1758–1838), whose detailed studies of the rich archaeological sites of Wiltshire set a model of scholarship for historians of the moor. Then many writers approached the moor in the guise of investigative travellers, and there is a significant body of travel writing in the form of anecdotal diaries or of straightforward (and often lively) guides to the sights and stories of Dartmoor. Even more compelling are the fictional accounts of the moor, because the range available to storytellers varies from sombre realism to fey pastoralism.

A Perambulation of the Antient and Royal Forest of Dartmoor by Samuel Rowe (1793–1853), published in 1848, was a key work in the antiquarian study of Dartmoor. Its grave tone, and formal multi-clausal style, gave the text claims to authority and it influenced writing on Dartmoor for the next sixty years, during which it stood as the only genuinely wide-ranging description of the moor. The third edition of Rowe's classic text was "revised and corrected" by Joshua Brooking Rowe (1837–1908) in 1896, prompting a further scholarly and fictional interest in the moor by local writers. Brooking Rowe was well qualified to undertake this important editorial task. A nephew of Samuel Rowe, he was well known and respected by his colleagues in the Devonshire Association as an author with a wide range of interests from local ecclesiastical history to archaeology. He trusted and used the advice of other highly regarded local historians such as Sabine Baring-Gould (1834–1924) and Robert Burnard (1848–1920) to assist in the preparation of the third edition of his uncle's book. His edition maintains the dignified style of writing appropriate to such a significant volume (though doing little about some of the more laboured descriptions) and reduces what the editor terms the "saturation" of the book with discredited Druidical theories. The use of the engravings from F. J. Widgery's water-colours to accompany the 1896 edition marks the continued popularity of commissioned illustrations, and Widgery's key position as a favoured artist. The mood of a calm study of the moor expressed by the water-colours signifies how accuracy is important to authoritative pictorial work.

William Crossing (1847–1928) was recognized by readers and colleagues as a leading authority on Dartmoor. His moorland writings were prolific, and like those of Rowe and Baring-Gould, based on a lifetime of research. Crossing's early interest in speech and drama (he wrote pieces for amateur theatricals and formed a professional drama group) certainly influenced his work of chronicling Dartmoor customs and collecting folklore and folk tales. His important *Guide to Dartmoor* (1909) was published at a time when there was in an increasing interest in the moor as a romantic, mysterious location for the tourist. It quickly became a standard reference book, rivalling, and to some extent up-dating, Rowe's *Perambulation*. Crossing's writings for local papers maintained the interest of his West Country audience, and "The Artist" (page 99) forms part of a sequence of writings for the *Western Morning News* at the turn of the century. Crossing's anecdotal style is well suited to serious journalism and he can sometimes spin out a passage of writing and say very little in a volume of words. His chapters on "A Dartmoor Thunder-storm" (page 101), from *Amid Devonia's Alps* (1888), and "Cranmere" (page 104), from *Gems in a Granite Setting* are fine examples of this loquacious and, again, eclectic style.

The Rev. Sabine Baring-Gould matched Crossing as a prolific writer and shared his enthusiasm for collecting Devon ballads. Many of his works were based on Devon tales, landscapes, and reminiscences, and the range – hymns, travelogues, novels, poetry, and historical writings – is dauntingly comprehensive. J. M. Barrie, in a criticism of Baring-Gould's novel of Dartmoor life, *John Herring*, rather disparagingly pointed to the enormous range of the author's "general information" before going on to criticize his pompous attitude to the working class and some "ignoble views of life".

Baring-Gould worked closely with Robert Burnard at the end of the 19th century on an intensive programme of archaeological work carried out by the Dartmoor Exploration Committee, with a straightforward ambition to end conjectural theories about prehistoric life on the moor and to base new arguments on well-researched archaeological evidence. There is a freer and more relaxed approach to recording evidence in "Jonas Coaker" (page 107), in Baring-Gould's *Dartmoor Idylls* (1896). This is a lively piece of documentary writing which reveals the author's sensitivity in recording alterations in the landscape of the moor and setting this pattern of changing nature against the reminiscences of the moorman Jonas Coaker. The conclusion is a strong piece of sentimental writing and it is genuinely emotional.

Eden Phillpotts (1862–1960), in his long series of romances and novels based on all aspects of West Country life, also brought Dartmoor to an enthusiastic audience. Phillpotts wrote novels, poems, and plays with equal facility, although, as with Crossing's less successful works, one often has a feeling of tiredness about the writing which must be due to the sheer repetition of subject matter. There are passages in some of his works which strive for poetical description without any clear sense of place, and his prose is often sombre and sententious.

Late-19th-century travel writing about the moor is in the main simpler, less pretentious, and more direct. This may be due to the travel writer's need to keep a reader's attention by enthusiastic discourse and to keep to a style of writing that is factual rather than imaginatively elaborate. *A Handbook for Travellers in Devon and Cornwall* (1865) (page 110) combines a sense of the spirit that must have been felt by pioneering tourists on Dartmoor with much sensible and unpretentious historical writing. As befits a level-headed author, there is a wry summary of the folklore associated with pixies. And the anonymous writer rarely lets any prejudices show, betraying Royalist sympathies only when referring to one of Cromwell's West Country military adventures as "a piece of Puritan scandal".

Tickler's *Devonshire Sketches: Dartmoor and its Borders* (1869) (page 114) has an occasional anti-establishment stance to enliven an otherwise deliberate text. "Tickler" was a pseudonym used by Elias Tozer (1825–73), a West Country journalist and newspaper proprietor. Like many Devon writers of the period, he was prone to quote Rowe or Carrington to amplify his text when short of inspiration or fact, although both authors come in for some stern criticism for their views on Druidical idolatry.

Maria Gibbons (1841–1900), a travel writer from East Budleigh, wrote popular books in a much gentler spirit. *"We Donkeys" on Dartmoor* (page 116) was one of a trilogy of Devon travel books from the late 1880s, appearing first in the *Devon and Exeter Gazette*. Gibbons's narrative is modest, anecdotal, unassuming, and sometimes simply flat ("the wonderfully extensive view from Cranbrook" is hardly evidence of a penetrating eye or pen). There are occasions when Gibbons's breath is clearly taken away by the serene beauty of the moor and she writes then with keen and emotional observation.

R.D. Blackmore (1825–1900) adopts a more measured air in his novel *Christowell: A Dartmoor Tale* (1882) (page 117). Fictional writing about the moor at the turn of the century allows each of the authors in this selection of extracts more freedom of expression than their antiquarian or travel-writing colleagues. The landscape or folklore of the moor can be seen through the eyes of a narrator or character, with the result that there are fewer passages of bombastic praise or mute admiration and more of sincere emotion. Blackmore's aim in *Christowell* was to draw a picture of a bygone time in a remote and fictitious Dartmoor village and to use the literary methods of melodrama and pastoral to impart a feeling of longing for that way of life. The changing moods of Dartmoor provide a rich backdrop for the book and the description of the village in this extract is carefully and grandly observed. Eden Phillpotts (who had been encouraged in his own career as a writer by Blackmore) noted his peer's studious literary self-criticism. There is indeed a more professional confidence about this novel, in marked contrast to much moorland writing of the period.

The mood of the opening chapters of *Christowell* is one of unalloyed pastoral romance, where characters are unerringly too good to be true (and the Dartmoor weather is suspiciously benign). F. J. Widgery's illustrations for the 1893 "Devon edition" of the book catch that mood. The fictional tales by Eva C. Rogers locate the moor as a place of mystery, mists, and evil-doing. Rogers is now little read, and little is known of her life, although her *Dartmoor Legends* (1898) merited an introduction by no less an authority than Robert Burnard. Burnard's own *Dartmoor Pictorial Records* (1890) (page 120) was a major and comprehensive photographic account of the moor accompanied by some down-to-earth prose.

Lethbridge of the Moor (page 123), another little-known work and by a little-known writer, Maurice Drake (1875–1923),

follows the melodramatic style in Blackmore's West Country fiction. Drake was an Exeter author with a small literary output from the first decade of the 20th century. His novel of Exeter life, *The Doom Widow*, was dramatized and considered by a contemporary reviewer to provide "very acceptable entertainment". Much the same can be said of the Dartmoor book, although Drake's account of prison life is a rare fictional excursion into one of the moor's most enduring, and least endearing, symbols of hopelessness. This passage of writing cuts across some of the more typical sentimental pastoral prose about the moor.

So too does the most famous account of Dartmoor, that given by Sir Arthur Conan Doyle (1859–1930) in *The Hound of the Baskervilles* (1902). Here the moor is host to secrecy, murder, and terror. Because Conan Doyle uses the symbol of the moor to accentuate and dramatize points of plot in a conventional detective story there is no over-reliance on grand or long-winded set pieces of natural landscape. Conan Doyle's successful and highly skilled technique is to rely on the compelling return of a small number of persuasive images and sounds (the deadly Grimpen Mire; the "long, low moan" of the Hound) to convey the unique atmosphere of the moor.

The Hound of the Baskervilles will remain as one of the most enduring testaments to the spirit of Dartmoor because of Conan Doyle's well-judged craft of understatement. The moor is glimpsed in his novel, rather than laboriously described, and its effects worked through the lives of its characters. Antiquarians, amateur historians, and travel writers, as well as other novelists, all gave different perspectives to Dartmoor in the writing of the period, and in the variety of these approaches is indicated the potency and challenge of the moor as a fitting test to any writer with aspirations to literary fame.

WILLIAM CROSSING
from The Western Morning News

The Artist

LORD MACAULAY, in noticing the illustrations in Southey's edition of Bunyan's *Pilgrim's Progress*, said that it was with unfeigned diffidence that he pronounced judgement on any question relating to the art of painting. It is just possible that there are those who, possessing even fewer qualifications for such a task, do not share that feeling, and lest I should be reckoned as one, let me at once explain that I have no intention of entering upon it. I merely desire to make a few observations on the work of those brethren of the brush who have sometimes chosen Dartmoor for their subject, or have made it their particular study. I make no pretensions to be an art critic; I only claim, knowing the moor as I do, to be able to tell whether the artist who has painted it has caught its spirit or not. If it were necessary that a man should be a painter in order to know a good picture when he sees it, I should forbear to write another word on the subject, for my own efforts with the brush, as I have already mentioned in this series of articles, have been limited to certain productions of the slap-dash order, a signboard for an inn in the Forest, and a picture executed on the bottom of a table drawer. I congratulate myself now on my choice of a position for the latter.

Northcote declared that Dartmoor was not worth painting. It is only necessary to turn to the works of those artists who have made it their study to understand why this opinion was not shared by others. It is possible to conceive a man, visiting it for the first time and finding himself enveloped in a dense mist during the whole of the day, drenched to the skin and ankle-deep in mire, arriving at such a conclusion, but no one who has seen it under more propitious circumstances would be likely to do so. It would have been much more true had he said that it was not everyone who could paint Dartmoor. Not a long while since an artist who had found work for his brush chiefly under the sunny skies of Italy turned away from the moor with a feeling almost akin to despair. "I should have to tramp over it for at least six months," he said, "before I could venture to begin painting it." And herein lies much of the secret of success. It takes time to know Dartmoor, and the artist who does not know it ... can never hope to paint a satisfactory picture of it.

It is not to be expected that the artist, any more than he who works with the pen, can give a true portrayal of Dartmoor in all its moods. There are times when Nature refuses to be interpreted. The sunbeam glinting through the bracken, and dancing upon the rippling water hurrying from the turbulent foam that gleams between the moss-coated rocks seeking to check the river's flow, or the pearls that hang upon the grass at early dawn, are not to be faithfully transferred to canvas. But he who has carefully marked the varying effects of cloud and sunshine upon this land of tors and brawling streams, who has caught its colour and its atmosphere, can give us such a picture that when we look upon it we are able to exclaim, "Here indeed is Dartmoor".

And in justice to the artist it must be noted that he has to refrain from depicting many of the beautiful effects that he sees, although well able to do so. And this for the reason that his picture would not be regarded as faithfully representing Nature. Who that has wandered on the moor at daybreak in the summer can dispute this? Take your stand upon some rocky height and look down into the deep valley filled with morning morning mist. How wonderful is the colouring. Its shaded portion is a pure ultramarine, and as it slowly rises in fantastic wreaths and is lighted by the rising sun, the lines are gorgeous. On one side of the valley the tors are "bathed in floods of living fire"; on the other they are silhouetted against a golden sky and show as one great mass of unbroken purple. To depict this the brightest colours of the palette would be needed – and what would be the effect of these? But it is, nevertheless, a picture that the old moor can show, though no artist would care to reproduce it. Similarly a sunset on the moor is sometimes such that most would shrink from painting, for those who had not seen such a one would doubt the truthfulness of the portrayal. A lady who was looking at one of Turner's pictures ventured to remark to the painter that she had never seen a sunset like the one it represented. "No, my dear madam," replied Turner, "I don't suppose you have. But wouldn't you like to?"

In every part of Dartmoor will the artist find subjects for his pencil, though it is on its verge that the most charming scenes occur. Here in that narrow borderland between the cultivated country and the stony hills, where the streams sweep down to the wooded vales, are picturesque old farmhouses, grey stone bridges often partly covered with ivy, furze brakes through which a path perchance leads to the commons beyond, river banks where slender ash trees bend over the water, and a hundred other objects that form good material. Further away from cultivation are great breadths of moor clothed with heather, and grassy slopes dotted with boulders, often beautifully coloured; streams where cascades are met at every turn; and hills crowned with the

grey tor. No matter where he may wander, he who has an eye for the beautiful in Nature will find it on the moor. Even in its recesses, where there is nothing of life, and the new-born streams filter slowly through their boggy channels giving no promise of what they are soon to become, there are spots, like bright oases in the desert, that offer a reward to those who will be at pains to seek them.

John Syer and William Widgery were the first to disprove the statement of Northcote; they were the pioneers of Dartmoor painting. Those who know the moor must admit that their pictures show that they studied it in its varied moods. They may not always be correct representations of places, but the features introduced never fail to be true to Nature. In this connection Mr Widgery was wont to observe, "I don't want a portrait; I want a picture." One day, when he was busy painting, a passer-by who had a slight acquaintance with him stopped to look over his shoulder at his work. He could not recognise the view before him as that which the artist was painting. In the foreground instead of a marsh there appeared a rocky stream. "Mr Widgery," said the visitor mildly, "there is no river at the foot of that hill." "Isn't there?" returned the artist, without looking up; "well, there ought to be." Widgery built a house at Lydford, now a private hotel, and thus being close to the moor he was able to study it not only in the golden days of summer, but in its grander aspect under a stormy sky. He died in 1893, and his mantle has fallen upon his son, Mr F. J. Widgery, who paints Dartmoor with excellent effect.

Every artist appears to be more or less of the opinion of William Widgery, that pictures, and not portraits, are wanted. I have never quite been able to understand why. We all know that objects occur in certain views that would utterly spoil a picture if they found a place in it, and no one even with the faintest instincts of the artist would wish to see them there. In such a case it is therefore better that the picture should not be a faithful representation of the scene. But why should it not be so where no such objects occur, and incongruous features are not found in the view? There would be no reason, further than that it might prove misleading, and the artist could very well be allowed to believe that he was able to improve upon Nature. But when it is put forward as delineating some particular spot we do expect that it will bear something more than a general resemblance to it. I have had pictures put before me with the remark, "Of course you know that", when I have not been able to form the faintest notion what places they were supposed to represent, though explanation proved that I was quite familiar with them. I have no doubt that every painter will consider that I am altogether wrong in my ideas on this matter. The only artist who may possibly agree with me is the one who uses the camera, and even he, it is more than likely, would be only too glad to follow the example of the painter

were such possible when a lamp-post or a factory chimney obtrudes itself on the view he wishes to photograph. In this connection the opinion of the Scotch peasant may be recorded. The story goes that one of our leading artists was painting in the Highlands, when a peasant approached, and watched him at his work. "Mon," he asked at length, "do ye never use a camera?" "No," was the sharp reply. There was a pause, and then came the remark, "It's a hantle quicker." "I suppose so," said the artist, working busily. The man began to move off, but not without firing a parting shot: "An' it's mair like the place!"

Dartmoor is a favourite subject with several present-day artists, who for the most part exhibit a good knowledge of the region. No-one who is not a stranger to it can look upon the pictures of Mr Charles E. Brittan without being conscious that they breathe its spirit. They are distinguished by a charm of colour, while his effects of light and shade on cloud are wonderful. Who that has seen Mr Baragwanath King's border scenes will not admit their fidelity, or that of his pictures of the moor when it wears its summer garb of purple? The cattle and sheep of the hills, and the half-wild ponies which roam over it, have a faithful delineator in Tom Rowden; while W. S. Morrish, a keen observer of Nature, possessing a full knowledge of the country he loves to paint, has given us some splendid pictures of the glorious heather which is its pride.

Probably none of our Dartmoor artists know the moor better than Mr A. B. Collier, who was painting it more than half a century ago, and still continues to do so. And it is certain that no artist is more true to his original. In his pictures the features of the moor are never exaggerated; one does not find the tors made to look like the Grampians. His endeavour is to depict the moor as it is, and in this he is not unsuccessful. Another among our older artists is Mr G. H. Jenkins, whose works show how closely he has studied Dartmoor. The pictures of Mr Arthur Enock, famous for his evening scenes, and Mr J. Barrett are well known, and will always claim attention. While they continue to use the brush our West Country highlands will not want faithful delineators. Mr Eustace A. Tozer makes a special study of sunrise effects and Dartmoor mists, and his work shows much knowledge and observation. His attention has been chiefly devoted to that part of the moor made so famous by William Widgery. His studio is close to the ancient keep of Lydford Castle, and a walk of ten minutes will take him to the commons. Being thus so happily placed Mr Tozer has opportunities for studying Dartmoor at all times and seasons, and that he has made good use of them his works amply testify.

Although the majority of our Dartmoor painters depict the moor in its summer dress, I cannot but think that the late E. M. Wimperis, sometime vice-president of the Royal Institute of

Painters in Watercolours, was right when he said that it did not look so well in sunshine as when the mist wreaths hung about its tors. Faithful to his convictions he has given us many fine pictures of the moor when the rain is beating its sides, or when eddying mists half shroud the hills. Dartmoor at such a time looks grand and mysterious, and if its spirit can then be caught the effect is wonderfully striking. But this cannot always be done; the artist perhaps is not on the spot. Naturally he loves the fine weather, and does not turn his attention to Dartmoor when the cloud bursts upon it, and yet Mr Wimperis said that the most valuable notes he had ever taken in his life was when he was wrapped up in a mackintosh; he did not believe, he said, in being a fine weather artist. Whether it is owing to other circumstances, or to the holding of a contrary opinion to that of Mr Wimperis I will not pretend to say, but certain it is that in any exhibition of Dartmoor pictures the studies are, with few exceptions, those of summer effects. Gorse and heather and sunlight we have in profusion, but how few grey pictures. Stormy effects may not be too pleasant a study, but they should not be altogether neglected. The Dartmoor artist is undoubtedly much advantaged by living near to it. Mr Brittan now resides at Dousland; Mr W. S. Morrish, as is well known, lives at Chagford; and Mr Tozer, as already mentioned, finds in the village of Lydford a congenial habitation, notwithstanding that Risdon refers to it as "a place where no nice nation would have made choice". But Risdon also speaks of it as being subject to the Dartmoor storms, and this is just what Mr Tozer wants. When the sort of weather arrives – and he has not often to wait long for it – that would detain most men indoors, he takes a leaf out of the book of Mr Wimperis, and puts on his mackintosh, walks up the banks of the Lyd and takes notes, a "chiel amang" rocks and dripping fern. It might be imagined that he gets a little damp. Not a bit of it; his clothes do, but nothing can damp the ardour of a lover of Dartmoor.

Painted on the shutters in a room in the Duchy Hotel at Princetown are some exquisite little gems. I have seen it stated that one of them is by Mr B. W. Leader, whose brush has so ably depicted Dartmoor, but Mr Aaron Rowe informs me that he believes it is the work of Mr A. B. Collier, who painted it when staying at the hotel some thirty or forty years ago with Mr Leader.

If there is sometimes a tendency on the part of the Dartmoor artist to exaggerate, it is a fault easily accounted for. The worker with the pen falls under the same reproach, for are not his pictures sometimes overdrawn? Those who are in love with their subjects are naturally prone to magnify their beauties.

Fifty-two years ago a party of six artists, Mr R. P. Collier (afterwards Lord Monkswell), his brother, Mr A. B. Collier, Field Talfourd, Samuel Cook, Philip Mitchell, and A. C. Bell, were gathered in the snug parlour of the Three Crowns at Chagford. The curtain has been drawn upon that memorable evening by the first named, who wrote an account of it in verse in the visitors' book. This has since been much mutilated, and some of the lines have been lost. I have been favoured with a complete copy by Mr A. B. Collier, from which I extract two verses.

Six artists forlorn, nor shaven nor shorn,
 Of fierce and romantic costume,
Who their moustaches curled at this pitiful world,
 Here indulged their Byronical gloom.

In whisky and water, songs, riot, and laughter,
 These misanthropes took their delight;
And bright flashed the joke through the thick wreathing smoke,
 That vexed the dull nose of the night.

WILLIAM CROSSING
from Amid Devonia's Alps

A Dartmoor Thunder-storm

ONE BEAUTIFUL MORNING in the summer of the year 1878, when I was staying for several months on the moor at Hexworthy, I set out accompanied by my wife, taking with us our pet dog Snap – a thorough little Dartmoor ranger – for a ramble over some of the high ground between the upper waters of the East and West Dart.

We proceeded by the road past Dunnabridge Pound, meeting the postman on our way, who gave us our letters, and then struck across the common towards Smith Hill, a small farm house on the banks of the Cherrybrook, and not far above the bridge which spans that stream near the enclosures of Prince Hall. The Cherrybrook is a tributary of the West Dart, the point of confluence being at no great distance below Prince Hall bridge. Passing Smith Hill we went across the new-take in the direction of the powder mills, and just before reaching the Princetown and Moreton road, we heard the low rumbling of thunder. Presently the sky became overcast, great black clouds covering the face of the heavens, and entirely shutting out the sunshine, while heavy drops of rain warned us that it would be well to seek shelter from the coming shower. Before, however, we could gain the building which lays near the road at the entrance to the powder mills the

shower descended, the distant thunder still rumbling across the sky. Seeking the shelter of the new-take wall we crouched down while the shower continued, "waiting till the clouds rolled by", which fortunately did not tax our patience, for shortly, as if by magic, struggling beams of sunlight burst forth, and soon all was bright and golden as before.

This, however, did not continue long, for hardly had we gained the road, when again the gathering clouds warned us that we were to expect a repetition of the downpour, and the low muttering of the thunder once more was heard. Hastily making our way to the building just referred to, we took shelter under its roof, and not a moment too soon, for barely had we reached it than the rain again descended in torrents, and continued for some time.

I now began to think we should have to give up our contemplated ramble and return to Hexworthy, but after a time the sky once more cleared, and the rain ceasing the bright sun shone forth in all its glory, giving us hope of a fine day. Leaving our place of shelter we betook ourselves across the common behind Cherrybrook Farm, and ascended the hill, with Crockern Tor on our left hand. There was now no signs of further showers, everything looking bright and clear, and reaching the summit of the hill, and pausing awhile to admire the beautiful moorland prospect around us, we made our way along the ridge to Longaford Tor.

This tor, which is a very prominent object for a great distance around, is situated on the hill to the eastward of Wistman's Wood, and is of a conical form, presenting a very striking appearance, from whichever side it is viewed. We clambered up its precipitous sides, and on the summit, where there is a tiny plateau of fine grass, we spread our luncheon, and while discussing it, also feasted our eyes upon the attractive expanse of moor which that elevated spot commands. Many and many a tor is to be seen from Longaford, and immense stretches of wild heath and fen on every side. Miss Sophie Dixon in her work *Castalian Hours* has some charming verses on this tor, which are most appropriate to our musings on that hoary pile of granite rocks.

> Here, seated on thy rock-built tower,
> – A place of ancient days remote –
> Our heart hath felt thy mountain power
> Our eyes thy mountain prospects note;
> The mists that o'er far summits float,
> The granite crag at distance viewed;
> Where man himself but looks a mote,
> Amid the Solitude!
>
> The gush of wild-winds as they spring
> Low murmuring round thy heathy side,

> A fresher incense seem to bring,
> A purer tone of joy provide;
> And as along our brow they glide,
> Methought in every touch to trace
> A spirit felt, but undescried,
> – The Genius of the Place.
>
> What dreams are ours, thus pondering mid
> The Desert all around us spread!
> Half seen in light, in shade half hid,
> Dusk vales below, rocks overhead;
> And where the cataract flashing dread
> Boils up in its tremendous glee, –
> By the blithe crowd unvisited,
> – Yet sought and loved by me.

Miss Dixon wrote many poems on subjects of interest connected with Dartmoor, all breathing of love for the "old, wild forest", and her descriptions of the scenery are exceedingly faithful and full of poetry. Two interesting works, consisting of Journals of Excursions on the borders of Dartmoor, also emanated from her pen, and were published at Plymouth, in 1830. She was born at Plymouth, but for some time made the moor her home, her delight, as evinced by her writings, being to wander over its wild hills. The preface to her book, *Castalian Hours*, is dated from Dartmoor, the 18th December, 1828; her death occurred in 1855.

Descending the steep sides of Longaford Tor we pursued a northerly course, and passing Higher White Tor, we reached the wild stretch of boggy land known to the moormen as Row Tor. Row Tor itself is further to the westward, and why this name is given to this portion of moor, I am unable to say. It is comprised between the upper waters of the East and West Dart and the new-take wall that runs along the hill side behind Archerton and the powder mills. The greatest part of it is very boggy, and it is of an extremely wild and desolate character, though its solitudes have been at some time invaded, for vestiges of ancient operations are not wanting on Row Tor. Now, however, it is forsaken, and in the worst of its miry spots is shunned by the cattle that range the moor. I remember on one occasion, when making my way over the northern portion of this boggy tract, from the East Dart below Cut Hill to the valley of the West Dart, starting a fox in the middle of the bog, and to observe the way he made off over the miry ground, on which I was obliged to tread with the greatest of care, made me quite envious of his powers of getting over such rough country.

I have mentioned the new-take wall that runs behind Archerton and the powder mills, which brings to my recollection a curious accident which befel a Dartmoor man of my acquaintance, in climbing over it. He related the circumstance to me,

several years ago, when we were seated one afternoon in a combe called Deep Swincombe, near to a little mining hut, which I had been examining, similar in construction to the one I have mentioned as existing on the Erme, near Staldon Barrow. There is a curious trough in front of it, which was used in all probability for purposes connected with the preparation of the ore, but the moor-men around will not see anything other in it than a feeding trough, and in the hut nothing more than a stye, and as a consequence the little hut is locally known as the "pigs' house". From our position near it we could look across the moor, and see the new-take wall behind the powder mills, some four miles distant, and in the course of our conversation my Dartmoor friend mentioned the circumstance in question. It seems he was returning homeward one day, when, in attempting to climb the wall, one of his fingers by some means got jammed between two stones, and it was in vain that he endeavoured to free himself. Having only one hand at liberty he was unable to move the stones, and though he pulled with all the force at his command he could not extricate his hand. At length believing he was really caught fast, and knowing that it was useless to think of waiting until any person might happen to pass that way, he pulled out his knife with the intention of releasing himself by severing his finger. While quite determined upon performing this surgical operation upon himself, our friend was, of course, in no violent hurry about it, and thought he might as well make one more effort for freedom before resorting to such an extreme measure. Accordingly there was more pulling and tugging at the unlucky member, this time, fortunately, with success, and our Dartmoor friend came out of his unpleasant predicament with no worse injury than a very sore finger.

I venture to think my readers will not be inclined so much to pity this unfortunate wight, as to look upon his accident as a retribution, when they learn that he was no other than the self-confessed despoiler of the old bridge at Bellaford.

It must, of course, have been between very large stones that the finger was caught, otherwise it would have been no difficult matter to have toppled a portion of the wall over, and so have freed the hand. As a rule, however, these new-take walls are composed of stones of no great size, and these being of rough, uneven shape, they do not lay closely together, so that it is not generally a hard task to move them from their position. But there are some walls on Dartmoor the stones in which are of an exceedingly large size, and of such no better examples are to be found than those constructed by John Bishop of Swincombe. By the side of the Ashburton Road, between Two Bridges and the Cherrybrook, may be seen one of his buildings, the stones, or rather blocks, composing it, being very large indeed, and of good shape, so that an exceedingly regular piece of building has been produced, quite different to the generality of these new-take walls.

No mortar is ever used, the stones simply being piled one upon the other, and grey and weather-stained as they are, their appearance is thoroughly in keeping with their rugged surroundings. Some of these walls have been standing for a very long period.

After rambling over a portion of the wild district of Row Tor we found ourselves at the head of the Cherrybrook, and here, sitting down by the little stream, we were once more fain to open our wallets, and satisfy the hunger which had been created by the keen air of the hills. It was now drawing on to the close of the afternoon, and since the morning the day had been all that we could desire for the purpose of our ramble, but as we sat resting ourselves by the brookside, we were aware of a rapidly impending change. A death-like stillness suddenly seemed to rest upon all around, a quiet which was not a calm, and which had something almost unearthly in it. A gloom, too, spread itself with great rapidity over the face of nature, the clouds rolling up and speedily obscuring the sun.

Hastily gathering our impedimenta, we made our way quickly towards the hollow, down which the stream rushes to the north-west of White Tor, but hardly had we gained it when the storm burst in its full fury upon us. First a pattering of big rain drops, and then, apparently at no great distance above our heads, a tremendous peal of thunder. The old moor seemed to tremble beneath the shock, and the hills around echoed and re-echoed the deep roar. Vivid flashes of lightning darted out from the inky clouds, and appeared to strike the dark crags which towered near us, and a drenching rain descended with a loud hissing noise. There was no cessation to the roar of the thunder. Peal after peal crashed out from the heavens, all nature seeming as if in the throes of some tremendous struggle. The storm was almost appalling in its severity, and there was no place to which we could turn for shelter from its pitiless fury.

> Heaven aid that hapless traveller then
> Who o'er the *Wild* may stray
> For bitter is the moorland storm,
> And Man is far away.
> Carrington. Ballad of *Childe the Hunter*

We toiled onward through the drenching rain, and as each lightning flash lit up the moor with a blinding glare, followed instantly by a sharp report which rolled around every hill and tor, it was as if the day of doom was at hand. There was a grandeur and an awfulness in the scene which was most impressive, and exposed as we were to the full violence of the storm, and thoughts of our safety being naturally paramount with us, yet could we not

restrain a certain fearsome admiration of the wild battle of the elements. It was an experience never to be forgotten, the artillery of heaven seeming to be arrayed against, and as with a desire of annihilating the grim tors of the moor.

The Cherrybrook rose rapidly, the rain descending in perfect sheets of water, and the ground at the bottom of the hollow was soaked to such an extent that we could proceed but very slowly. But we made the best of our way onward, splashing over the boggy ground, and drenched to the skin, the storm continuing to rage all the time with unabated fury.

On drawing near the water-course – or leat – which supplies the powder mills, we saw that it had overflowed its banks, and the little bridge formed of granite stones laid across it, and which was in our track, was not to be seen, being entirely covered by the swollen stream. This was now so turbid that it was seemingly impossible to discover where the bridge was, but knowing its situation I waded into the water, and feeling about with my staff at last found it, and looking carefully down, could just discern it beneath the dark brown stream. I had to be very cautious in my movements, for the banks being under water, a false step would have plunged me into the leat. Carefully noting the position of the bridge, I returned to the spot where I had left my wife, and lifting her in my arms, again waded towards it, and made my way slowly across, landing safely on the opposite side.

By this time the storm had somewhat lessened, although the rain still continued to descend furiously, but as we plodded on it gradually moderated. At length we gained the Princetown and Moreton road, and entered on the new-takes, on the opposite side, our design being to make for Dunnabridge Pound, where we should strike the road to Dartmeet. Across these we pursued our way, as quickly as the state of the ground and our drenched condition would permit, and on reaching Dunnabridge were glad to have firm ground under our feet once more.

WILLIAM CROSSING
from Gems in a Granite Setting

Cranmere

Where once was a tarn on the lonely Moor,
The springs of Ockment near,
A darksome hollow now is seen
On the hill-top bleak and drear,
And the gossips still the story tell
How Binjie drained Cranmere.

The Legend of Binjie Gear

As THE ALPINE climber's ambition is to make the ascent of Mont Blanc, so the great aim of the Dartmoor explorer is to visit Cranmere. And when he has accomplished his object he finds it to be nothing more than a hollow in the peat bog, and wonders, perhaps, how it is he has always heard it referred to as a pool. But notwithstanding this, he does not return from it disappointed, unless, indeed, he had expected to find nothing less than a lake. And the reason of this is that, however unattractive Cranmere may be in itself, the ramble thither has taken him through some of the most solitary parts of Dartmoor, and has enabled him to look upon primeval Nature – to see her in her rudest garb. It is not the pool he thinks of when he has penetrated into the recesses of the Moor and stands beside its broken bank, but of the wilderness in which it is placed. With that he cannot fail to be impressed. Cranmere must be regarded as an objective to be gained not so much for what itself has to show as for what the journey to it will reveal. It is in this that the explorer really meets his reward.

Time was when this black, peaty hollow was filled with water, upon the surface of which, when ruffled by the mountain breeze, the reflected rays of the sun sparkled like myriads of diamonds, and brightened the face of the grim old desert. Then was Cranmere worthy to be counted as one of the gems of the Moor; and because it has lost its lustre, because it has been robbed of its beauty, shall it be refused a place among them now?

A good deal has been written about the difficulty of finding Cranmere, and "travellers' tales" have been told of the ignorance of the Moormen concerning it. But there is nothing surprising in the fact that strangers should fail to discover it, particularly when it is remembered that it cannot be seen until one is within a few yards of its brink. There are numbers of objects on Dartmoor that could not be found any more readily by those unacquainted with the locality. But it has been the fashion to attach something of the mysterious to Cranmere, and to speak of it as concealing itself from the explorer. The latest Ordnance Survey Map has, of

course, done much to remove the difficulty of the search, but it is always best for the stranger to take a guide with him. And this not only that he may be conducted to the spot he desires to reach, but, what is also of importance, that he may learn something of the objects of interest passed on the way. Besides, it is one thing to steer by the map, and thereby possibly flounder into a mire, and quite another to gain your objective in a comfortable manner. On Dartmoor, notwithstanding its openness, it is often true that "the longest way round is the shortest way home".

With regard to the Moormen's knowledge of Cranmere, it is only those connected with the north quarter of the Forest who would be likely to be acquainted with it. Speaking generally, it is in the pasturage alone that the Moorman feels much interest, and such a place as Cranmere, which, situated in the midst of the fen – or *vain* as he terms it – is not approached by cattle, would not claim much notice from him. I remember taking a Moorman to the so-called pool many years ago, who, although he had long pastured cattle in the east quarter of the Forest, and had frequently been within half a mile of it, was ignorant of its exact situation. And I am acquainted with men at the present time, natives of the Moor, who have spent all their days on it, and yet have never set foot on that part of it lying around Cranmere. Still, there are those whose duties take them there, for sheep range over the fen, and are sometimes seen at the pool. I once knew a farmer who for years was a Moorman of the north quarter, and who was at one time in the habit of visiting the pool, or passing close to it, every day. It was not possible to ride over the fen, so his pony was left at some distance off, tethered to a ring-bolt fixed into a rock for that purpose.

Cranmere Pool, to give it the name by which it is usually called, is situated on the northern edge of a boggy plateau, about six miles from Chagford, Okehampton, and the village of Lydford, which places lie approximately to the east, north, and west respectively; Two Bridges is about seven miles south. The tourist who essays to reach it from either of these points must, of course, expect to find the distances rather greater, unless he can contrive to follow the example of the proverbial crow. Around the plateau the most important of the Dartmoor streams take their rise. On one side of it, and less than half a mile east by north of the pool, is the fountain-head of the Taw; on another side, somewhat further removed, and in a south-easterly direction, are the springs of the East Dart; westward of the plateau are two feeders of the Tavy, one rising not quite half a mile southward of the pool; and on the north side of this elevated stretch of fen is the head of the West Ockment. So near to Cranmere is the latter that the stream has been said to flow from it. But this is not so; the springs of the Ockment are in a little hollow many feet below it, though in the days when the pool really was such it poured its overflow into that

river, and this probably gave rise to a belief that in it it had its source. There is no spring in the bed of the mere; the water that at one time filled it was the drainage from the great bog.

But the belief has at all events the respectability of antiquity. As early as the fifteenth century it existed, for William of Worcester, in his Itinerary, speaks of the river flowing below Okehampton Castle, which river, he says, had its source at "Cremere in Thertmore." This is the earliest mention of the lonely tarn, and the form of the name would almost seem to suggest that its present appelation is a corruption of an older one, and that it is not derived, as generally supposed, from the crane. But what is more probable is that the pool did bear the name of Cranmere or Cranemere in the fifteenth century, but that it was pronounced as the ancient chronicler has spelt it, as it sometimes is by the Dartmoor man at the present day.

It has been thought that the name is traceable not to the birds which are supposed to have resorted to the pool, but to the Celtic word *aun*, meaning *water*. But however this may be, the popular idea is that Cranmere means the mere, or lake, of cranes, in which connection it is worthy of note that in the south quarter of the Forest there is also a large tract of fen, where, near an eminence known as Crane Hill, is a hollow that it is plain to see was once a pool. It goes by the name of Ducks' Pool, and was in all probability emptied of its water by the tinners, there being some very extensive workings quite close to it.

Dartmoor men usually refer to the heron as a crane, and in the opinion of ornithologists the true crane once frequented the Moor. But for sixty years previous to 1830, according to Dr. Moore, only four specimens had been procured in Devon. The most recent of these, he says, was a fine male, shot in the parish of Buckland Monachorum, in September, 1826.

Cranmere Pool is irregular in shape, and its size cannot accurately be given, owing to the encroachments of the heather on the west side, where the ground slopes down to the black, peaty bed. But from measurements which I took in 1881, placing the tape on what I considered was the true margin of the pool, I found it to be one hundred and ninety-two yards in circumference. Its deepest part was at the eastern end, where the bank is about ten feet high. Where the heather has not covered the bottom of the hollow, there the peat is seen, wet and spongy in the winter, dry and dusty in the summer. Near the centre is a tiny cairn, erected by the late Mr. James Perrott, of Chagford. Mr. Perrott made no note of the date, only remembering that the work was done during the time of the Crimean War, and that this was so is proved by a communication to the press, made some years ago by Mr. W. L. Munday, of Horrabridge, in which he states that the cairn was formed in 1854. A tin, or other small receptable, was placed in the cairn by Mr. Perrott for the reception of the cards of

visitors to the pool, and a small book was also provided in which they might enter their names. Later on, when postcards were introduced, a custom sprang into existence among visitors to Cranmere of leaving addressed cards there, with the request that the next comer would post them at the nearest office they might happen to reach. As the regularity of the postal system depends very largely on the season and the climatic conditions, it may perhaps be only right to state that occasionally letters are not dealt with quite so expeditiously as is generally considered desirable, but the novelty of receiving a letter posted in the middle of a Dartmoor bog, probably amply compensates for any trifling delay in delivery the recipient may experience.

Quite recently it occurred to two Dartmoor ramblers that the jar with the leaden cover, which for some time had done duty as a receptacle for cards, and as a post-box at the pool, might well be replaced by something better, particularly if the entries made by visitors were to be preserved. The sanction of the Duchy was obtained, and a zinc box and a specially prepared book having been provided they were deposited at the pool. The box is fitted with a deep cover, and is thus well protected from the rain should it penetrate into the little hollow in the cairn. It bears the inscription:— "Authorised by the Duchy. Cranmere Pool. Box containing visitors' book. – H. P. Hearder, Plymouth, 1905." The book is furnished with a waterproof cover, and has the words "Dartmoor", "Cranmere", and the date, "1905", burnt into its edges. On the first page it is set forth that it is placed at the pool with the sanction of the Duchy, by two lovers of the Moor. A hope is expressed that visitors will record their names and impressions. This is signed by Mr. H. P. Hearder and Mr. H. Scott-Tucker, the donors. It is pleasant to think that in these prosaic days there are those who take such an interest in the curiosities of Dartmoor. It is frequently a race to get to the pool, and the odds are that many who try never do get there. Those who succeed and reach the winning-post, as it were, will not improbably grumble at the roughness of the course. But one thing is certain: though they may never become attached to such Dartmoor racing, they will, if they leave their signatures at Cranmere, help to make a book.

The "Urn of Cranmere", as Carrington calls it, is broken, and can no longer hold the "liberal mountain flood". How this came about is not quite known, though more than one story is told in explanation of it. The rift, which is in the northern bank, is many feet in width, and extends down to the bed of the pool, and that this was intentionally made seems certain. One version of the circumstance is that the bank was dug through in a dry season by a miller of Okehampton, in order that the water might run into the Ockment, which stream turned his mill-wheel. Another is

that it was the work of Moormen who, having had sheep drowned in the pool, decided to rid themselves of a source of danger to their flocks. And a third relates how a fox having gone to earth there, an endeavour was made to dig him out, which operation undermining the bank, it gave way beneath the pressure of the water.

But stories more weird in their character attach to this dried-up tarn. Cranmere was once haunted by a misshapen dwarf, the spirit of one who in his "days of nature" had been Okehampton's Mayor. The tradition tells us that one Benjamin Gayer, who in the seventeenth century filled the civic chair, was condemned after death to labour at the impossible task of bailing the water of the mere with an oat sieve. By its margin the unquiet spirit laboured year after year, wearing the form of an ugly dwarf. But every dog has his day, and even Binjie, as he was called, was able to free himself, and to be revenged. Finding a sheepskin on the Moor he covered his sieve with it, and rapidly emptied the pool of its waters. The Ockment rose, and rushed in a mighty flood down the valley, sweeping everything before it, and reaching the town of Okehampton, submerged it, and drowned all the inhabitants. It is probable that the tradition is much older than the seventeenth century, and that it has merely been fastened on to Benjamin Gayer. It is also not unlikely, if there is any truth in the story of the miller, that the latter part of the legend is a modern addition suggested by his action.

Cranmere is also said to be haunted by a black colt, and this, too, it seems, is the restless spirit of Gayer. After his death he reappeared in Okehampton, and caused such annoyance that a number of clergymen were convened to "read him down". But although they brought all their learning to bear and addressed him in various languages, there was no result until one spoke to him in Arabic. That was more than the spirit could stand, and he intimated the fact to the speaker. Being vanquished, Gayer was promptly turned into a black colt, a halter was put upon him, and a man set upon his back with instructions to ride him to Cranmere. The orders were carried out, and on the edge of the great morass that girds the lonely pool, the colt was left, and there, according to the gossips' story, he may be seen to this day.

The rambler over the silent waste on reaching Cranmere finds himself within a hundred and fifty feet of the highest point of the Moor. But though on so elevated a spot, the lowlands are hidden from his sight except in one place. There the receding hills above the valley of the West Ockment afford him a narrow view of far-away pastures. But for that he looks only upon a wilderness, and sees nothing but what Nature has formed.

S. BARING-GOULD
from Dartmoor Idylls

Jonas Coaker

ALMOST IN THE CENTRE of Dartmoor is a singular depression. The hills fall away from all sides towards what seems to have been, at a vastly remote period, the bed of a lake. Nevertheless there is a fissure – a valley to the south through which the Dart, that traverses this basin, has sawn its way. It has had to rasp its bed through a dyke of rock just above that same Snaily House which has been already described, and till that dyke was sawn through, the basin was occupied by a sheet of rippling water. Now, however, that trough is encroached on by farms and fields, a tavern, a church, a Dissenting chapel, and a pair of grand porter's lodges, one on each side of a gate – leading to nowhere. In the time of the Prince Regent, great and chimerical ideas of the importance of Dartmoor filled certain heads, and a certain Squire Hullett resolved on building himself a stately mansion some mile or two up this basin, and began by planting a strip of beech beside the road, and by constructing two porters' lodges. Nothing further was done; even the road up to the site on which his mansion was to rise was not made; and now no one knows exactly where that site was to be.

There is one very interesting feature in this basin in the midst of the moors. It is traversed from east to west by three roads, all belonging to different epochs of civilisation.

First of all, there runs athwart it a paved causeway, that crosses Dartmoor from Tavistock to Bovey, and was in connection with the Fosse Way, that great diagonal line of communication between Cornwall and Exeter, to Lincoln, and thence by Doncaster to York, and so northwards. It was older than the Roman domination. It can be distinctly seen on Dartmoor, and a section at Post Bridge, where it is now in process of being demolished for the building of a wall. It is about six feet wide, and is paved in an arc, the pavement laid on a bed of smaller stones.

Next comes a road of a different kind, unpaved, of no construction whatever, cut by the hoofs of the pack-horses that travelled over it throughout the Middle Ages, and looking like a trench drawn by a huge plough in the face of the moor. That old pack-horse road is as completely disused now as is the old paved causeway.

Thirdly, we have the macadamised highway maintained by the County Council, smooth as a bowling-green, drawn out over the face of the moor like an unrolled measuring-tape.

But the existence of these three roads is not all that is interesting in this basin.

The hills around are, and were still more so, crowded with the remains of prehistoric peoples. Every slope was occupied by a village, surrounded by a ring of wall. Every height is crowned by the cairns and the rude stone coffins or kistvaens of their dead. In almost every field, along almost every track-way, may be picked up their flint chips, scrapers, and arrow-heads.

Now many of these ancient settlements have been converted into plantations or fields, modern walls have been constructed out of the ruined bee-hive huts, on top of the ancient outer wall of defence. Nevertheless, a great number of these remains still cover the sides of the hills; and a word on those who occupied such villages will not here come amiss.

It may be premised that every sort of theory has been propounded relative to these clusters of circular huts. They were shelters from wolves; they were pounds for sheep; they were the habitations of tin miners. They were Druidical circles; they were imitations of the constellations, forming temples for sidereal worship; they were mediæval miners' cottages . . .

The earth is the great book of reference for history. It must be turned over before history can be read. Theories are mere air till established by the pick and shovel. Now pick and shovel have been employed on these villages of bee-hive huts, and they have revealed something quite unexpected – that there dwelt on Dartmoor at a vastly remote epoch, before the written history of Great Britain begins, an extremely rude population in extraordinary numbers, living in the most savage manner, without the knowledge of metals, and with very little, and that very rude, pottery. In the centre of each hut was the fire. The door, always to the south, was so low that the hovel had to be entered on all fours. A segment of the circular hut on the higher side was raised as a dais or platform, with curb-stones, and was bedded with heather and rush, to form a seat by day and serve as a couch by night. All baking and roasting was done in the same manner as Catlin describes as among the Assiniboyne Indians. A hole was dug in the clay floor a foot or eighteen inches deep; this was the oven. Into it smooth pebbles from the river heated red-hot were put, along with the meat to be roasted. If water had to be boiled, a skin was made to line the hole; this was filled with water, and then the red-hot stones were throw into it. Bed-places, hearth-stones, roasting-holes, roasters, remain where left thousands of years ago, before that Cæsar had crossed into Britain, aye, and before the Britons had come over and occupied our isle.

Rising out of the marsh – once a lake – is a gravelly margin, and there this ancient people sat chipping flints brought from afar, to shape them into arrow-heads and scrapers, the latter for the dressing of the skins in which they clothed themselves. And there, where they formed their tools, perhaps three thousand years before the history of our isle begins, may be gathered their broken tools and the chips of flint they cast aside as unprofitable.

On a gentle incline descending towards the marsh is a singular circle of trees, surrounded by a wall; this enclosure goes by the name of Ring Hill. It is, in fact, an old walled village that has had the huts within the wall destroyed. The stones from these primeval bee-hive habitations have been removed and utilised for the construction of a quaint little farmstead, enclosed within rectangular walls to screen its windows and door from the hurricane and snow and hail. There has been a sort of attempt at picturesqueness in the little habitation, for it has been given pointed windows. The court-yard is paved with great slabs of granite, the sheds are buttressed with long posts of the same material laid at an incline to prop up the mortarless walls. Very white geese waddle about, dip their yellow bills into the water that occupies a trough dug out of a huge granite block. The white and crimson saxifrage has made a home of the walls, and rooted itself in every fissure between the stones, and the yellow stonecrop shows as a mass of sunshine on the roof. A rowan, or as it is called in Devon a witch-beam, grows near the cottage . . .

There is no road to this little farm, hardly a path. To reach it one must wade through water, and skip from tuft of rush to hummock of grass in the watery morass that intervenes between the road and the farm, a distance of half-a-mile.

In Ring Hill homestead lived for some years a remarkable man, named Jonas Coaker, and there he died in February 1890.

I visited him in 1888. He was born in 1801, so that he had almost reached his eighty-ninth year when he died. For some time he had been stone blind, and he was tended by an old woman who kept house for him. He was very poor, but patient, gentle, and uncomplaining.

When I saw him, he had but just been got down-stairs, and the old man was seated in an ancient leathern, high-backed chair. The light from the little window illumined his pale, finely-cut, intelligent face, which must have been handsome when he was young, and when the soul could look out of the windows, and when the teeth had not fallen from the gums. Now the golden bowl was cracked, and the daughters of music were low, and the pitcher broken at the fountain.

Jonas was considered, and considered himself, to be a poet. Alas! some persons conceive themselves to be inspired with the divine spirit of poesy if they can make *cow* rhyme with *bow-wow*, and *kitchen* with *pitching*. Jonas, it must be admitted, was a sorry poet, really was no better than an indifferent rhymster. Of poetic fire, of imagination, he had none, but he could knock lines together that jingled like horse-bells, and these pleased the unexacting ears of the moorland men.

Some years ago, Dartmoor was chosen as a field for military operations. Troops were sent down to camp on the moor, and there execute manœuvres, and conduct sham fights.

It was an unfortunate experiment. That year happened to be one of extraordinary wet. The troops arrived, camps were formed, tents pitched, all was prepared, when the rain descended, the windows of heaven were opened and forgotten to be shut again all that summer.

The horses floundered in bogs. The men were drenched to the bone; accoutrements became sodden, boots resolved themselves into pulp, weapons became rusty, gunpowder would not ignite, tempers waxed ferocious. .

On this occasion Jonas Coaker printed a number of his "poems", and went about among officers and privates selling them. The cost was but trifling, and he realised a comfortable sum. Owing to the never-ceasing rain, the soldiers had nothing to do but sit in their tents swearing; and Jonas Coaker's effusions were gladly purchased and even read, because there was nothing else to be got, in mid-moor, in mid-downpour.

On that occasion a company of Highlanders had a bad experience. Farmers' wives and daughters came to the camp offering Devonshire cream. The Highlanders eagerly purchased, and considering what they purchased to be mere curd, each man consumed as much cream at a sitting as if it were broase or curd. The consequence was that the whole company was down with a bilious attack, and the surgeon had to dose the entire kilted body of warriors with blue pill. Racked with headache, with yellow faces and orange-coated tongues, the Sawny brothers languidly cast their pennies to Jonas, and bought his poems, and read them only because too racked with bile to be able to read anything else, nor were they in a condition to appreciate the merits or demerits of what they read.

When I visited the old blind "poet" – let us call him *jongleur*, or jingler of rhymes – I was collecting the folk ballads and songs of the West of England. I found his memory stocked rather with his own productions than with traditional minstrelsy. However, he was able to give me a couple of ancient ballads; one was only recollected because he had recomposed it, and was proud to recite the original and place his own performance beside it for comparison. The alchymist turned base metal into gold. Alas! in this case it was the fine gold resolved into mere dross. One ballad, however, he had not rewritten, and very interesting it was. It related to the Commonwealth, and the exclusion of organ and musical instruments from the service of God. I was able also to

recover the melody to which it was sung, and that was of the same date. The ballad began –

> All ye that love to hear
> Music performed in air,
> Pray listen, and give ear
> To what I shall perpend.
> Concerning music, who'd –
> If rightly understood –
> Not find 'twould do him good
> To hearken and attend.

It proceeds to extol the church music and church musicians of Brixham, and then to relate how a new minister

> In office and in gown
> Strove to put singing down.

Then the ballad writer goes on to argue with this new-light divine –

> Go question Holy Writ,
> And you will find in it,
> That seemly 'tis and fit,
> To praise and hymn the Lord,
> On cymbal and on lute,
> On organ and on flute,
> With voices sweet, that suit,
> All in a fair concord.
>
> In Samuel you may read
> How one was troubled,
> Was troubled indeed,
> Who crown and sceptre bore;
> An evil spirit lay
> On his mind both night and day,
> That would not go away,
> And vexed him very sore.

The ballad writer proceeds to relate how that Saul was advised to send for the son of Jesse –

> Now when that David, he
> King Saul had come to see,
> And played merrily
> Upon his stringed harp,
> The devil all in speed,
> With music ill agreed,
> From Saul, the King, he fleed,
> Impatient to depart.

> Now there be creatures three,
> As you may plainly see,
> With music can't agree
> Upon this pleasant earth,
> The swine, the fool, the ass,
> And so – we let it pass,
> And sing, O Lord, Thy praise
> The while that we have breath.

The self-laudation of the minstrels, their placing themselves on so high a pedestal, and the kick over of the preacher who does not value their performance into company with the Devil, the swine, and the ass, is vastly droll, and perhaps not a little characteristic of village musicians all Christendom through.

Jonas Coaker was at one time landlord of "The Warren Inn", said to be the loftiest situated road-side tavern in England. It stood on a piece of land which the owner regarded as his property through the right of squatting. It had this disadvantage, that it stood on the south side of the road, and was somewhat cheerless, facing the blustering northern gales, and with the sun never entering the rooms. Unhappily, a fire broke out, and the tavern was burnt down. The landlord determined to take advantage of the catastrophe, and rebuild in a more congenial situation, on the opposite side of the highway.

Masons, plasterers, carpenters, hod-men worked away, and the proprietor had pretty well expended all his hard-earned savings on the new house, when just as the last slate was nailed on, the Duchy of Cornwall agent came down on him, and said, "Now you are on Duchy land you shall pay rent for the inn you have built on *our* land without our gracious permission."

The old "Warren Inn" was the scene of the well-known gruesome story of the benighted traveller who was taken in one snowy winter evening and placed in a bedroom where was an oak chest. During the night he woke, the moon shone in at the little casement on the chest. It had dispersed the clouds. His imagination began to work. He was uneasy as to this chest; he got out of bed and crept to it, threw up the lid, and saw a dead man in it. Of course, no more sleep for him that night. Next morning he came down to his breakfast off a rasher of salt bacon, and eyed the cheery host and hostess with some suspicion. At last he ventured to mention what he had seen.

"Oh!" said the hostess, "it's only old vayther. The frost be that hard, the snow that deep, us can't carr'n yet awhile to Lydford churchyard to bury'n, so us has salted'n in."

The traveller pushed from him his plate with the rasher untouched.

Jonas Coaker had a somewhat lively time when landlord, for at that period the Vitifer tin mines near at hand were in full work, and the miners came there to drink and dance and brawl.

On one occasion when he refused to hand out more liquor, because his customers were becoming unruly, they combined against him, drove him from his own door, broached his barrels, and drank themselves dead drunk. Jonas was constrained, as he termed it, to play "hidey peep" on the moor so long as this turbulent crew held his premises, which they did till they had drained the last drop from his barrels and emptied all his bottles.

Then sobriety necessarily returned, and the miners felt they had gone too far. They went back to their work, and Jonas estimated what his loss had been, of course with a margin on his side, and they paid for their spree according to his valuation, which they were unable to check.

Jonas had long legs, a fine physique, and lungs like blacksmith's bellows. On one occasion he ran from Post Bridge to Exeter, a distance of twenty miles, up hill and down dale, without halt, in a little over four hours. He was then aged thirty.

His last occupation was rate collector for the parish of Lydford, the largest parish in England, that comprises within its bounds the major portion of Dartmoor, in fact nearly 57,000 acres.

ANONYMOUS
from A Handbook for Travellers in Devon and Cornwall

Route 11.

Exeter to Ashburton and Buckfastleigh. (Buckland, Holne, Holne Chace).

(The tourist may make his headquarters either at Ashburton or Buckfastleigh, either of which places is well situated for exploring the scenery of Holne and Buckland – among the finest in Devonshire. From Ashburton he may join the South Devon Rly. at the Brent Stat., and proceed to Plymouth.)

From Exeter to Chudleigh the same as Route 10.

2 *Knighton.* Beyond this village the traveller enters the *Bovey Heathfield*, and obtains an uninterrupted view of the barren slopes of Dartmoor. A road on the rt. leads, in 2 m., to

Bovey Tracey (Inn: Union Hotel), a village conveniently situated for a visit to the *Heathfield* and an excursion to the *Heytor Rocks, Houndtor Coomb, Becky Fall,* and *Lustleigh Cleave* (Rte. 12). In early times it belonged to the Traceys, barons of Barnstaple, and has a place in history as the scene of Lord Wentworth's discomfiture by Cromwell, who dashed upon the Royalist camp at night, and captured 400 troopers and 7 standards. So complete, it is said, was the surprise, that Wentworth's officers were engaged at cards, and escaped only by throwing their stakes of money out of window among the Roundheads. This, however, is a piece of Puritan scandal, frequently repeated elsewhere. For the real history see Sprigge's "England's Recovery." Upon an open space in the village are the shaft and steps of an ancient cross, and in the street above it one of the wayside monuments of the same description, now built into a house, called Cross Cottage from the circumstance. It bears the stamp of a cross, which is a modern addition. The *ch.,* ded. to St. Thomas of Canterbury, which has been renovated through the exertions of the Hon. and Rev. C. L. Courtenay, contains a perfect screen and roodloft, a coloured stone pulpit, and some curious inscriptions to the memory of Archbishop Laud and others, placed there by Forbes, the expelled vicar, after his restoration, temp. Charles II. It is throughout Perp.

The *Bovey Heathfield*, as the neighbouring valley is called, is the lowest land in the county, and remarkable for containing deposits of sands and clays which are used in the manufacture of china. It is supposed to have been originally a lake, in which the decomposed granite brought by the rains from Dartmoor was gradually deposited; nature having thus formed the china-clay in the same manner as it is now artificially prepared in Cornwall. The *Pottery*, estab. 1772, is close to the village, and worth a visit, as the manufacture has greatly improved during the last few years. Adjoining it are the pits of *Bovey coal,* or lignite, a bituminous fuel, used only at the pottery, in the limekilns, and by the poor of the neighbourhood, as it emits a disagreeable odour in burning. It is the Norwegian "surturbrand", the driftwood of ancient forests, chiefly fir, which has accumulated in this valley for a distance of 7 or 8 m. The coniferous trees are sometimes found entire in it, together with lumps of inspissated turpentine, called *bitumy* or *bitumen*, which will burn like a candle. It is evidently a deposit of comparatively modern date, as the bark and internal structure of the wood may be distinguished. A very beautiful *ch.,* in which the daily service is choral, has been built close to the Potteries, for the especial benefit of the workmen.

Bovey is situated at the foot of a great ridge of hills, which is

crowned (at the village of *Hennock*, 2 m. E.) with the *Bottor Rock*, an interesting tor of *trap* (its fissures lined with *byssus aurea*), now islanded in cultivation, but overlooking the moor and neighbouring country for miles. The road to Hennock is an excellent specimen of the *Devonshire lane*, frightfully steep in places, and so narrow, particularly where intruded on by the boles of huge trees, as barely to afford room for the *wains* of the country. It will give you rare peeps into valleys; and Hennock itself is exceedingly picturesque, and contains the fragment of an old cross like that at Bovey. A *lead-mine* is worked 2 m. N.E. of Hennock. The *White Stone* and *Skat Tor*, in the same direction, are other rocks often visited from Bovey.

Proceeding again on our route, – the road cross the *Heytor railroad*, used for the conveyance of granite; then passes on the l. the entrance of *Stover Lodge* (Duke of Somerset); and then, on the l., *Ingsdon* (C. H. Monro, Esq.). *Bagtor*, some distance to the rt., among very picturesque scenery, under Heytor, is a seat of Lord Cranstoun's, and was the birthplace of *Ford* the dramatist, 1586. In its neighbourhood is the village of *Ilsington*, and (near the ch.) ruins of the *Manorhouse of Ilsington*, commenced, but never finished, by Sir Henry Ford, Charles II.'s Secretary for Ireland. In Ilsington ch. some of Lord Wentworth's fugitive troops barricaded themselves, after their flight from Cromwell at Bovey Tracey. They left it, however, on his approach.

7½ *Ashburton* (*Inns*: Golden Lion, best; London Inn), one of the old Stannary towns, situated in a valley on the skirts of Dartmoor, which are here characterised by a grandeur and variety of scenery not surpassed in the county. The places to be visited in this neighbourhood are pre-eminently *Buckland* (a seat of the Bastards), and *Holne Chace* (Sir B. P. Wrey, Bart.), grand wilds of rock and wood on the banks of the Dart. *John Dunning*, solicitor-general in 1767, and *William Gifford* (1756), apprenticed in his early years to a shoemaker, but afterwards known as a translator of Juvenal and the editor of the "Quarterly", were natives of this town. In 1782 Dunning was raised to the peerage as Baron Ashburton, a title which became extinct in 1823, but in 1835 was revived in the person of Alexander Baring.

In 1646 Ashburton was taken (without conflict) by Fairfax, who lodged after the exploit at the Mermaid Inn. This is now a shop, but of very venerable appearance. Another old house in West Street, the property of B. Parham, Esq., containing an ancient *oratory* (?), richly decorated with carved oak, is supposed to have been an occasional residence of the Abbots of Buckfast, though without the slightest foundation. The *Town-hall*, constructed entirely of timber, is picturesque and curious. A very curious timber market-house was pulled down some years since.

The *ch*. (St Andrew) is a fine cruciform structure of Perp. date

(the transepts date from about 1679), but has suffered much from modern "improvements". The screen and pulpit have been removed, and the roof and many of the windows rebuilt. The roof of the N. aisle is ancient, and has carved oak timbers with fine bosses – much decayed. The S. aisle contains a tablet with inscription, by Dr Johnson, to the memory of the first Lord Ashburton. The tower of the ch. is 110 ft. high, with indifferent parapet and pinnacles.

The excursion through the woods of *Buckland* and back to Ashburton is about 10 m. (The drives are at present (1865) open *for carriages* only on Tuesdays, Thursdays, and Saturdays. Carriages must enter by Holne bridge – reversing the order in the following description.) You can take the road to the village of *Buckland on the Moor* (3 m.), a continual ascent until close upon the summit of *Buckland Beacon* (rt.), a rocky tor, which should be ascended for a panorama of singular interest. The following objects will present themselves at different points in the picture: *Rippon Tor*, alt. 1549 ft., close at hand, N.N.E.; *Cut Hill*, that lonely hill of bog, on which the Dartmoor rivers have their source (see Rte. 12), very distant, but marked by a pile of turf, N. of N.W.; *Crockern*, and his brother tors, fringing the horizon in the N.W.; *N. Hessary Tor*, alt. 1730 ft., and *Prince's Town*, N. of W.; *Buckland House* and village ch., W.; the huge dreary ridge of *Holne Moor*, alt. 1785 ft., on which the winter's snows make their first appearance, W.S.W.; the *windings of the Dart*, and woods of Buckland, S.W.; the distant but striking eminence of *South Brent Tor* (which serves the purpose of a barometer to persons in this neighbourhood), S.S.W.; *Answell* or *Hazel Tor*, rising from a wood of firs on the other side of the road, and often ascended for the sake of the view, S.; and the little town of *Ashburton*, nestled among its hills, S. of S.S.E. The Beacon consists of a white and close-grained granite. Three low distorted oaks on its western slope will remind the traveller of Wistman's Wood (Rte. 12). Hazel Tor is crowned by a large cairn; and there is a circle of stones (not a hut circle) on the side of Buckland Beacon.

Having descended from this hill, we enter the little hamlet of Buckland, where most picturesque cottages of old red brick are shut out from sunshine by lofty trees; after passing the ch. we turn into Mr. Bastard's grounds by the first gate on the l., and proceed along a drive which will eventually lead us to Holne Bridge. The road makes at first for the *Webburn*, a stream flowing from the moor by Widdecombe, and then turns and winds through the valley so as to accompany the torrent in its course. Soon an old bridge is passed, leading toward *Spitchwick*, seat of the late Lord Ashburton, on the opposite bank. A stream, which has had the run of mines, then enters the valley, tinging the Webburn with its ferruginous hues. At length, after glancing up a steep-sided vista at one spot, and following the narrow roadway along all its ups

and downs and convolutions, we reach the turbulent Dart, and enter a deep and tortuous ravine, where the woods are pierced by rocks, and naked crags crown the hills And here a turn of the road will open to our view the gem of the Dart scenery, – the *Lover's Leap*, a rough mass of slate rising vertically from the river. Beyond it the heights have quite a mountainous appearance, and soar so boldly that their sombre woods of fir are often capped by the clouds. Having passed the Lover's Leap, we reach, in another mile, the Ashburton road at *Holne Bridge*, and from this spot those who are curious in such deposits may trace up the l. bank a bed of gravel, at an elevation of about 8o ft. above the present course of the river, apparently affording evidence of the stream having once flowed at a higher level than it does at present.

Holne Chace extends about 2 m. into the forest of Dartmoor, and skirts the Dart and Webburn opposite to Buckland. The carriage-drive here winds along the valley at a lower level, and the trees were finer (they have been ruthlessly felled within the last few years) than those of Buckland. The banks of the rushing river are fringed with *Osmunda regalis*.

New Bridge, on the Dart, beyond the mansion of Holne Chace, is another spot which should be visited, as the scene is little inferior to that at the Lover's Leap. The bridge is a lonely, picturesque structure, green with ivy, and the river on each side is hedged in with schistose crags and woods. It is crossed by the road to Two Bridges, which immediately climbs the moor by a most formidable hill (the long ridge of rocks, rt., is *Longator*, or the "Raven's Rock"), and again passes the E. Dart at *Dart-meet*, (the confluence of the E. and W. Dart). Those who travel this road will find on *Yartor*, just above the descent to Dartmeet Bridge, a great number of ancient *hut circles* and lines of stones, and from the same spot will enjoy a very delightful prospect in a southerly direction. *Sharpitor*, a height of remarkable beauty, rising l. of the road. Among the remains on Yartor (rt. of the road) is a *rectangular enclosure*, 42 ft. by 11 ft.; nearer the river, a *hut circle*, 38 ft. in diam., with walls 6 ft. thick, and door-jambs 6 ft. high; and a very perfect *kistvaen* surrounded by upright stones. The village was, evidently, of considerable size, and a road appears to have led from it across the river by a bridge, formed of huge blocks of granite, which was standing some years ago. The scene at New Bridge is calculated to give most pleasure to those who come suddenly upon it on descending from the moor, as the confined valley and green woods are a most agreeable change from the long-continued view of naked hills; and the craggy and richly coloured schistose rocks a striking contrast to the grey massive tors of granite. The Dart flows for a long distance in a wild tumultuous stream, and its "cry", in the stillness of night, may be heard far from its banks. It

is subject to frequent and sudden inundation. "Dart came down last night" is an expression often in the mouths of the moor-men, and it is said that a year never passes without one person at the least being drowned in the river. Hence the local rhyme:

River of Dart, oh, river of Dart,
Every year thou claimest a heart!

The admirer of wild scenery will do well to find his way along the banks of the Dart from New Bridge to Dart-meet. This will be a laborious pilgrimage, but one that will introduce him to, perhaps, the very finest points on the river. *Benjie Tor*, at all events, must not be left without a visit. It may be reached most conveniently from the village of *Holne*, where a guide should be procured, as there is no road across the moor. The visitor will find himself unexpectedly on the summit of a lofty pile of rocks, which descend in rugged steps to the river. Beyond rise wild "braes" with equal steepness – their sides strewn with moorstone, and mantled with furze and heather; the grey cone of Sharpitor lifts itself above all. To the rt. the eye ranges freely over Dartmoor, and to the l. across a vast extent of cultivated land to a blue fringe of sea, the Isle of Portland being visible in clear weather. Far below, in the river, are 2 still and dark "wells" known as *Hell Pool* and *Bell Pool*. The scene is strikingly Highland.

The little Dec. ch. of *Holne* contains a carved screen, with painted figures of saints, which are curious and worth examination, and were probably the work of the monks of Buckfast, to whom the building belonged. Holne is so named, either from the holly-trees (*holline*, *holne*) which abound in the chace, and are of very great size, or, more probably, from a Saxon word signifying "deep", "hollow".

The traveller may visit *Dart-meet* by way of New Bridge, passing over Yartor, and return by a road which, skirting *Cumston Tor* (a fine mass of rock on the l.), will bring him to the village of Holne, whence the road is clear to Ashburton (dist. $3\frac{1}{2}$ m.). By this route he will enjoy some fine moorland scenery, especially near a curious old structure called *Packsaddle Bridge*, over a feeder of the Dart.

Another course for a ramble in this neighbourhood is the road through *Buckland* in the direction of Widdecombe. Buckland we have already visited, but a drive of $\frac{1}{2}$ h. beyond this village will bring the traveller to a scene on the banks of the Webburn where he must draw the rein in admiration.

Close to Ashburton (in the first lane to the l. on the Totnes road) is a gate called *Sounding Gate*, as the spot at which an echo, remarkably clear and loud, may be drawn from a quarry opposite. From this lane another branches off to the *Penn Slate Quarry*, an excavation about 100 ft. deep; and in this neighbour-

hood also (1½ from Ashburton, l. of the Totnes road) is a limestone cavern on a farm called *Pridhamsleigh*, running an unknown distance underground, quite dark, and containing pools of deep water. From *Whiterock* (to be reached through a lane and some fields, rt., on the road between Ashburton and Buckfastleigh) there is a fine view over the upper valley of the Dart.

Widdecombe in the Moor, the *Heytor Rocks*, *Houndtor Coomb*, and the curiosities in their vicinity (*see* Rte. 12), can be conveniently visited from Ashburton. – *Berry Pomeroy Castle* is more within reach from Totnes (Rte. 7).

Proceeding on our route:–

3 *Buckfastleigh* (*Inn:* King's Arms), a large village, encompassed, like Ashburton, with short steep hills which characterise this part of the county. It has 4 blanket and serge mills, 2 of which are occupied, and employ about 400 hands. The objects worth notice are, the *ch.*, on a commanding eminence, bounded on each side by black marble quarries. It is rendered difficult of access by 140 steps, and capped with a spire, which is uncommon in Devonshire churches. The tower and chancel are E. Eng., the nave Perp. Remark the rude blocks of granite which form the steps of the tower. The tradition common to churches on high ground belongs to this of Buckfastleigh. It is said that the Devil obstructed the builders by removing the stones; and a large block bearing the mark of the "enemy's" finger and thumb is pointed out on a farm about 1 m. distant. The churchyard is darkened by black marble tombstones, and contains the ivied fragment of an old building, "which could never have been very large; but whether baptistery or chantry must be left uncertain. Apparently it is of E. Eng. date. It stands due E. of the ch., with which, however, it was never united. There are remains of a piscina at the S.E. angle." *R.J.K.* – The *black marble quarries* are now worked principally to supply the kilns. – The ruins of the Cistercian *Abbey of Buckfast*, founded in the reign of Hen. II. by Ethelwerd de Pomeroy (but on the site of a Benedictine house of Saxon antiquity), are situated 1 m. N. of the village, on the rt. bank of the Dart. This was the richest Cistercian house in Devonshire. Edw. I. visited it in 1297; and the abbot supplied 100 marks towards the expenses of the Agincourt expedition. It had one learned abbot, William Slade, famous (circ. 1414) at Oxford for his lectures on Aristotle. He "adorned the abbey with fair buildings" after becoming its head. The last abbot, Gabriel Donne, received his promotion as a reward for the share he had in the capture of Tyndale, the reformer, at Antwerp. He was a monk of Stratford-le-Bow. The ruins of this abbey are inconsiderable, consisting of little more than an ivied tower (part of the abbot's lodgings – the garderobe tower?) close to the present mansion of *Buckfast Abbey*, and the tithe-barn, a building about 100 ft. long,

at the Grange. A part of the abbey site is occupied by a large woollen factory. The woollen trade at this place is probably of great antiquity. The Cistercians were all wooltraders; and a green path over the moors towards Plymouth, known to this day as *the Abbot's Way*, is said to have been a "post-road" for the conveyance of the wool of the community. The modern Buckfast Abbey is Strawberry Hill Gothic, but stands on the ancient vaulted foundations, of E. Eng. date. About 2 m. N.W. of the town is *Hembury Castle*, an oblong encampment of about 7 acres. In the neighbourhood is *Bigadon* (– Fleming, Esq.), commanding fine views over the lower valley of the Dart, towards Totnes. On the estate of *Brook* (belonging to the Earl of Macclesfield) is a Jas. I. house of some interest, and some picturesque woodland scenery.

You can make excursions either from Buckfastleigh or Ashburton to the *Vale of Dean Burn*, and to the village and *Beacon* of *South Brent*. You should also see the pretty view of *Austin's Bridge* below Buckfastleigh, on the road to Totnes, and that of the Dart valley from the summit of *Cadover Hill* (turn up Cadover lane, just beyond Austin's Bridge), a point of view selected by Turner for his picture of Buckfast Abbey, now in the gallery of Mr. Windus of Tottenham.

From Buckfastleigh the road to Plymouth (and to the Brent Stat.) abuts on the southern slopes of Dartmoor.

1 rt. the *Vale of Dean Burn*, of which Polwhele remarks, "it unites the terrible and graceful in so striking a manner, that to enter this recess hath the effect of enchantment." Halfway up the glen are some picturesque waterfalls. One tumbles into a deep hollow called the *Hound's Pool*, of which the following story is told. "There once lived in the hamlet of Dean Combe a weaver of great fame and skill. After long prosperity he died and was buried. But the next day he appeared sitting at the loom in his chamber, working diligently as when he was alive. His son applied to the parson, who went accordingly to the foot of the stairs, and heard the noise of the weaver's shuttle in the room above. 'Knowles,' he said, 'come down; this is no place for thee.' 'I will,' said the weaver, 'as soon as I have worked out my quill' (the shuttle full of wool). 'Nay,' said the vicar, 'thou hast been long enough at thy work; come down at once!' So when the spirit came down, the vicar took a handful of earth from the churchyard, and threw it in its face. And in a moment it became a black hound. 'Follow me,' said the vicar; and it followed him to the gate of the wood. When they came there, it seemed as if all the trees in the wood were 'coming together', so great was the wind. Then the vicar took a nutshell with a hole in it, and led the hound to the pool below the waterfall. 'Take this shell,' he said; 'and when thou shalt have dipped out the pool with it, thou mayest rest – not before.' At

midday or at midnight the hound may still be seen at its work."
R.J.K.

Dean Prior, once belonging to the Priory of Plympton, was the living of *Herrick* the poet, who wrote most of his Hesperides here, and was buried in the churchyard, 1674. (His interment is duly recorded in the register). He was expelled during the Protectorate; but lived to be reinstated under the Act of Uniformity. His poems contain many hits at his parishioners, whose manners, he says, "were rockie as their ways"; but they are full of the wild flowers – the daffodils and primroses – which abound in the orchards and steep hedge-rows of Dean: and he probably found his "Julias" and "Antheas" in the "fair mistresses" of *Dean Court*, a house built by Sir Edward Giles, temp. Edw. VI. It passed by marriage (which Herrick commemorates) to the Yardes; and is now the property of Lord Churston. At the vicarage of Dean Prior are portraits of William Johnson, when a boy (nephew of Sir Josh. Reynolds), by his aunt Fanny Reynolds, and of Mary Furse (niece to Sir J. R.) by *Sir Josh. Reynolds*. To the l. is *Bigadon* (– Fleming, Esq.).

$2\frac{1}{2}$ l. *Marley House* (T. Carew, Esq.)

$1\frac{1}{2}$ m. *Brent Stat.*, where the tourist may join the rly. to Plymouth. (For Brent, and the stations between it and Plymouth, see Rte. 7.)

"TICKLER" (ELIAS TOZER)
from Devonshire Sketches: Dartmoor & its Borders

Grimspound

A lovely day in June was that on which I journeyed to Grimspound and other picturesque portions of the Moor. Starting from Exeter by an early train, with some very lively companions, we travelled on the South Devon line to Newton Abbot, and from thence to Moreton. Ocean and land views on either side, of an exceedingly beautiful and refreshing character, make this journey of itself remarkably pleasant. But when one can enjoy, in addition, a few hours on the Moor, returning to Exeter on the same night, you have crowded into a single day a rich store of happy experiences, which, probably, will never be forgotten. Like the birds, the bees, the butterflies, and the flowers, I revelled in the Summer sunshine, and inhaled with delight the exhilarating moorland air. Hiring a carriage at Moreton, we soon found ourselves on the breezy heights, surveying the distant tors, and gazing, with an infinite longing, across the vast expanse of silent, solitary wastes that seemed to the eye that day boundless and illimitable. Near the road, a few miles on the Moor, stands an ancient granite cross, and further on is a little inn, where we stopped for refreshment. Sending on our carriage, we set out to have a peep at Wistman's Wood. I had seen it in its Autumn costume, and I wished to see it in its fair Summer attire. I was much struck and delighted with its more radiant aspect. The old trees were covered with foliage, as they have been through all the many radiant Summers of the eventful past. The storms of Winter and the shocks of Time seem to have no power over this old grove, where, in centuries gone by, religious ceremonies and worship (called idolatrous by some, but in which great earnestness and reverence were doubtless exemplified) were performed:

> As grows the grass the temples grew,
> One spirit shines their fabrics through;
> Trances the heart through chanting quires,
> And through the priest the mind inspires.
>
> And still the word by seers told
> In groves of oak, or fanes of gold,
> Still floats upon the morning wind,
> Still whispers to the willing mind.

The sight of the old oaks in their livery of green, interspersed with the mountain ash, crowned with blossoms; the dark, flowing river below; and the brown heights above; in association with reminiscences of the solitary and now beautiful spot, that naturally welled up in the mind, touched me with an inexpressible tenderness and glow of delight. Carrington, in his valuable notes to his Poem, speaks of the old wood generally as a "cheerless and forbidding solitude"; and that in "Spring and Summer a little green may betray itself in foliage; but whosoever has the melancholy satisfaction, at any time, of viewing it, must subscribe to the truth of Wordsworth's lines:

> "I looked upon the scene both far and near;
> More doleful place did never eye survey,
> It seem'd as if the Spring time came not here,
> Or Nature here was willing to decay."

Viewing the wood on this bright Summer day I could not agree with either Poet's description of it. Our guide, Mr. Perrott, told me he had never seen the foliage more luxuriant in all the many Summers he had been in the habit of visiting the wood. Carrington, Rowe, and other writers, refer to the idolatrous and "horrid rites" of the ancient Druids. Now, is this true of the earlier worship of the inhabitants of the Moor? Were they not simple sun worshippers, or is not what a writer has written nearer the truth? – "Regions like this, which have come down to us rude and untouched from the beginning of time, fill the mind with grand conceptions far beyond the efforts of art and cultivation. Impressed by such views of nature, our ancestors worshipped the God of Nature in those boundless scenes, which gave them the highest notions of eternity." Verily, there is much nonsense talked and written about the idolatry and ignorance of our forefathers, as compared with what some sanguine people call "this great age of progress and enlightenment". Now, in the matter of worship, I venture to say that that of our ancestors was of a more real, simple, and natural character, than the worship I once witnessed on the Moor, on a peaceful and lovely Sabbath day. I saw in Lydford Church a congregation composed of the parson and clerk, two or three old persons, and a half-a-score of boys. The parson and clerk read, or rather drawled the prayers, which sounded to me more like parrots repeating solemn words by rote, or schoolboys getting over their tasks as quickly as possible, than the earnest, elevating, and spontaneous worship of the soul. I really think that, in many things, the people of England in this century are neither so simple, real, natural, or religious, as those "barbarous forefathers" of ours. Passing away from the old grove, we had a look at Crockerntor, or Parliament Rock, as it is called by some; a glance at the ancient Cyclopean bridge, one of the slabs of which still lies in the water, no one yet having restored what Vandalistic hands removed; and thereafter we rested at Two Bridges. The inn, so convenient to Moorland travellers, was consumed by fire some months ago, but is now rebuilt. It might have been made a more comfortable hostelry, but, as it is, the proprietress does her best to make her guests comfortable. Spirited portraits of "Tom King" and "Dick Turpin", mounted on "chainey" ornaments, adorn the chief room of the house. These "heroes" may possibly have been suggested as appropriate to a locality where the Convict Prison stands. We returned to the little solitary inn before mentioned, from which Grimspound may be seen about two miles off. This interesting remnant of an ancient British town is remarkably perfect. It lies in a solitary region, surrounded by rocky heights, and was no doubt a place of some importance in ancient British times. A strong wall of granite blocks encircle the remnants of old dwellings; and on the eastern side a large stone indicates the spot where a spring rises. "Its situation" (says Rowe) "is on the N.W. slope of Hamildon, on the borders of the parishes of Manaton, North Bovey, and Widdecombe. The wall or mound is formed of moorstone blocks rudely piled up, but so large as not to be easily displaced. The base of this rampart covers in some parts a surface of twenty feet in breadth, but the average height of a section taken at any point would not exceed six feet. With the exception of an opening on the east and west sides the enclosure is perfect, surrounding an area of about four acres. The original entrance is supposed to have been on the south. The vestiges of ancient habitations within this primitive entrenchment are numerous, and occupy the whole area, leaving only one vacant spot at the upper end, which might have been a kind of forum, or place of public concourse, for the inhabitants. A spring rising on the eastern side and skilfully conducted for some distance below the wall supplied the inhabitants with pure water; and the whole presents a more complete specimen of an ancient British settlement, provided with means of protracted defence, than will perhaps be found in any other part of the island. After a dry spring, and a whole month of continuous hot weather immediately preceding, I have found at Midsummer a clear and copious stream issuing immediately from the source; so that it would appear, under ordinary circumstances, the inhabitants would have been always sufficiently supplied with pure and wholesome water. The classical investigator will probably be disappointed at not finding in Grimspound the characteristics of an ancient British town, defended by woods, swamps, and thickets, as described by Cæsar, in his account of the fortified post occupied by Cassivelaunus, where a large body of persons and herds of cattle might be congregated in security. But without raising the question whether, when Grimspound was originally built, these naked declivities might not have been clothed with wood, as some suppose, the present natural circumstances might suffice to account for the different kind of castrametation exhibited in the stronghold of that valiant British prince. The eastern Britons, on the banks of the Thames, had not the same advantage, in point of materials, as their Danmonian compatriots possessed in the granite blocks and boulders of Dartmoor, from which an effectual circumvallation could be speedily formed; to which those aboriginal engineers appear to have deemed it unnecessary to add the further protection of a fosse, since Grimspound is totally unprovided with any kind of ditch, or additional outwork, beyond its single rampart. This is a feature of much significance, and should be duly regarded in our endeavours to ascertain the period of the erection of this rude but venerable fortress. The rampart is doubtless much lower than it was originally built, but unlike many of the *valla* of our hill-forts and earthworks, it has not been tampered with, nor the original design altered by successive occupants.

M. S. GIBBONS
from "We Donkeys" on Dartmoor

Around Fingle Bridge

Having seen the church [at Manaton], we searched out Mr. Perrott, the great Dartmoor guide and authority. He was out, unfortunately, but Mrs. Perrott said she thought her son would serve our purpose, and most excellently he filled his father's place. We told him exactly what time we had to spare, and put ourselves in his hands. What a drive he took us! Over such roads and to such heights as we never believed mortal pony could attain. First he drove us to the top of Hunts Tor, to which, indeed, there is no regular road, and which is a neat little prominence at a great height, with a precipice on each side; but somehow we felt such entire confidence in our driver and his good little steed, that we could, without any drawback, enjoy the glorious view, with the Teign rolling beneath us.

We then proceeded to Drewsteignton, and saw the church dedicated to the Holy Trinity. It is still disfigured by a gallery. There is an old door, which we fancied led to a parvise, and some 17th Century tombs. In the vestry is a handsome table made from the old sounding-board. The belfry rules in the tower are quaint. They are headed, "The Ringers' Articles", and run thus:

I.
Whoever in this place shall swear,
Sixpence he shall pay therefore.

II.
He that ring here in his hat,
Three-pence he shall pay for that.

III.
Who overturns a bell, be sure
Three-pence he shall pay therefore.

IV.
Who leaves his rope under feet,
Three-pence he shall pay for it.

V.
A good ringer and a true heart
Will not refuse to stand a quart.

VI.
Who will not to these rules agree
Shall not belong to this belfrie.
John Hole, Warden

Outside in the Churchyard were some beautiful limes, in full flower, and musical with the sound of bees. We were sorry not to have time to see the famous Cromlech in this parish, the only erect one in Devon. This once fell down, but was restored at the expense of the owner of the property – a lady. It always had the name of the Spinsters' Rocks, being supposed to be the "before breakfast" work of three spinsters.

From Drewsteignton Church we drove to Fingle Bridge. "According to many sound opinions – at variance with others almost as sound – the valley of the Teign, near Fingle Bridge, is the finest thing to look at in the West of England. As in the vales of Lyn or Barle the rugged lines of Exmoor descend in grace, so here the sterner height and strength of Dartmoor fall with beauty, and yet preserve their grandeur. The widenings of the great hills as they interwend each other come down with sweet obeisance to the shelter of the valley. Their rounded heights are touched with yellow of scant grass or grey of rocks; but under the bleak line furze begins, and heather and oak foliage. With rapid steps, as must be down a pitch of such precipitance, the foliage slides from tone to tint, and deepens into darker green. But the play of lighter colours also and the glimpse of lighter stems arise around the craggy openings, and the birth of some fern-cradled rill. Far in the depth short loops of water flash, like a clue to the labyrinth. All this is very fine, and may be found in other places too, but the special glory of the Fingle Vale is the manifold sweep of noble curves, from the north and from the south by alternate law, descending, overlapping one another by the growth of distance, and holding up their haze like breath that floats to and fro between them. These, with winding involution and recessed embossing, in fainter and fainter tones, retired to the dim horizon of the heights." Mr. Blackmore will forgive my long quotation from his work, for my pen would not dare a description when one in such words as these exist.

Fingle Bridge, as well as the picturesque mill which we also visited, are both worthy subjects for the artist's brush. Here we gazed at the grand hill-fort of Prestonbury, towering above in gigantic grandeur; but, as Mr. Perrott remarked, "presently, when we look down upon it, it will look quite a pigmy". It is one of the four Dartmoor camps mentioned by Sir J. Gardner Wilkinson. We began an ascent up the zigzag path, where "Rose" wandered on the day of Lady Touchwood's famous gipsying party. Truly might our driver declare, when we attained the summit, "You've never driven up a hill like that before". The climb to the top of Cranbrook Castle is one we never imagined

could be done in any vehicle but a balloon. Just before reaching the top we waited for some time to study a view as curious and unique as it is beautiful. Here in the coombe beneath the ridges, six hills cross and recross each other, interlacing like the teeth of cog-wheels in this wonderful piece of Nature's machinery. This was "the corner" where a "glorious opening shone" before the eyes of "Rose", and again we will venture to quote from "Christowell": – "At the just height, and the proper turn, to catch the long avenue of winding vale, a grassy knoll gave standing-place and the obstruction of the wood sank down into copse that only paved the foreground. Before her eyes were unfolded the long hazy windings of the Fingle Vale, the loveliest view that has ever filled her eyes." Then we arrived at Cranbrook Castle, where the 25 men "waited till, at the hoisting of a flag, they descended", and by "Dicky Touchwood's orders" performed that dreadful piece of engineering and wholesale poaching of the poor trout.

Cranbrook Castle itself is a particularly interesting old British camp, having a very perfect dry stone rampart with a ditch on every side except towards the river. A "new take" wall on one side rather spoilt the effect, and also spoilt our temper. Here "Romulus" won golden opinions from Mr. Perrott for the exceedingly business-like way in which he proceeded to hunt for rabbits.

After thoroughly enjoying the wonderfully extensive view from Cranbrook, we proceeded to Moretonhampstead, where we looked at the church dedicated to St. Andrew. Among other interesting old tombs are some with very curious carved stones to be found in the belfry. Here are also memorials of some of the French prisoners of war. There is still a "sounding-board" in this church. In one so-called "restoration" the old screen was removed. We believe it is now in a little church near Plymouth. Moreton boasts of a very curious tree formed into a kind of platform, where musicians were wont to perform on gala days. This tree also had been made famous in "Christowell". Who that has read that work forgets the description of "the kindest and most tranquil-minded little town of Moretonhampstead, and the tree in which those exceedingly economical public dances used to be held at such reasonable hours, announced on the morning of the diversion thus: "Ball to-night; Zax o'clock." And in answer to the question, "How much be tickutts?" one heard, "Zaxpince aich – dree vor a zhillun." This tree has, alas? been shorn of some of its splendeur by a circus – probably jealous of its renown – that in passing broke off some of its branches; but it is still a sight to behold.

After this we bade our kindly and interesting driver farewell, and, calling at the inn for our carriage, drove "Nem. Con." joyfully back to Manaton.

R. D. BLACKMORE
from Christowell: a Dartmoor Tale
Lark's Cot

CHRISTOWELL VILLAGE (in full view of which, the horse, cart, and driver, had rested so long) affords to the places above it, or below, fair plea for contemplation. Many sweet beauties of tempered clime flower the skirts of the desolate moor, and the sweetest of these is Christowell. Even the oldest inhabitant cannot, to the best of his recollection, say, whether he ever did hear tell, that the place was accounted beautiful. He knoweth that picture-men do come, and set up three-legged things, and stand, as grave as judges, to make great maps, like them that be hanging in the schoolroom; but he never yet hath known any odds to come of it; the rocks abide the same, as if they never had been drawed, and the trees – you may look for yourself, and say whether they have fetched another apple. For when the Lord rested on Saturday night, His meaning was not, that the last of His works should fall to, and make strokes of the rest of them.

Sound sense of such lofty kind is the great gift of this village.

Every man here would be contented, if he only had his due; failing of that, he keeps his merit to the mark of his wages, by doing his day's work gently. If a neighbour gets more than himself, he tries hard to believe that the man should have earned it; and even his wife is too good to declare, what she thinks of the woman next door to her. Among themselves sometimes they manage to fall out very cordially; but let anybody sleeping out of the parish, have an unbecoming word to say of his betters who are inside it, and if he walk here, without a magistrate behind him, scarcely shall he escape from the sheep-wash corner in the lower ham.

For a beautiful brook of crystal water, after tumbling by the captain's cot, makes its own manner of travelling here, rarely allowing the same things to vex it, or itself to complain of the same thing, twice. From crags, and big deserts, and gorges full of drizzle, it has scrambled some miles, without leisure for learning

self-control, or patience. And then it comes suddenly, round a sharp corner, into the quiet of Christowell, whose church is the first work of man it has seen, except that audacious cottage. Then a few little moderate slips, which are nothing, compared with its higher experience, lead it with a murmur to a downright road, and a ford where men have spread it gently, and their boys catch minnows. Here it begins to be clad with rushes, and to be chaired by jutting trees, and lintelled by planks, for dear gossip and love; for cottages, on either bank, come down, and neighbours full of nature inhabit them.

Happy is the village that has no street, and seldom is worried by the groan of wheels. Christowell keeps no ceremonial line of street, or road, or even lane, but goes in and out, as the manner of the land may be, or the pleasure of the landlords. Still there is a place where deep ruts grow, because of having soft rock under them; and this makes it seem to be the centre of the village, and a spot where two carts meet sometimes; for the public-house is handy. Once upon a time, two carts met here, and here they spent a summer's day, both being driven by obstinate men, who were not at all their owners. Neither would budge from his own rut, and the horses for several hours rubbed noses, or cropped a little grass, while the men lay down. Being only first cousins, these men would not fight; as they must have done, if they had been brothers. Yet neither of them would disgrace his county – fair mother of noble stubbornness – by any mean compromise, or weak concession; so they waited until it grew dark; and then, with a whistle of good will, began to back away together, and as soon as they found room to turn, went home to supper from a well-spent day.

But such a fine treat and stir of interest was rare, and the weather was the only thing that could be trusted for supplying serious diversion. Herein nobody was wronged of subject; for the weather was so active, that the hardest-working man could spend his time in watching it. No sooner had he said that it must be fine, than ere he could catch up his spade again, it was flying in his face, and he was eating his own words. Herein alone, is variety enough to satisfy people of contented heart. For scarcely ever did the same things look the same, for two hours together.

Upon a day of well-conducted weather, beginning brightly in the morning, a stranger newly arrived from town may feed, and gaze, alternately. At sunrise, he is in bed of course; largely saving the disappointment, which the lavish promise of the east might bring. But even at eight of an average morning, when he wants his breakfast, the world is spread before him well, with soft light flowing up the plains, and tracing lines of trees, and bends of meadow. He stands, or sits down to his bacon and eggs, twelve hundred feet above sea-level, with fair land, and bright water, spreading three-fourths of the circle around him. To the east,

some five leagues off, are the dark square towers of Exeter cathedral, backed by the hazy stretches of Black-down; on the right are glimpses of the estuary of Exe, from Powderham Castle towards Starcross. Outside them, and beyond, and overlapping every landmark, the broad sweep of the English Channel glistens, or darkens, with the moods above it, from the Dorset headlands to the Start itself. Before he has time to make sure of all this, the grand view wavers, and the colours blend; some parts retire, and some come nearer; and lights and shadows flow and flit, like the wave and dip of barley, feathering to a gentle July breeze. The lowland people descry herein the shadow of the forest as they call it; and the "Dartymorevolk", looking down upon them, are proud to have such a long "tail to the moor".

For the line of the lane is definite here, as the boundary of a parish is. In many other parts it is not so, and the moor slopes off into farmland; but here, like the fosse of an old encampment, the scarp of the moor is manifest. Over this, that well-fed stream, the Christow, takes a rampant leap, abandoning craggy and boggy cradle, desolate nurture, and rudiments of granite, for a country of comparative ease, where it learns the meaning of meadow. And its passage, from rude into civilized life, occurs in the gardens of the "Captain". Brief is its course, and quickly run; for in the morass, where it first draws breath, three other rivers of wider fame arise, and go their several ways; and one of them, after twenty miles of crooked increase round the North, quietly absorbs poor Christow brook, and makes no gulp of acknowledgment. Without wasting one pebble in calculation, or a single furrow upon forethought, the merry brook hurries to whatever may befall it, and never fails to babble of whatever comes across it.

Now it happened that the vicar of the parish, Mr Short, was a "highly temperate" man, as all who love cold water are supposed to be; although they may love many other things therewith. No sooner had he seen Master Pugsley up the hill, with a strong shove to second old Teddy's motion, than he left those two to go in, and deliver the relics of their cargo, and their own excuses.

"Do'e come in now, and break it to the cappen," the carrier vainly pleaded with him; "do'e, like a dear good minister."

"Tell your own lies, your own way," the parson answered pleasantly; "If I were there, I should have to contradict you."

"How partikkler you be – outzide of the pulpit!" said Pugsley with a sigh, yet a grin at his own wit.

Well seasoned to such little jokes, the vicar looked at him seriously, so that the carrier felt sorry for his wit; and then, with a smile, Mr Short went back to the place where he had left his coat. This was just over against the pile of pots, which had found the ground too hard, and has lost all tenure of it for ever. Looking at these, as he donned his coat, the parson said, "Ha! The newest, I believe, of that wonderful man's inventions! Let me take the

liberty of looking at the fragments." This he soon accomplished to his heart's content, but failed to make head or tail of them, because he was not a born gardener. Then he took up a shord of one rounded side and went down to the river, with that for his cup. Not that he felt any thirst, although he had worked very hard – for a parson; but that a certain school of doctors had arisen, and said that every man, who wished to live, must take his cold pint every morning of his life. Some ten years later, every man, desirous to prolong himself and his family, was bound to take four gallons, shed outside him. And now he takes shivering claret inside.

For the nostrums of the moment Mr Short cared little; but people had praised him, for liking now and then a draught of cold water; and this made him try to do it. With his slip of pantile, as he called it (in large ignorance of garden ware), he passed through a gap in the hedge of the lane, and walked down to the brook, and scooped up a little drink.

Assuring himself how delicious it was, he was going to pitch the shord into the stream, when he spied on its inner rim certain letters, invisible until the cloam was wetted.

"What a queer thing! And how could it have been done?" he thought, as he began to peer more closely; and then he made out the words – "Pole's patent". He tried it, several times, and he turned it several ways; but nothing else was to be made of it. And presently his own surprise surprised him, for what was there marvellous in the matter? Nothing whatever; but it was rather queer that the brand should be inside the pot (which must have required a convex mould) and the name not that of Mr Arthur, although the design was entirely his, as Mr Short knew, from having seen the drawings.

"What a blessing for me that I am not gifted with much curiosity!" said the vicar to himself, as he turned the last corner of the lane, and sat down by the captain's gate, to wait till the carrier's job was done. "Nine out of ten of my brother clerks would have it on their conscience, to rout up this question. A mystery in one's own parish is a pest, when the man at the bottom of it comes to church. Otherwise one might wash one's hands. But this man is honest, and God-fearing, and a gentleman; and the only one fit to smoke a pipe with in the parish!"

Mr Short sighed; for he liked his fellow-men, and was partly cut off from them by his condition, or at least by his own view of it. Though many of the moorland pastors still looked after their flock, in a gregarious manner, not disdaining their assemblage at the public-house sometimes. "Our mysterious friend," he continued, as he gazed, "not only has a very large amount of taste, but also much strategic power. How well he has made his garden fit the stream, so that the stream seems to follow the garden! Grass in the proper place, beds in the proper place, and trees planted

cleverly to drink the water, and flourish like the righteous man! But greatest device of all, and noblest, because of its pure simplicity, the safeguard against morning calls, and the check to inquisitive ladies; for instance, Lady Touchwood. How I should like to know that man's history! Hi, there, Pugsley! Give me a lift over. I can't jump, as I used to do."

A man's resemblance to a tree has been discovered, and beautifully descanted upon – from nethermost tail of tap-root, to uttermost twig, and split sky-leaf – by hundreds of admirable poets. But thoroughly as these have worked out the subject, they seem to have missed one most striking analogy. A man (like a tree) can have no avail of comfort, unless there belongs to him the margin of a brook, to part him from the brambles, and the ruffle, and the jostle of the multitudinous thicket of the world.

"Lark's cot" – as Mr Arthur's home was called by the natives, and even by himself, at last – was gifted with a truly desirable brook – the Christow, as aforesaid. The cot stood about a mile above the village, under a jagged tor, known as "the beacon", and in a south-eastern embrasure of the moor. This lonely, quiet, and delightful spot looked as if it ought to have no road to it, or at any rate none to go any further. Upon its own merits indeed, it never would have earned or even claimed a road: but it fell into the way of one, by a "causal haxident", as Devonshire people term it. For it happened, that one of the feeds of the main Roman road, across the desert, helped itself up the steep labour of the heights, by the crooked balustrade of the Christow brook. This lane, every now and then, cold-shouldered the merriment of the brook, with a stiff dry hedge, and feigned to have nothing to do with it; yet times there were, and as much as a fortnight of Sundays in a downright season, when lane and brook made exchange of duty, as lightly as two parsons do. And the public – so faithful to variety it proves – was pleased in this case, as it is in the other; and after a while found a new charm, in recurring to its veteran and inveterate ruts.

But in moderate weather, and decent seasons, the Christow keeps to its natural bed, strewn with bright pebbles, and pillowed with rock. Through the garden of the captain, its glittering run is broken, by some little zig-zags of delay, and many laughing tumbles; at one of which, it does some work, by turning a wheel, when driven to it. And when the gardener's day is done, and the sun is gone to the western world, while the apple with uplifted, and the pear with pensive eye, stand forth of their dim leafage, in the rounding of the light – then down here, by the fluid steps, and twinkling passage of the stream, a bench is hung with clematis, and tented round with roses, for leisure, and the joy of rest, and bliss of admiration.

Now dwelling here; and seeing how the land was in his favour, the captain helped the hand of nature, to secure his quietude. The

cliff on the west of his garden had offered possibility of descent, to ladies of clear head, and strong ankle. This bad temptation he soon removed, by a few charges of rock-powder; and then towards the north, where the ground was softer, he planted a brake of the large-flowered gorse, having thorns of stiff texture and admirable teeth. The bloom of this was brighter than the fairest maiden's tresses, even of the now most fashionable ochre; and the rustle of the wind, among the tufts, was softer than the sweetest silvery nonsense.

Thus he well established ramparts, solid and spinous, all about his rear; and then he had leisure to improve his front, and eastern flank towards the village. Nature had defended these, truly and honestly enough, by sending a nice watercourse around them. Still there were lapses in the vigilance of the brook, where a lady with her skirts up, might flip through, or even, with a downward run, spring over; and having much experience of the fair, he knew how slow they are to hesitate, with curiosity behind them. So, with a powerful spade, and stout dredging-rake, he made good those weak places; and then looking round, with glad defiance, suddenly espied at his very threshold a traitorous inroad, a passage for the evil one. For here was a series of wicked stepping-stones, coming across a shallow width of water, as old as the hills, and looking quite as steadfast. Strictly heeding these, and probing vigorously with a crowbar, he found one towards the further side, which was loose in its socket, like a well-worn tooth; and after a little operation, he contrived to leave a fine gap in the series. Curiosity on tiptoe might come thus far, but without winged toes or wading boots, was sure of catching gold, if it came any further. Thus a gentleman's wife, from a parish down below, who kept the spy-glass of the neighbourhood, was obliged to stop there; and at once pronounced him a vastly superior, and most interesting man, but undoubtedly a noted criminal.

ROBERT BURNARD
from Dartmoor Pictorial Records

Tavy Cleave

THE TAVY rises about half a mile south of Cranmere Pool, and about the same distance west of Dart Head, at an elevation of 1849 feet above sea level. It is quickly fed by two small tributaries, both rising near Great Kneeset, at elevations respectively of 1800 and 1562 feet.

At the point of junction the stream falls to 1456 feet, with a further decline of nearly 200 feet where the Rattlebrook joins the parent river.

A little below the latter point the Cleave commences, and extends a mile down stream, forming one of the most weirdly romantic gorges to be found on Dartmoor.

On either hand the heights are steep and rugged, rising, especially from the right bank of the river, to miniature mountains, crowned with beetling, jagged, and confused masses of boulders, weathered, worn, and riven by ages of storm and frost. The illustration taken from the bed of the river, looking up stream towards the entrance to the Cleave and Ger or Great Tor, conveys some idea of the romantic beauty of this most interesting gorge. The high ground dominating the left bank, although not so precipitous and rugged as that towering above the right, is steep, rising with great sweeps up to and beyond Stannon Down, fully 500 feet above the river bed.

The Cleave is treeless, but the granite clitters strewing the sides are partially hidden during the sunny season with a wealth of heather, fern, foxglove, and wortle, brightening with colour the more soberly-toned lichen-clad boulders.

Whether approached from its nethermost end, or seen from the summit of Ger Tor, the view is magnificent, and conveys to the observer the impression that in former ages the Tavy must have been larger and more active than it is at present, consequent on descending from a far greater height than now; for we cannot imagine that this ravine has been scooped out during any conceivable period of time by the present small and usually sober stream.

The reservation as to its sobriety is necessary, for at times the flood comes down in mighty volume, but generally runs quickly off, for the fall of the river from the source to Tavistock is rapid, and but moderate damage usually results.

> Here digs a Cave at some high Mountaines foot:
> There undermines an Oake, teares up his root:
> Thence rushing to some Country-farme at hand,
> Breaks o'er the Yeoman's mounds, sweepes from his land
> His harvest hope of Wheat, of Rye, or Pease:
> And makes that channell which was Shepherds lease.
> BROWNE's *Britannia's Pastorals.*

Occasionally, however, a moorland storm of unusual severity so swells the Dartmoor streams that they become abnormally

destructive, and such a deluge of rain fell during the early hours of the 17th of July, 1890, over the watersheds of the Tavy, Walkham, and Cowsic, resulting in such rapid and heavy flooding of these rivers that the oldest inhabitants could not remember its equal. Although the thunderstorm was general over the whole of Dartmoor, and all the rivers rose to an unusual height, the heaviest fall of rain occurred on the above watersheds. Between 8 and 9 a.m. the tors visible from Tavistock, right up to Great Mis Tor, bore a remarkable appearance; for numerous streams were rushing impetuously down their slopes, swamping fields, deluging the roads, and swelling each tiny rivulet into a mighty torrent. By half past eight a terrific roar was heard, and the good folk of Tavistock knew that a big river was coming down. The Tavy presented a sight not easily forgotten. It came in immense volumes, increasing in strength and height every moment until the Guildhall Square was flooded, and the Abbey Bridge was threatened with destruction. All the low-lying cottages were flooded, and a prisoner was rescued from a cell in the police station with some difficulty. Although the bridge stood, the weir which supplies the canal was washed away.

At Marytavy, apart from the havoc and destruction wrought by the storm which broke over the upper reaches of the Tavy basin, the sight was supremely grand. From the heights of Stannon the water flowed in roaring cataracts, so broad as to appear like one vast sheet of foam, down into Tavy Cleave, where, seething, boiling, and dashing irresistibly along, it swept away clams, banks, and bridges, including the picturesque old structure at Harford.

The Walkham also rose in violent flood, carrying away a portion of Merivale Bridge, and destroying the quaint seventeenth-century Ward Bridge in the valley below.

The West Dart came down vigorously; but eye-witnesses agree that the Cowsic appeared to be rushing with twice the volume, and consequent impetuosity, of the Dart. The Cowsic has a fall of 207 feet from the point where the Devonport leat crosses it to its junction with the West Dart, a few yards above Two Bridges. From enquiries made on the spot it was found that the river began to rise at 7.30 a.m., and half an hour later the height of the flood was reached. From measurements made by the author, the united Cowsic and West Dart at Two Bridges rose nine and a half feet in that time. The bridge vibrated in an unpleasant manner, and it was afterwards found that a large number of the casing-stones on the north and west side of the central pier and western abutment had been washed out, leaving the bridge in an insecure condition for anything like heavy traffic.

The most serious damage, however, occurred higher up the Cowsic. All that now remains of the picturesque Clapper are two imposts on each side of the stream. The remaining six, with the smaller one which partly fill a gap on the boulder pier nearest the north side, are all lying in the water a few yards below.

Sweeping onward, after this piece of destruction, the water must have rapidly accumulated in front of the bridge carrying the road by a single arch over the river to Beardown Farm. The strain proved more than it could stand, and every trace of it was swept away, so that in a distance of about half a mile two bridges were destroyed and a third seriously damaged.

The extraordinary flood subsided as rapidly as it rose; for by 8.30 a.m. all the extreme violence had passed, and the river, although swollen, was of ordinary flood dimensions.

The great downpour of rain on this occasion appears to have been on the Tavy, Walkham, and Cowsic watersheds. There was no extraordinary flooding of the Tamar. At Post Bridge the water for a few minutes lapped over the eastern-most impost of the Clapper Bridge, and at Badger's Holt, Dartmeet, the amount of water coming down was equalled some fifteen or sixteen years since.

The waterspout seems to have fallen on the high ground between Stannon Hill and Great Mis Tor, and for a short distance east and west of these points. The Tavy drains the largest portion of this watershed, and was consequently flooded to a greater extent. On this river it has been thus far the flood of the century, and the same may be said of the Walkham and the Cowsic, if the sweeping away of bridges, some of which have stood for centuries, may be taken as a standard of violence.

Post Bridge

THE PRINCIPAL FEATURE in the hamlet of Post Bridge is the ancient Clapper Bridge, so often described by numerous writers, some of whom have seen in it a structure of Celtic origin, and ascribed to it an antiquity of twenty or thirty centuries.

Although the time of erection is unkown, it is safer to assume it to be of a much more recent period, for it was probably built for packhorse traffic, perhaps as far back as mediæval times.

The old packhorse road from Plymouth and Tavistock to Moreton, Widecombe, and Ashburton was conducted over the East Dart by this bridge, and the late Jonas Coaker, who was born in 1801, remembered seeing it carrying horse traffic, and his parents habitually used it before the present roads and county bridges were constructed. A portion of this packhorse road is still visible in Lakehead Newtake, leading down to the western approach to the bridge.

What is certainly the most ancient continuous road on Dartmoor is the Great Central Trackway, now identified with the Great Fosseway. If the bridge was of great antiquity, as some would lead us to suppose, this causeway would have led to it – as surmised by Rowe in his *Perambulation of Dartmoor*; but the

contrary is the case, for the trackway crosses the East Dart, through a ford, one-third of a mile above, thus neglecting the bridge altogether.

In a marsh on the north side of the main road, nearly opposite the church, there is an exposed section of this causeway, illustrating the manner in which a pre-Roman roadway was constructed. It is ten feet wide, and is composed of stones of various sizes, the larger at the bottom, with the smaller at the top, all roughly packed in to a depth of over two feet in the centre. When covered with gravel it made a hard and well-drained road.

Although the bridge may not be able to claim remote antiquity, it is without doubt of respectable age, and is a most interesting structure, for it is the finest clapper on Dartmoor, being forty-two feet seven inches long, and varying in width from six feet four inches to eight feet four inches. The slabs forming the bridgeway are four in number. A single stone spanning the western opening weighs six and a half tons, whilst the eastern stone weighs a quarter of a ton less. The central opening is spanned by two stones twelve feet long, and each four feet two inches wide. These slabs vary in thickness from nine inches to a foot. The piers, which are about seven feet high, are constructed of large flat stones, some two feet thick, dry laid, and roughly shaped so as to present the least resistance to the river when coming down in flood.

The present turnpikes appear to have closely followed the packhorse roads, for remains of the latter may be frequently met with alongside the former.

The route, say from Plymouth to Ashburton, was over the Blackabrook by Okery Bridge, across the West Dart by the clapper which formerly stood at Two Bridges, and over the East Dart at Dartmeet by the bridge which was swept away by a flood in 1826, and is now partially re-erected.

From Tavistock to Moreton the way led over Merivale Bridge, across the Blackabrook by Fice's Well, over the West Dart by the clapper at Two Bridges, and the East Dart by the erection at Dartmeet. Another route went by Bairdown, and over the Cowsic by the small clapper above the modern bridge. Near the eastern end of the stone avenues above Merivale is an old granite guide-post with T engraved on one side, and A on the other. This indicated the way from Tavistock to Ashburton – it appears to have led down to Okery Bridge.

Returning to Post Bridge. There are, just below the bridge on the right bank of the river, two fine mould stones, in which the tinners cast their blocks of tin. The discovery of these by the author caused him to make enquiries, which resulted in the establishment of this place as the site of an ancient blowing or smelting-house. The late Jonas Coaker recollected, when young, that this spot was by tradition regarded as such, and other persons now alive remember that it was considered to be a central smelting-place for the neighbourhood; the tinners all over this part of the Moor bringing their black tin here to be blown. When this was a working blowing-house is unknown; for, like the bridge, there are no accessible documents which throw any light on the matter. The ruin in which the mould stones lie is modern, and occupies the site of the ancient smelting-house.

The Merivale Menhir

THIS EXAMPLE of a Menhir, or "long stone", is situated two hundred yards south of the well-known stone avenues near Merivale Bridge, and can be plainly seen from the train, distant one-third of a mile north, as it rounds King Tor for Princetown. It is ten feet high, fairly square in form, with a diameter of about two feet, gradually tapering towards the top, and stands in the centre of what may have been a circle of stones. Thirty-four yards north of the Menhir is a circle, sixty feet in diameter, composed of ten upright stones, some of which are eighteen inches high. The late Mr Spence Bate cut a trench from the centre of the circle southwards to the circumference, searching without success for objects indicative of its purpose.

This obelisk is usually described as being unwrought, for it bears no evidence of having been worked with tools of any kind; but its general appearance certainly suggests that it has been roughly shaped by the hand of man.

It is much more shapely, and more finished in appearance, than either Bairdown Man or the Gidleigh Menhir.

According to the best authorities these stone pillars were generally erected to commemorate some particular event, or were Archaic tombstones of pre-historic times. Cornwall possesses numerous examples of such rude and bulky monuments, and some of these have been thoroughly examined by digging into the soil around them, and their sepulchral character established. Many of those examined had incinerated remains at or near the covered base of the monolith, and in the case of the Tresvenneck Pillar two urns were found, one nearly twenty inches high, and the other a little over five, containing calcined remains of a human being, including a molar tooth; whilst the latter is described as being filled with a snuff-coloured powder.

Some, at any rate then, of the Cornish Menhirs were tombstones, but others which have been similarly examined have failed to yield evidence of interments, and may therefore be fairly supposed to represent memorials erected to commemorate some particular events. In dealing with the Merivale Menhir the surrounding antiquities must be taken into consideration; for it appears to be an integral part of a somewhat elaborate plan.

On the north we have the ruins of a village, comprising some thirty hut-circles; and a short distance in front of these a double

row of upright stones about two hundred yards long, with a similar row further south of nearly three hundred yards, forming an avenue running nearly east and west one hundred feet in width. Associated with these are remains of cairns, and a cromlech, indicative of places of interment; whilst about two hundred yards more southerly still is the circle previously described, and also the subject of this illustration. We can understand the cairns and cromlech, for they are understood to be connected with early burial, and we can imagine that the Menhir may be a monument erected to commemorate some event, a tombstone or a cenotaph; but what were the avenues and the large circle near the obelisk? The earlier writers placed all they could not understand, when dealing with objects such as these, to the credit of the Druids. This was an easy way out of a difficulty, which does not now pass muster with modern antiquaries. Dismissing the Druidic idea altogether from our minds, we are yet bound to admit that the pre-historic men of Dartmoor probably possessed medicine men, who practised some form of savage ceremonial of which these avenues may have formed a part. This theory, unless the whole of the remains are sepulchral, is at any rate as feasible as that which represents the avenues as being memorials of a great battle, or ranks of soldiers defending the village in the rear; for it is by no means certain that this village is coeval with the other antiquities, since it might have been the residence of later but still early men who streamed the neighbouring valleys for tin.

The Menhir on Gidleigh Common is also associated with remains of other longstones, cromlechs, cairns, and avenues; but the monolith known as Bairdown Man, situated close to the west side of Devil's Tor, stands alone, with no trace of accompanying antiquities. It is nearly eleven feet above the ground, is slablike in shape, three feet five inches wide and one foot deep. The base is notched on the west side, but whether this is natural or artificial it is impossible to say. It is deeply planted in boggy ground, and is so placed that its broad planes face south-south-east, and north-north-west. It is a solitary sombre-looking object covered with black lichen, standing alone in a desolate part of the Moor, with no near traces of the handiwork of early man. It may be sepulchral, or it may be an ancient guiding-mark, for it lies (although not in a straight line) between Little White Tor, where the Great Central Trackway is temporarily lost, and Great Mis Tor, near which the road reappears on its way through Cornwall via Tavistock.

MAURICE DRAKE
from Lethbridge of the Moor
The Prison

DARTMOOR IN AUGUST; a sea of granite, desolate and illimitable, beneath a cloudless summer sky. Range upon range of tors, great gently rising hills, aligned despite their altitudes so regularly between valley and valley, so gradually sloping from upland to higher upland still, that they bear some mighty likeness to the undulated sand on a tide-rippled shore. But for the tiny span scarce the full compass of a child's hand, 'twixt ridge and ridge of wrinkled shore, earthquakes and outbursting subterranean fires in ages past have tossed this granite sea in waves of rock long miles from crest to crest; and for the sea-strewn pebbles on the sand, gigantic granite blocks, larger than great cathedrals, crown the highest hills.

Under foot, sheltered between the scattered boulders, snatching scanty nourishment from the debris of the eternal granite, lies the poor verdure of the moor. Pale coral-flowered ling; feathered tufts of heath, clustered with tiny Tyrian bells; moorgrass spun fine as woman's hair – even at this late season bracken plumes of young and tender green – whortle bushes, their soft ripe fruit staining intruding feet with purple juice, and here and there peach-fragrant gorse, its yellow blossoms bright as fire.

Scarce half a mile away the granite cresting of a tor towers high against the spotless blue. Its level fractures, suggesting cyclopean masonry, appear as though some long departed giant builders here had reared their keep, leaving their work, now weather-worn, seamed with great crevasses and besmeared with stains of lichen, standing in gaunt grey majesty. . . .

There is limitless range of sight in the pure and unbreathed air of these high solitudes. The eye ranges across league-wide valleys to other gently rising summits, shouldering themselves above the waste in wide-bosomed slopes of purple, flecked with strewn grey boulders, grouped at random like feeding sheep. Here an old swaling fire has scarred the hillside bare and brown; miles beyond, a brimming treacherous bog allures with vegetation of rank emerald green; and in the valley bottoms, where heather and brake fern give place to scrubby stunted oaks, the many watercourses tinkle and glitter in the silent noontide.

Through all this wilderness is no sign of moving life. No cattle pasture on the starving ground, scarcely a bird flutters athwart the bare hillsides, and even bees droning in the heather bells are rare intruders. Fish in the streamlets – a few quick lizards in the fern – a kestrel hovering watchful high in air, a tiny stationary dot against the blue – and that is all. Torn barren hills and the silence of great wastes, all dominated by the grey prison buildings, grim as the rock-strewn wilds on which they squat, two miles away, yet seeming in the clear untainted air of the wilderness close at hand. It is such a loneliness as drives men mad.

But where the great granite tor offers some shelter from the keenest winds, a few square stone-walled fields, ravished from the moor, chequer its southward slopes. Heartbreaking human labour has riven and removed the boulders that once cumbered the ground, piling the fragments in loose walls to form the rude enclosures. Plough and harrow, drawn by human cattle, have broken the heathery ground and cleared the land of smaller stones; and now, after years of cultivation, it grows some of the poor hay on which the prison horses feed in winter time.

From the top of the tor, or higher still, from where the watchful kestrel hawk still hangs in air, shabby yellow-brown and blue-black ants seem to perform strange evolutions upon the sunlit chequerboard of fields. They march slowly in scattered lines – stooping and rising erect, advancing and retreating with purposeless, inconsequent manœuvres. But close at hand, upon the lower slopes, the ants are seen to be convicts – biped cattle – making hay for their luckier four-legged brethren.

Biped cattle, howsoever well tamed, are untrustworthy, and so are provided with none of those implements with which free labourers earn their wage. Hay forks, for instance, are not deemed good things with which to trust convicts – a hayfork in the hands of a desperate prisoner proving a far too effective weapon – and the long line of men, six feet apart, that cross and recross the field in sullen silence, turning the thin grass over and over to dry it thoroughly, gather and respread it with their unaided hands.

Behind and at either end of the stooping and rising line of humanity – heavy shod in clumsy prison-made shoes, clothed in coarse drab prison clothing, stamped at intervals with the degrading broad arrow – walk blue-coated warders. The clinking of their sword scabbards, the heavy breathing of the labouring prisoners, and an occasional low-voiced command are the only sounds that break the sunlit silence. At angles in the loose stone walls around the fields are other blue-clad men, keen-eyed and alert, standing as old soldiers stand at ease, with bodies erect, heads warily glancing from side to side, and their hands crossed before them on the muzzles of loaded carbines. No stone walls – which, poets despite, do most effective prisons make – no iron bars

of cages, can show closer or more strait confinement than open sky, bright sunlight and free air, when tempered by this blue-clad vigilance, with, ready at its need, the quick Martini's action.

As the line advanced, tossing the hay before it, a lark, cowering in the grass to hide from the watchful eye high above it in the heavens, broke cover before the heavy-shod feet to flutter a few yards and settle again. The kestrel dropped like a falling stone, coming to a sudden stop a dozen yards above the men's heads and resting there, with slowly flapping wings. Again the advancing line drove the lesser bird from cover; the hawk stooped swiftly, wheeled within arm's length of one of the convict figures, and rose again a few feet, as the lark, cowering and panting with terror, flung itself upon the ground between the man's feet. His hand closed over it quickly but gently, and he went on with his work, tossing the grass with one hand closed.

The wheeling flight of the hawk around him drew the warder's instant attention, and then the clumsy hand caught his eye.

"G, seven fourteen; attention," came the low-voiced order from behind; and G, 714, once George Lethbridge, stood erect, the terrified bird still sheltered in one of the hands that hung at his sides.

The warder stepped up. "Hold our your hand," he said quietly, and the hand went out in immediate obedience.

"Open it."

The hand opened, the bird still cowering in the palm. The men's eyes met impassive across the tiny palpitating life, and then the convict's fell.

"Throw it down."

Again immediate obedience. The bird pitched on the ground and rested motionless. But at a movement of the warder's foot towards it it fluttered a few feet, a swift shadow slid across the bodies of the two men, and with a shrill twitter and a puff of brown feathers the lark was dead beneath the kestrel's worrying beak.

"You'll be reported for this, G, seven fourteen," the warder said, note-book in hand.

G, 714 was stooping unbidden to resume his work. At the words he hitched one shoulder upwards – and muttered an oath.

"Lucky – bird. He's dead," was all he said.

"And for insolence," the warder continued quietly, almost as though he had not heard the words. An answer from so well-behaved a prisoner was rare; but he showed no surprise and never lifted his eyes from his labouring pencil until the entry was complete and the book restored to his breast pocket. The silent line was three yards away when he rebuttoned his tunic.

Sentiment is not encouraged in penal establishments, and his ill-judged effort to interfere with nature's laws cost George Lethbridge some small dietetic luxury for a week. For answering

the warder the heavier penalty of "marks" went against him, entailing some addition to the time he had to serve, which as a well-conducted prisoner he had already considerably reduced in the endeavour to claim his ticket-of-leave at the earliest possible moment.

That earliest possible moment should occur at the end of the following February. Nearly four years of confinement and servitude had turned the boy to a man, sullen and ill-conditioned enough, it is true – the finer arts and graces find no place in the curriculum of the gaol – but yet with some few such impulses as that which prompted him to try and save the shuddering bird that had flung itself for shelter between his feet.

His punishment had been bitter beyond all his deserts. Fresh from the quiet, assured happiness of a home-life not lacking in refinement, softened by his father's unswerving affection, the early months of his confinement had been sheer torture by day, dull, wakeful agony by night. The regulations of his sentence demanded that before being sent to Dartmoor he should serve a period in gaols of a probationary class, under a different regime, and devoid of the small privileges granted to the prisoner with some years' service to his discredit. Those first days were all darkness of agony, untouched by any lighter gleams of hope. His stay in each gaol was too short for him to gain any insight into his tedious and painful tasks; the officials, knowing him for a bird of passage, restricted their intercourse with him to half a dozen statutory enquiries; and, worst of all, the journeys from place to place were an open shame before the eyes of all his fellow men. His young fresh face, pale from confinement and devoid of the scrubby black stubble that defaced the countenances of the older prisoners, attracted the attention of idlers on every railway platform on which he stood, chained to ruffianism and branded as a criminal, a felon, a thing without the rights of manhood.

The curt communication that he was in the next draft for Dartmoor, meant terrified shame as well as hope. Weary to death of the confinement of his temporary prisons, hoping blindly for labour in the open air once more, the possibility of recognition on passing through Exeter yet struck him cold and trembling. His fears were groundless, for the obscured windows of the closed van in which the prisoners travelled disclosed no strange curious faces, no view of outer air, until it opened upon the platform of Princetown station.

Here, though the most stringent of his servitude had but begun, the life weighed less heavily upon him. Healthy, young and strong, he was at first sent out with the weary-footed draining gangs. Because they were armed with broad-bladed cutting shovels, these gangs were strongly guarded, some of the refractory prisoners working in light but strong steel chains.

The work, too, was the cruellest of toil, cutting deep gutters in the tough peat, coffee-coloured bog water to mid-knee. In the cold spring, sharp east winds blew across the high plateau, and the prison doctor tapped the broad chests of the men at statutory inspections with more than common care; in the hot summer days, the straining shoulders could scarce drag the tough peat from the drains, and the blazing sun on the backs of stooping men, their feet in icy water, would sometimes strike a weak or elderly prisoner to the ground insensible, groaning and floundering in the mud and water like a pole-axed ox in the shambles.

But the lad was at the age when bodily labour is a daily delight to the growing and hardening muscles. If the winds were cold, the labour kept him warm; if the sun struck hot, the hill breezes were yet fresh upon his healthy bronzed skin, and the cold water in which he had to stand, though fatal to men of mature years, was only pleasantly cooling to his strong young blood. After long confinement, the open air once more; after four square bare walls, long range of sight across wild and uncultivated hills and valleys, and above his head God's open sky. It is not strange the boy was less unhappy.

When two years of his time had been served, some shift in the floating population of the gaol transferred him from the draining gangs to one of the drafts that laboured in the granite quarries. Here the labour told more heavily on him. The men were of a more degraded class even than his companions in the bogs, where nearly always was a leaven of prisoners from agricultural districts, often rough and brutal, but less vicious and depraved than the brutes from the larger towns and manufacturing areas who wielded hammer and drill in the ringing quarries. As a natural consequence the discipline was sterner, and the guards and warders, hating the discomfort and danger of the work to the full as much as did the prisoners, were harsher than in the gangs devoted to other less unpleasant labours of the penal settlement. Steep and rugged walls of blasted granite shut out the open view and free breezes that had in part reconciled George Lethbridge to the open bogland, and he grew to hate the quarries more and more as the weary days dragged on from spring to summer again.

One stifling Sunday the occasional letter allowed him by statute was handed in at the door of his cell addressed in a strange handwriting, and from it George learned that he would never see again the one script that was familiar to him. His father's letters, always awkwardly worded, stiff and strange in tone, had of late been shorter than ever, the writing perceptibly failing, and now a curt note from his solicitor announced the old man's death.

Who can blame him if the news affected him but little? His sentence had divorced him too completely from his former life to allow him to experience any sense of loss. Besides, the labour in the stifling quarries beneath a July sun was telling on him; he had of late been suffering from attacks of giddiness, and on the very

next day an accident emancipated him from the quarry work for good and all.

A row of holes had been drilled behind a bed of flawed and valueless stone, and the gang, having removed their drills, had fallen in to be marched away from the dangerous vicinity of the blast, four of the most trusted prisoners – men whose sentences had nearly expired – being left in charge of two warders to adjust the fuses. The head warder in charge of the remainder had opened his mouth to give the order to retire when the first of the charges accidentally exploded. The prisoner holding the coil of fuse snatched it away at the cost of a badly burned hand, and the other charges were saved from following the first.

But a loose fragment of stone from the top of the drilled hole flew up in the face of one of his fellows, wiping from it all human likeness, and his body, reeling in horribly ludicrous semblance of life, stagged down a declivity, colliding with George Lethbridge's back, striking him to the ground, and falling fairly across him.

He scrambled to his feet again in a moment, sick with horror, for the awful head that had lain across his breast had nothing recognisable as a face! Only the bearded chin – the man, being within a few days of his release, had a month since been exempted from the prison cropping – showed which had been the front of his head.

Prison diet, coupled with the strenuous toil in which he had perhaps outgrown his strength, had sapped George's constitution somewhat, and he had a violent attack of hysteria. It was just such an attack as had sent him running down the Mamhead road that night two years before.

Sharp treatment on the part of the warders, men not unused to the symptoms of overwrought minds, reduced him to silence almost immediately, but in the night the horror came on him again, and he sobbed and chuckled noisily until the night watchman on duty threatened to report him.

Brought before the Governor in the morning his feverish condition was apparent, and he was sent to the infirmary and handed over to the care of the prison doctor. That official promptly diagnosed a touch of sunstroke, and he was in the hospital a month, wildly delirious for the first quarter of the time. His ravings were lucid enough to give the doctor a hint of his former occupation, and on his return to his cell he found himself ordered to the office of works attached to the gaol, where drawings for a new row of warders' dwellings were in course of preparation. Here he, who had once been almost contemptuous of estate work, traced plans and elevations, copied bills of quantities, and did whatever similar tasks came his way, all of his occupation proving a keen delight to head and hand, so long divorced from their chosen walk in life.

The chaplain, interesting himself in the quiet and intelligent young prisoner, suggested to him that he should resume his architectural studies, supplementing the prison library, filled principally with devotional works, with books from his own shelves. His duties sometimes took him into the convict work-shops; and when, at the end of six months, no more tracings and quantities were needed, he asked to be allowed to join the squad of joiners. His request was granted, and through the last winter but one of his time he belonged to a draft of "star" prisoners who shared a comfortable and well-lighted shop, lively with the cheerful clicking of mallets, the long drawn whistling lisp of the planes, and scented with sweet-smelling pine shavings.

Even limited conversation was not impossible. Despite the presence of sharpened tools the guard was light, the men being the best conducted prisoners in the gaol, and the warders, well dispositioned towards them, were in the ordinary course of things not unready to wink at some slight relaxations of the prison discipline.

At the end of the winter, the extensions being completed, he was sent back, at the doctor's recommendation, to open-air labour on the farm, and in the care of horses, in hedging, ditching, and haymaking, spent the short mountain summer. When the shortening days warned of coming winter, he was promoted by the chaplain's good offices to the post of library orderly, in which wholly congenial occupation he remained until the day of his release.

Partly through the same friendly influence, and partly owing to his otherwise exemplary character, the few bad marks against him were wiped off, and at the end of the following February the boy that had entered into bondage over four years before was enlarged to the world, a man in years, and free once more.

BIBLIOGRAPHY

Arts Council of Great Britain, *Landscape in Britain, 1850–1950* (Catalogue of an exhibition at the Hayward Gallery, London, February–April 1983), London, 1983

Baker, C. Jane, *Reynolds, Hogarth and the Art Educational Theories of the 18th century*, Unpublished thesis, University of Newcastle on Tyne, 1966

Baldry, A. Lys, "The Herkomer School", in *The Studio*, vol. vi, October 1895 "Pencil Drawing at Bushey", in *The Studio*, vol. x, February 1897

Baring-Gould, Rev. Sabine, *Dartmoor Idylls*, 1896

Burnard, Robert, *Dartmoor Pictorial Records*, 1890

Carrington, Nicholas Toms, *Dartmoor, A Descriptive Poem* (Preface and notes by William Burt), London & Devonport, 1826

Certigny, H., "Une source inconnue du Douanier Rousseau", in *L'Oeil*, no. 291, October 1979

Circa Fine Art, *Frederick John Widgery* (Catalogue of an exhibition. Compiled by Philip Saunders), Plymouth, n.d. [1983]

Cocks, J. V. Somers, *Devon Topographical Prints 1660–1870: a Catalogue and Guide*, Devon Library Services, Exeter, 1977

Crossing, William, *Amid Devonia's Alps*, London & Plymouth, 1888
 The Ancient Crosses of Dartmoor, Exeter & London, 1887
 From a Dartmoor Cot, Taunton & London, 1906
 Guide to Dartmoor, Exeter & London, 1909
 The Land of Stream and Tor, Plymouth, 1891
 "Present-day Life on Dartmoor", in *The Western Morning News*, 5 August 1903 onwards (Edited by Brian Le Messurier as *Crossing's Dartmoor Worker*, Newton Abbot, 1966)
 Tales of the Dartmoor Pixies, London, 1890

Dixon, Sophie, *A Journal of Ten Days Excursion on the Western and Northern Borders of Dartmoor*, Plymouth, 1830

Farington, Joseph, *The Farington Diary* (Edited by James Greig), 6 vols, London, 1922–6

Gould, Cecil, *Space in Landscape* (Themes and Painters in the National Gallery, 9), London, 1974

Groser, Albert, *Greece and the Grecians: Records of a Holiday Trip to Greece, through Italy and Switzerland, by a Party of Gentlemen, chiefly from Devonshire*, Plymouth, 1889

A Guide to the Eastern Escarpment of Dartmoor with a Descriptive Map, London, Exeter, Devonport and Plymouth, Chudleigh, 1851

A Handbook for Travellers in Devon & Cornwall, Exeter, 1865

Holloway, James, and Errington, Lindsay, *The Discovery of Scotland* (Catalogue of an exhibition at the National Gallery of Scotland, October–November 1978), HMSO, Edinburgh, 1978

Hoskins, W. G. (ed), *Dartmoor* (National Park Guide no. 1), HMSO, London, 1965

Howard, Peter J., *Changing Taste in Landscape Art*, Unpublished thesis, University of Exeter, 1983

Jones, Rev. J. P., *A Guide to the Scenery in the Neighbourhood of Ashburton, Devon*, Exeter, 1823
 Observations on the Scenery and Antiquities in the Neighbourhood of Moreton-Hampstead, and on the Forest of Dartmoor, Devon, Exeter, 1823

Koninckx, W., *Trois Peintres Anversois: Charles Verlat, Piet Verhaert, Charles Mertens*, Musées Royaux des Beaux-Arts de Belgique, Brussels, n.d. [late 1940s]

Langhorne, Rev. R. W. B., *A Sermon preached in the Cathedral Church of Saint Peter in Exeter, 11th July, 1943 (Choristers' School Founders' Day)*

Laskey, J., "A Ramble on Dartmoor", Letters to *The Gentleman's Magazine*, 1795–6

Longman, Grant, *The Beginning of the Herkomer Art School 1883–5*, Bushey, 1983

Northcote, Lady Rosalind, *Devon: its Moorlands, Streams, and Coasts*, London & Exeter, 1914

Parris, Leslie, *Landscape in Britain c.1750–1850* (Catalogue of an exhibition at the Tate Gallery, London, November 1973–February 1974. Introduction by Conal Shields), Tate Gallery, London, 1973

Murdoch, John, *The Discovery of the Lake District* (Catalogue of an exhibition at the Victoria and Albert Museum, London), Victoria and Albert Museum, London, 1984

Newman, John, "The Conjuror Unmasked" (in *Reynolds*, catalogue of an exhibition at the Royal Academy of Arts), London, 1986

Phillpotts, Eden, *My Devon Year*, London, 1916

Presland, John, *Lynton and Lynmouth: a Pageant of Cliff and Moorland*, London, 1908
 Torquay: the Charm and History of its Neighbourhood, London, 1920

Pycroft, George, *Art in Devonshire: with the Biographies of Artists Born in that County*, Exeter, 1883

Reynolds, Sir Joshua, *Discourses on Art* (edited by Robert R. Wark), Yale University Press, New Haven & London, 1981

Rogers, Eva C., *Dartmoor Legends*, 1898

Rowe, Samuel, *A Perambulation of the Ancient and Royal Forest of Dartmoor*, Plymouth & London, 1848; third edition, revised and corrected by J. Brooking Rowe, Exeter & London, 1896

Royal Academy of Arts, *Bicentary Exhibition, 1768–1968* (Catalogue of an exhibition December 1968–March 1969), London, 1968

Royal Albert Memorial Museum, Exeter, *Paintings of Dartmoor: Eighteenth–Twentieth Century Work* (Catalogue of an exhibition May–June 1985. Compiled by C. Jane Baker), Exeter Museums, 1985
 William Widgery 1826–1893: Frederick J. Widgery 1861–1942: Paintings, Watercolours, Drawings (Catalogue of an exhibition June–July 1972. Compiled by C. Jane Baker), Exeter Museums, 1972

Simmons, Jack, *A Devon Anthology*, London, 1971

Smiles, Samuel A., *Plymouth and Exeter as Centres of Art 1820–1865*, Unpublished thesis, University of Cambridge, n.d. [1982]

Watford Museum, *Stand to Your Work – Hubert Herkomer and his Students* (Catalogue of an exhibition. Edited by Stephen Poole), Watford Borough Council, 1983
 A Passion for Work – Sir Hubert Von Herkomer 1849–1914 (Catalogue of an exhibition February–March 1982. Edited by Stephen Poole), Watford Borough Council, 1983

Williams, T. H., *Picturesque Excursions in Devonshire*, Exeter, 1815

Wootton, M. and S., *The Little Book of Lydford: facts and legends*, Tavistock, 1971

ACKNOWLEDGEMENTS

Because of the scarcity of available material, I have had to check a great number of points with many individuals and institutions. To all of them I am indebted for their willing and instant cooperation, even when our joint efforts yielded negative rather than positive results.

As always, I relied heavily upon the resources of the West Country Studies Library, Exeter, and the help of Ian Maxted and Peter Waite and their colleagues. I was also greatly assisted by Mrs Sheila Stirling and her colleagues at the Devon and Exeter Institution Library. Richard Jupp of the Exeter reference library, staff in the reference sections at Bideford and Torquay, Marjorie Rowe and Alice Wells of the Devon Record Office, and Audrey Erskine of the Cathedral Library all provided assistance in their respective fields.

Anne Buddle and Helen James both went to enormous trouble to trace some virtually unknown and rare material on the life and work of Charles Verlat. Similarly, rare material on Herkomer and his art school was acquired through the good offices of David Setford of Watford Museum. Lt. Col. Rory Clayton, Major Sandy Dakin, and the National Army Museum library all contributed to research into F. J. Widgery's military associations and activities.

Maureen Attrill of Plymouth City Museum and Art Gallery was of tremendous help in providing data on the Plymouth-based Dartmoor artists and other information from her files. Robin Paisey, Keeper of Art at Leicester Museums and Art Gallery, provided detailed information on Francis Towne's *The Valley of the Teign*, as did Jane Farrington, of the Department of Fine Art at the City Museums and Art Gallery, Birmingham, on Richard Wilson's *Okehampton Castle*. (These two paintings are in the collections of Leicester and Birmingham respectively.) Similarly, Les Retallick of Torre Abbey, Torquay, provided immensely useful notes on the early works by William Widgery that are housed there. Lt. Col. C. Delforce greatly assisted me with information on Powderham Castle and works of art therein and I am also indebted in this matter to the Earl of Devon and the Earl of Halifax. The Earl of Iddesleigh helped with my enquiries about Lady Rosalind Northcote.

Dr John Edgcumbe, Canon J. P. Hoskins, Christopher Kingzett, Mary Oliver, Dr Michael Pidgley, Philip Saunders, and Peter Wale have all contributed useful information.

My thanks are also due to Peter and Gilly Manson and Bruce and Iris Sutton for giving me guided tours and information on the history and contents of Taddyforde House and to Mrs Linda Elliott and Mr and Mrs Boulter of Lydford for information on the 1987 Widgery celebrations and the Lydford House Hotel.

Mr D. Walsh and Mrs Rosemary Wakelin, both direct descendants of William Widgery, helped greatly with information on other members of the family. I am especially indebted to Mrs Wakelin for her tremendous efforts in trying to trace as much information as possible for me and for her compilation of a family tree.

Overseas, Mrs Betty Desnoy has garnered what information she could on a possible Australian branch of the family and the Corcoran Gallery, Washington D.C., have made great efforts to trace information about Julia Widgery and her work as an artist in the U.S.A.

Richard Gowing, great-grandson of William Widgery's friend Richard Gowing, provided me not only with interesting information on his great-grandfather, but also copies of the original glass-plate photographs of William at work on Dartmoor.

Much appreciation is due to my patient and willing typist, Miss Susan Holden, my sister, Ann, for work on the Bibliography, and David Garner for his care and skill in photographing the illustrations. I would also like to thank Peter Nicholls, Director of Exeter City Council's Department of Leisure and Tourism, Mrs Hilary McGowan, Assistant Director, Museum and Arts, and all my colleagues at the Museum for their forbearance and support while I have been writing my text. In particular, Kelvin Boot gave me much initial practical advice, and throughout the project I have had continual support and encouragement in innumerable ways from my colleague and friend, Jeremy Pearson.

C.J.B.

I would like to add my thanks to those offered by my co-writer. In particular, I am grateful for the help so generously given me by the West Country Studies Library, Exeter, and the Devon and Exeter Institution Library.

S.O.